A HISTORY of HOSTELRIES in
NORTHAMPTONSHIRE

With love
from
Jen. x

2016

A HISTORY OF HOSTELRIES IN
NORTHAMPTONSHIRE

Peter Hill

AMBERLEY

First published 2010

Amberley Publishing Plc
Cirencester Road, Chalford,
Stroud, Gloucestershire, GL6 8PE

www.amberleybooks.com

British Library Cataloguing in Publication Data.
A catalogue record for this book is available from the British Library.

ISBN 978 1 4456 0197 7

Typesetting and Origination by Amberley Publishing.
Printed in Great Britain.

CONTENTS

ACKNOWLEDGEMENTS

Such an exhaustive and diverse range of subject matter involved in a book of this nature, requires a great deal of time-consuming research and tracking down a variety of sources. I am grateful therefore to the many contacts who have helped me over the years in this task and with my previous books. In some cases, this has necessitated asking my contacts to carry out seemingly impossible missions!

Among them I wish to thank Sarah Bridges and the staff at the Northamptonshire Record Office, past and present for allowing access to and usage of relevant material over the years. Likewise the record offices of Leicestershire, Lincolnshire and Oxfordshire have been of great assistance. Of paramount importance has been specialist material held at the National Archives, British Library, Law Society, and the libraries of universities in the region. In addition, the English Heritage database of listed buildings has also been helpful.

Local help has been forthcoming from staff at libraries around the county, particularly Andrea Pettingale of Kettering Library, who with her special interest in local history and knowledge of that town, has been of great help, carrying out searches tirelessly without complaint. The Local Studies Collection at Northampton Central Library has also been of great use with its archive of books and early newspapers, as have the libraries at Peterborough and Stamford. In addition the heritage centres at Burton Latimer, Desborough and Rothwell, have also been of assistance in the material they have uncovered, as have the museums in Kettering, Oundle, Peterborough, Stamford and Wellingborough.

A special mention must go to those individuals named and unnamed, past and present, who provided additional information or material, in particular Jack Bailey, the late Quentin Bland, David Brookhouse, Ben Butler, David Close, Mollie Dunkley, Glenn Foard, Audrey Forgham, Maurice Goodwin, Phil Greenway, Joyce Griggs, Hilary Hillman, Steve Hollowell, Belinda Humfrey, Tony Ireson, Francis James, Elizabeth Jordan, John Meads, Ron Mears, Anna Peacock, Jack Robinson, Sue Payne, the late Roy Pettit, Monica Rayne, Stephen Richards, the late Beryl Simon, Jane Smith, Rosemary Smith, Sheila Southwell, Terry Sumpter, Reg Sutton, Joe Tebbutt, Arthur Welch, George West, David Wilcox, and Bill Williams. There have been a number of others, now long

gone, with whom I spent much time in their homes, discussing their early days, including one remarkable lady of 104 years old, a crucial link with a vanished world where the pace was slower, everyone made the most of what they had, and hardly travelled beyond their parish or neighbouring villages.

Among the most rewarding experiences over the years has been whilst lecturing and running courses around the county and elsewhere. This has enabled me to meet some interesting people whose families have been established in the area for several generations, and who have consequently been able to shed light on some of the more nebulous social historical aspects of their communities. Others with an interest in a certain topic have likewise been of great assistance, some of them providing material not found in any official archive – priceless items such as personal memoirs (including mini autobiographies written specifically for family members only), diaries, and even letters, that have somehow managed to survive the ravages of time and circumstance, and which might have been lost for ever, like so much else. Similarly the two great history projects I have been involved with around the county (and the old Soke of Peterborough) as historical consultant: the 'People of the Forest' and 'Rose of the Shires', continue to produce a hitherto unknown wealth of information that one could scarcely dream about.

Finally, mention must be made of the sterling work done by committed individuals and local historical societies in documenting their village, either for an archive or in book form. They deserve a lot of praise and credit for piecing together the past of the county, particularly in tracing names and even locations of hostelries within their communities. Though they not be mentioned here by name, their painstaking efforts are acknowledged for the great contribution they have made to the subject and this book.

FOREWORD

For many people since time immemorial, the pub in all its forms has been the perfect place to relax, enjoy oneself, socialise, escape temporarily from the rigours of everyday life, and sample some of England's best liquid refreshment. At last there is now a book which conjures up the atmosphere, and looks at the drinking culture in the county from the earliest times to the present, showing the changes and customs, licensing laws, and other things that have come and gone, as well as the incidents and events that have taken place inside and outside the hallowed walls of the public house.

Northamptonshire has had (and still has) some of the most interesting pubs in England. Writer, historian and lecturer, Peter Hill, has now managed, after ten years' research, interviewing countless people and visiting sites around the county, to bring everything together in this attractive readable volume, his nineteenth book, to add to the annals of the county's history. It is my pleasure in recommending its contents to the reader who I am sure will enjoy weaving his or her way through the pages, on a path of revelation and discovery of what is one of the most fascinating subjects in the world.

Phil Greenway,
Chairman of the Northamptonshire branch of the Campaign for Real Ale (CAMRA).

INTRODUCTION

'There is nothing which has yet been contrived by man, by which so much happiness is produced as by a good tavern or inn.'
(Samuel Johnson, as quoted in James Boswell's *Life of Samuel Johnson*, 1791)

The subject of public houses forms a vital part of our social history, and gives a colourful glimpse and insight into how Northamptonshire folk used to live, work and play. The inns, alehouses and beershops of the county with which they were familiar, traded under a vast array of interesting names, which reflected various aspects of contemporary life, some of which were commonly found around the realm, some unique to a particular locality, whilst others were of a quirky or cryptic nature, often with an underlying sense of irony, or touch of humour.

Over the centuries the villages of England, even those with small populations, had one or more of these hostelries to cater for their thirsts and which also, like the church or chapel, acted as a focal point for the community, where one could find a refuge from the rigours of life and work. That traditional role has changed today with an unprecedented growth in population, increased mobility, different lifestyles and a greater choice of leisure activities, which has led to villages in the county having lost at least one or most, if not all, of their hostelries. This trend is still continuing.

Several hostelries have a claim to be older than they really are. Many certainly have their origins in the seventeenth century – at least part of the building, or some of its furnishings date from that time. Since then however there would have been extensive alterations or rebuilding, and in the majority of cases they would not have begun their existence as hostelries, a transformation which would not occur until the following century or after. Therefore questions need to be answered to verify a claim:

(a) *Has it always been a hostelry?*
(b) *What is the proof of its age?* Many are rebuildings or extensions of an earlier dwelling, which have retained some of the original fabric or furnishings eg at Brackley, the *Crown* has a late sixteenth-/early seventeenth-century moulded stone fireplace, whilst the *Red Lion*, has a modern front concealing early seventeenth-century fabric.

The *Wheatsheaf* at Daventry has a seventeenth-century staircase, the *Golden Lion* at Brigstock dates from the seventeenth century but has a medieval cruck frame roof from the earlier structure, and the White Swan, at Harringworth has a sixteenth-century staircase and six casement windows with moulded surrounds (two of which are inscribed with later graffiti from the eighteenth century).

(c) Is it on the site of an earlier hostelry? If so, did it retain that name, or take on another? The eighteenth-century George Inn in Kettering is a good example, being on the site of the seventeenth-century Cock Inn.

(d) Has it been resited, taking on the name of a previous hostelry? The *Bell* at Finedon is one such example.

Buildings dating from before the seventeenth century are rarely found, due to their transient nature, being constructed of perishable materials such as cob (clay and straw), and wattle and daub, thatched roofing, and with their foundations resting on the surface – in fact, most dwellings would need rebuilding about every twenty years for a new generation, earlier if hit by fire, storm or flood. Even those buildings with a more durable fabric such as limestone rubble, or ironstone, would require periodic renovation or rebuilding. There was more of a sense of permanence from the seventeenth century onwards, when some of the more grandiose buildings would be constructed with coursed limestone, ashlar chimneys, Collyweston tiled roofs, thick gable coping and stone mullioned windows, but even these over the years have undergone change, in the form of extension or enlargement.

The oldest surviving vestiges of hostelries in Northamptonshire can be found in two buildings at Fotheringhay, which in both cases date from the mid-1400s – a unique

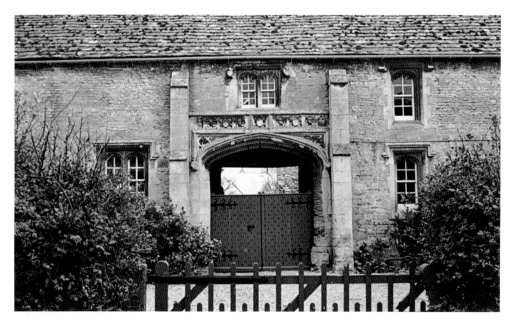

The gateway of the former *New Inn* at Fotheringhay, one of two mid-fifteenth century inns built by Edward IV for visitors to the castle. It is now part of Garden Farmhouse.

situation anywhere. Both the 'old inn' and the 'new inn' (1461-1476) were built for the Langley family, dukes of York, as 'overflow' accommodation for the many guests staying at their castle nearby, the latter hostelry being commissioned by the future Edward IV. Many years later in 1821, the local historian and vicar of Kingscliffe, Henry Key Bonney, wrote:

'At the eastern end of the street are two houses nearly opposite each other, called the old and the new inns. The former has long been converted into tenements for the use of the poorer parishioners, and has nothing remarkable in its appearance'.

Today, the five dwellings that constitute the old inn (now known as 11-17 Main Street) have visible vestiges of its former use, in the form of the now-blocked carriage arch in the front walling, together with an irregular twelve-window range in the upper level.

Its successor, the 'new inn' is now called Garden House and still has the original frontage which would have impressed visiting dignitaries. In 1624 it was described in a survey for King James I as containing a hall, parlour, diverse other chambers, 'fair stables', barns and outhouses. In 1821, the Revd Bonney, described it as 'a more substantial and handsome edifice', with the following description:

'The front of this building, injured as it by this time preserves its original form, and affords a specimen of the domestic architecture of the fifteenth century. The entrance is under a gothic arch, decorated with roses and armorial bearings. Above the entrance is a window ornamented in a similar manner...The galleries mentioned by former writers as 'running around the inner court' have been removed; and no part of the interior affords anything to attract attention. It forms at present three sides of a quadrangle. The greater part of it is converted into barns, and granaries, and the rest is still inhabited.'

The castle had two main claims to fame during its existence: one being the birthplace of the future Richard III in 1452, the other in its final days, as the prison and execution place of Mary Queen of Scots in 1587, by which time the two inns were in their final days of use as hostelries.

The site of the *Talbot* in Oundle can claim, with some justification, to be the earliest surviving hostelry in the county, standing on the site (recorded 638AD) of where an early Christian 'hospitium' dispensed ale and food, and provided accommodation, for wayfarers and pilgrims to the church. A succession of buildings carrying out a similar function at the same site continued through the years, the latest having a new frontage added in 1626.

The *Bell*, at Finedon, like the *Talbot*, has a loose claim to be the oldest hostelry in the county, but in this case is not the original building, nor is it standing at the same site. Its predecessor stood a short distance away but in the nineteenth century its licence and name were transferred to a late sixteenth-century farmhouse (with a datestone on its rear gable, inscribed 'RC/1598/MC'), where the frontage was rebuilt and transformed in typical Victorian-Gothic style, by the eminent county architect, E. F. Law, with medieval and Tudor features, including old-style carved heads and finials, stone mullioned windows, and an oriel window, below which is the commemorative inscription 'ER 1072 Tingdene Hostelre VR 1872' and carved coats of arms. A niche to the right of the porch contains a statue of Queen Edith, wife of Edward the Confessor, who held the manor during the Saxon era. The building fitted in with a group of others commissioned by the lord of the manor, William Mackworth-Dolben, who had a passion for the 'new' style' and follies, or eye-catchers, including the Ice House Tower, Ex Mill Windmill (a converted cottage with castellations, 1860), and the Volta Tower (1863/5).

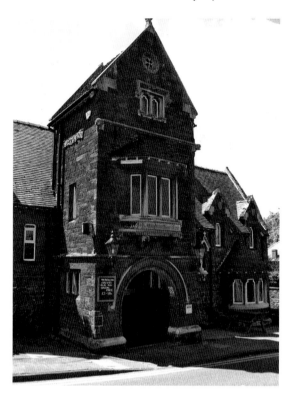

The *Bell* at Finedon.

A similar claim of being one of the oldest hostelries is the *Old Cherry Tree* at Great Houghton, which has an inscription on a quoin (*not* resited): Anno Dni 1576, Grobyns A R', whilst the *Golden Lion* at Wellingborough dates from 1540, and has a minstrels' gallery, but like several other contenders, began life as a farmhouse, only becoming a hostelry at a much later date.

Back in the 1990s, I ran a series of ten-week WEA courses on the History of Hostelries around the county. The attendance was phenomenal, showing the degree of interest in the subject – and this did not include any field-trips! More amusing was at one session, when BBC Radio Northampton came along to do a live broadcast, recording snippets and interviewing some of the people attending. The *Evening Telegraph* also came along and wanted to do a feature. They also needed a (colour) photo whilst there, preferably with me holding a glass of wine. There was only Ribena in the vicinity and so we had to make do with that!

This book will reveal a wealth of scrupulously researched tales and facts. Hopefully you will be tempted to go out and explore the county, seeking out some of the places and sites mentioned, whilst perhaps sampling a little of its heritage in liquid form, soaking up the atmosphere of some of the older surviving places, and letting the imagination wander into part of a world that was so vital in the lives of our ancestors.

Peter Hill, Summer 2010.

Northampton County

LOUNGE TARIFF

CASK ALE

XX and Brown Ale	7d.
XXX & P.A.	8d.
I.P.A.	9d.
XXXX	10d.

Glasses ½d. less than ½ Pint price.

BOTTLED BEERS

P.A. & MILD Ale	... pts.	
Brown Ale & Star	... pts.	9d.
„ „ „	Split pts.	
„ „ „	... ½ pts.	5½d.
I.P.A. (No Splits)	... ½ pts.	7d.
Jumbo Stout ...	pts.	10d.
„ „ „	Split pts.	5d.
„ „ „	... ½ pts.	6d.
Stingo (No Splits) ..	½ pts.	8½d.
„	Nips	6½d.
Bass & Worthington ...	½ pts.	8d.
Guinness ½ pts.	8d.
„	Nips	6d.
Sportsman's Ale ...	Can	7½d.
Lager (British)	.. ½ pts.	9d.
Lager (Foreign)	... ½ pts.	10d.
Cyder (Flgn.) ...	Glass	4d.
„ ½ pt.	4½d.
Cyder ...	½ pt. Bottle	6½d.

MINERALS

Minerals	4d.
Grape Fruit	4d.
Baby Schweppes	3½d.
Schweppes Splits	5d.
Lemon & Dash	4d.

WINES & SPIRITS

Proprietary Whisky			9d.
Scotch, Irish, Rum, Gin	8d.
Eady & Dulley Special and VERY OLD HIGHLAND			9d.
Phœnix ███████████████			
Booths & Gordons Gin	9d.
Hollands Gin (Monogram)	9d.
Pale Brandy	10d.
Martells Brandy	1/-
Jamacia Rum	9d.
Port, Medium Tawny (W.S.) ..			8d.
„ Selected White (Y.S.) ...			9d.
„ Old Tawny (R.S.) ...			10d.
„ Hunting (Blk. S.) ...			10d.
Sherry, Medium Full (W.S.) ..			8d.
„ Full Bodied (Y.S.) ...			9d.
„ Fine Dry (G.S.) ...			10d.
„ Choice Old Brown (Blk.S.)			10d.
Benedictine	1/2
Cherry Brandy	10d.
Ginger Brandy	9d.
Sloe Gin	9d.
Gordons Orange & Lemon Gins		9d.
Cocktails	1/1
Wine Cocktails	9d.
			9d.
Advocaat		1/-
Gin & Italian	10d.
Gin & French	10d.
Gin & Lime	10d.
Ginger Wine	4½d.
Peppermint	4½d.
Dubonet	11d.
De Kuyper's Hollands	10d.
Heering's Cherry Brandy	1/-
Pimms	1/8

...

Cloves, Aniseed, Angostura Bitters } Per Dash		1d.
Orange Bitters, Peach Bitters }		

CHAMPAGNE

De la Ronciere	... ½ Bots.
Moussec	... Baby Botts.	...

1/12/39

The price list of drinks at the lounge of the George, Desborough, December 1939.

ORIGINS AND ALEWIVES

The first type of hostelry in England was introduced by the Romans. Needing to cross the country with men, animals, goods and supplies, it was necessary to stop *en route* for rest and refreshment. Thus the *mansio* or *caupona* came into being. This was basically a posting station and inn situated at intervals along roads, about twenty miles apart, and in settlements, providing wine and food, and consisted of rooms for accommodation, bathing, and (like the smaller *mutationes*) stabling/change of horses. Also situated *en route* and in towns were *tabernae*, where one could enjoy some wine and perhaps some form of entertainment. These would evolve over the centuries into the tavern and today's wine bar.

With the arrival of the Anglo-Saxons, who preferred large quantities of ale and mead, numerous *ale-booths* or *ale-stands* began to appear and rapidly required official regulation, beginning in 616 under Ethelbert and, as they became so numerous and unruly, by Ina of Wessex in 728.

After Christianity had established itself, a new form of hostelry would slowly begin to appear, the prototype of one that would become dominant in the Middle Ages, as travel became more general around the realm: *the inn*. Starting as monastic guesthouses, some with chapels attached for travellers, tradesmen or pilgrims to give thanks for a safe journey and a shrine for offerings, they became profitable to the monks, who were expert brewers of ale, and could therefore make a stay a pleasurable experience. Several of these monastic dwellings would expand and become inns, eventually losing their religious origins and features.

Guest accommodation could also sometimes be found in the homes or property of absentee lords of the manor, who were away on a crusade, pilgrimage, or other enterprise. It would be a good way of accruing extra income whilst they were away, with a steward or other representative overseeing the proceedings on their behalf. The manorial coat of arms would usually be on display outside the building, and were probably instrumental in the name appearing on certain hostelry signs at a later date, especially if such a house was in later years, converted into an inn proper.

The medieval inn in general however left little to be desired by modern standards. There would have been no privacy, with patrons of both sexes sleeping en masse on

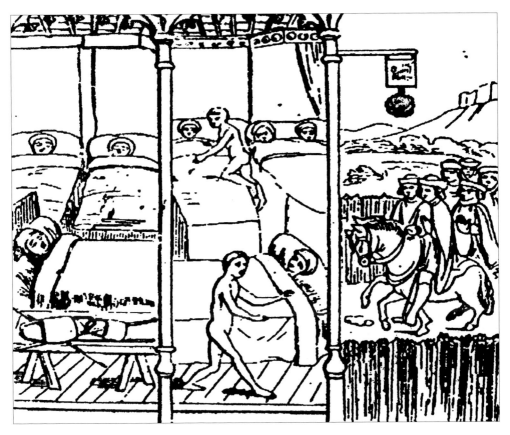

A medieval inn, showing the degree of privacy and comfort that was the norm.

pallets in one or two large rooms like dormitories, stepping over each other to reach their chosen place, the bedding infested with fleas, and vermin running around the place. They would also be locked in at night. At least there would have been ale and basic food, such as bread and meat. The standard cost of an overnight stay was a penny in London, and a halfpenny in the provinces, but even that seemed expensive, causing Edward III to issue a statute constraining prices.

At the same time, the ale-booth evolved into the alehouse, a less transient structure where ale could be enjoyed under shelter and arguably, in more congenial surroundings. Originally these would have been recognised by having an *ale-stake* such as a bush suspended above the doorway – an early type of hostelry sign. Similarly, 'bough houses' signified that ale was for sale during fairs or markets. Many of these were run by women who brewed and dispensed the ale on offer at the premises. Later known as *alewives*, the prototype 'barmaid', some went on to achieve fame in later years, though perhaps with a little satire attached to their appearance or diligence. For example, the sixteenth century poet Andrew Skelton seems to have had a distorted opinion of alewives, in one of his ballads painting a picture of one such person as a withered dame with a crooked nose, humped back, and grey hair, who 'breweth noppy ale, and maketh thereof poorte sale, to travellers, to tynkers, to sweters, to swynkers, and good ale drinkers'.

However, some descriptions were more flattering, such as this picture of an alehouse and the ideal alewife:

'If these houses haue a boxe-bush, or an old post, it is enough to show their profession. But if they bee graced with a signe compleat, it is a signe of good custome: In these houses you will see the history of Judith, Susanna, Daniel in the Lyons Den or Diues and Lazarus painted vpon the wall. It may bee reckoned a wonder to see, or find the house empty, for either the parson, churchwarden, or clark, or all, are doing some church or court businesse vsually in this place. They thriue best where there are fewest; It is the host's chiefest pride to bee speaking of such a gentleman, or such a gallant that was here, and will bee againe ere long: Hot weather and thunder, and want of company are the hostesses griefe, for then her ale sowres: Your drinke vsually is very young, two daies old: her chiefest wealth is seene, if she can have one brewing vnder another: if either the hostesse, or her daughter, or maide will kisse handsomely at parting, it is good shooing-horne or bird-lime to draw the company thither againe sooner. Shee must be courteous to all, though not by nature, yet by her profession; for shee must entertaine all good and bad; tag and rag, cut, and long-tayle: Shee suspects tinkers and poore souldiers most, not that they will drinke soundly, but that they will not lustily. Shee must keepe touch with three sorts of men, that is: the maltman, the baker, and the justices clarkes. Shee is merry, and half mad, upon Shroue-Tuesday, May-daies, feast-dayes, and morris-dances: a good ring of bells in the parish helps her to many a tester[taster], she prays that the person may not be a puritan: a bag piper, and a puppet-play brings her in birds that are flush, shee defies a wine-tauerne as an vpstart outlandish fellow, and suspects the wine to bee poisoned. Her ale if new, looks like a misty morning, all thicke; well if her ale bee strong, her reckoning right, her house cleane, her fire good her face faire, and the towne great or rich; shee shall seldom or neuer fit without chirping birds to beare her company, and at the next churching or christening, shee is sure to be ridd of two or three dozen of cakes and ale, by gossiping neighbours...'

Another name for an alewife was 'Mother Redcap'. It is a pub name that can still be found in England, in places such as Luton, but in the nineteenth century there was an alehouse of that name in Northampton. Above the doorway was a slogan:

'Please step in and taste my tap, 'twill make your nose as red as my cap'.
There was also another rhyme associated with such alehouses:
'Old Mother Redcap, according to her tale,
Lived twenty and a hundred years by drinking good ale.
It was her meat, it was her drink and medicine besides,
And if she still had drunk ale, she never would have died.'

Some alewives and male brewers could be dishonest in the amount of ale they dispensed, giving short measure by adding pitch to bring the contents to the brim, or even using soapwort or other means to give a 'head' to the ale! The development of the cucking stool around 1215, enabled such miscreants and other dishonest tradespeople to be punished, by strapping them in a chair-like device and then displaying them for public humiliation. (In the county at Wilbarston, there is a field once known as Cuckstool Hill). The pillory was also used in a similar way after 1256.

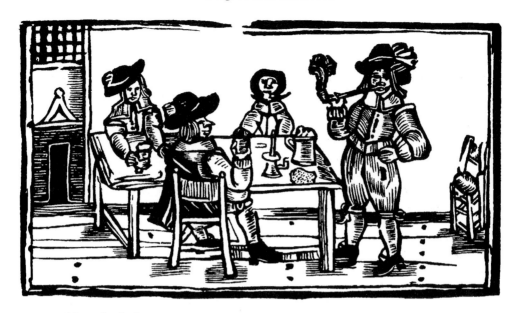

A typical late Elizabethan tavern scene.

During the Tudor and Stuart period, three newer forms of hostelry appeared in towns. Firstly there was the 'ordinary', which took its name from the set meal it provided on a daily basis, whilst still dispensing ale, as well as being a place to gamble at cards and dice. They became very popular and ranged from a very seedy cheap establishment (patronised by the poorer classes and the haunt of dubious clientele such as thieves, tricksters, and whores) offering the meal at a penny; the more respectable premises used by the ordinary townsman, or the professional, where a threepenny meal was standard; and the fashionably expensive for the upper classes, where wine was available as at a tavern.

At the same time, the 'chophouse' came into being a forerunner of today's steak and grill houses or restaurants. With a wide range of cooked meat dishes available and plenty of alcohol, including the finest wines, they were especially popular with merchants and dealers as trade with Europe expanded, bringing in new ideas and goods.

The mum-house also found favour with those wanting something a little different from the normal alehouse. It was so-called after the beer it sold, a beverage exported from the German region of Brunswick, brewed with wheat and malt, with the addition of oat or bean meal, and herbal flavourings.

During this period some of the larger inns had become more grandiose and comfortable, compared to their medieval predecessors, as travel and communications became more extensive. They now had separate rooms known as 'pomgarnets' with carpets, tapestries, and embossed leather and guests had more freedom to come and go. That did not mean however that everything was rosy. The self-styled 'water poet' John Taylor wrote about his stays at various inns in 1630, and included a description of his room at one such place as being:

'most delicately decked with artificial and natural beauty..the walls and ceilings adorned and hanged with rare spiders' tapestry or cobweb lawn, the smoke so palpable

and pernicious that I could scarcely see anything...on retiring to bed I was furiously assaulted by an Ethiopean army of fleas...'

It was in the large courtyards of inns with their tiers of balconies overlooking the wide space below, that travelling players would perform their plays. (During the Reformation, the religious nature of guild-produced miracle and mystery plays had been supplanted by new secular-themed plays, many of which were initially performed in universities or other academic establishments). The layout of the inn courtyards proved ideal for both actors and audience and would influence the structure of the newly-built theatres shortly afterwards. It is no coincidence that some of the early theatres were named after various inns in London, such as the Globe, the Swan and the Rose.

In the eighteenth century, many inns did indeed continue to play host to travelling theatre companies, such as the *White Lion* and *George* in Northampton. [In 1878 when part of the *Catherine Wheel* was being demolished in Northampton, two theatre bills from the *White Lion* were discovered.] Another favourite venue in the county was the *Crown Inn* at Oundle, where thirty-one performances took place within a two-month period during 1771, in a yard at the rear of the hostelry. A standard performance of travelling companies would consist of a play and a farce, often accompanied by song and dance.

Many of these inns also acting a staging point for the collection and delivery of goods to London and other places. These had begun to proliferate in the early years of the seventeenth century. In a pioneering guide published in 1637, 'The Carriers Cosmography, or a Brief Relation of the Inns, Ordinaries and Hostelries', dedicated 'in kind remembrance to the Posts, Carriers, Waggoners and Higglers', the writer, John Taylor (who had previously written 'A Collection of Taverns in London and Westminster') gives a tantalising glimpse of the times, with a gazetteer of those towns in England from which carriers were operating to and from London. Interestingly for Northamptonshire, Syresham and Deanshanger are listed, but Oundle, Kettering and Wellingborough get no mention, though they would certainly have been used during that early period:

With Entertainments *of* SINGING *and* DANCING, *between the* ACTS, *particularly between the* 2d *and* 3d Maſk-all. 3d *and* 4th, *A favourite Song by Mrs.* Campbell, *call'd The* New Flown Birds. 4th *and* 5th, *A Scaramouch Dance, by Mr.* Quelch.

To which will be added, A *P A N T O M I M E* Entertainment, call'd,

HARLEQUIN MILLER:
O R, T H E
Art of Grinding Old Men and Women young.

The Whole to conclude with a Grand *Dance*, by Mr. and Mrs. *Quelch*, Mr. *Dillon*, Mrs. *Campbell*, Mr. *Edwards*, Mrs. *Burt*, &c. &c.

N. B. *Tickets* to be had at Mr. *Dillon's* Lodgings at the *White-Lion* in *Abington*-Street.
Pit 2 *s.* Gallery 1 *s.*

An advertisement from the 1750s by a visiting travelling theatre manager staying at the *White Lion*, Northampton.

THE
Carriers' Cosmography:
or

A Brief Relation
of

The Inns, Ordinaries, Hostelries,
and other lodgings in and near London; where the
Carriers, Waggons, Foot-posts and Higglers
do usually come from any parts, towns,
shires and countries of the Kingdoms of Eng-
land, Principality of Wales; as also from the
Kingdoms of Scotland and Ireland.

With nomination of what days of
the week they do come to London, and on
what days they return: whereby all sorts of
people may find direction how to receive or send
goods or letters unto such places as their
occasions may require.

As also,

Where the Ships, Hoys, Barks,
Tiltboats, Barges and Wherries, do usually attend
to carry Passengers and Goods to the coast towns
of England, Scotland, Ireland, or the Netherlands,
and where the Barges and Boats are ordinarily
to be had, that go up the River of Thames
westward from London.

By *John Taylor*.

London Printed by *A. G.* 1637.

The frontispiece of *The Carriers' Cosmography*, 1637.

'The Carriers of Brackley in Northamptonshire do lodge at the George near Holborn Bridge. They come and go on Wednesdays, Thursdays and Fridays... The Carrier of Daintree doth lodge every Friday night at the Cross Keys in Saint John's street... The Carriers of Duneehanger and other places near Stony Stratford, do lodge at the Three Cups in Saint John's street... The Carriers of Northampton, and from other parts of that country there about; are almost every day in the week to be had in the Ram in Smithfield. There doth come also Carriers to the Rose in Smithfield, daily; which do pass to or through many parts of Northamptonshire... The Carriers of Sisham in Northamptonshire do lodge at the Saracen's Head in Carter lane. They come on Friday and return on Saturday... The Carriers of Torcester in Northamptonshire do lodge at the Castle near Smithfield-bars. They come on Thursdays...'

During the same century there was an inconvenient shortage of copper coins and other small change, especially in the years following the Civil War. This was a nationwide problem that lasted nearly two centuries. To overcome the problem, authority was given to traders to produce their own pennies, halfpennies and farthings, in copper or brass, for business transactions. Because of their limited and short-lived circulation and a tendency to wear, few exist today. They are mainly circular and usually depict the arms or symbol of the trade such as a sugarloaf or candles, the initials or name of the proprietor, sometimes a date, and with a variety of different spellings for the same town or village. Survivors exist from Brackley, Brigstock, Daventry, Geddington, Grendon, Higham Ferrers, Kettering, Kingscliffe, Lamport, Lutton, Moulton, Northampton, Oundle, Peterborough, Potterspury, Rothwell, Stamford Barton, Thrapston, Towcester, Weedon, and Wellingborough.

Among the tradesmen were some innkeepers, a few tokens of whom survive such a halfpenny of the landlord of the *White Hind* in Northampton, on the obverse side of which is a depiction of a 'hind statant' and 'AT THE WHIT HIND' and on the reverse 'GEE' and 'IN NORTHAMPTON GEE'. Others tokens include:

(Northampton): obverse side, a depiction of St George & the Dragon, and 'AT THE GEORGE IN' and on the reverse, 'IMS' and 'IN NORTHAMPTON 1650 IMS'.
(Rushden): halfpenny, obverse side: St George & the Dragon, reverse, 'Geo.Carter at Rushden.'
(Welford): farthing, dated 1669 for 'Will.Wicken' of Welford'.
(Thrapston): farthing, obverse, a swan and 'WILLIAM WILMOT', reverse, 'OF THRAP. 1666. WW'.
(Towcester): farthing, obverse, a 'talbot passant' and 'RICHARD FARMER', reverse, 'IN TOSSITER REF'. (Brackley): a halfpenny exists for 'Mary Skilden' of the *Sun*, dated 1665,
(Aynho): a halfpenny for 'Tho. Norris' of the *Red Lion*.
(Easton Maudit):a farthing for William Glover, of the *Red Lion*, dated 1668.

During the Restoration period, coffee houses were established in England, with the first one opening in 1650. Despite the name, they were also licensed to sell alcohol, in fact, many had originally been taverns, and some proprietors were later listed as 'innkeepers'. They became extremely popular, especially for those who loved debate, gossip, politics, intrigue, and so on, making them the in some ways, precursors of the modern version of the club.

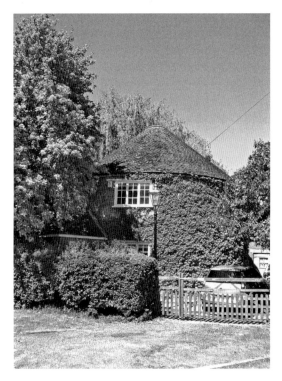

The *Round House* at Sudborough, a former seventeenth-century tollhouse and alehouse.

The advent of the coaching inn during the latter part of the seventeenth century was of great importance, not just fulfilling its traditional role of providing refreshment, meals and/or accommodation, but hiring out a horse or a post-chaise for local travel, as well as acting as a staging post for long-distance mail, goods and passenger traffic, and providing fresh teams of horses (changed on average every seven to ten miles) for the long distance journeys, which would be improved in most cases by the newly-created turnpike roads during the following century. The first Turnpike Trust was set up in 1707, following the first of what would be over a thousand such acts around the realm, in which trustees would be responsible for the repair and maintenance of the road surfaces, which had become dangerous as a result of increasingly heavy traffic, paid for by fees collected at tollhouses set up by gated roads. The fees would vary from an average one penny for an unladen horse, four to eight pence for a loaded wagon or cart, and between a shilling and eighteen pence for a coach and four horses. The *Green Man* at Duston acted for some years as a tollhouse, as did the *Round House* at Sudborough. Travelling would be slow (for example the coach from Wellingborough for London would take fifteen hours, leaving the *White Hart* at 5am and arriving at 8pm, which was considered fast at the time), uncomfortable (especially for those travelling on the outside, exposed to the wind and rain), but also prone to misfortune, as this 1794 report in the *Northampton Mercury* shows:

'Yesterday morning the Manchester coach in turning round the corner from the Drapery into Gold Street was unfortunately overset, by which accident the coachman had his thigh broke and two gentlemen, inside passengers, were much bruised, but we are happy to hear they are both in a fair way of doing well. None of the outside passengers were hurt.'

Northampton and Towcester in particular had several inns competing with each other for the potentially lucrative trade that the coaches brought. They would also look after travellers' goods up to the value of thirty pounds sterling. The word 'ostler' ie the person stabling the horses, came from the word hostel, an alternative word for the inn, and from which 'hotel' derives. Coaching inns were also an early instance where giving a gratuity, or tip, was common practice. A special moneybox or urn, inscribed 'T.I.P'

An eighteenth-century coaching inn advertisement in Northampton.

NORTHAMPTON, STAMFORD, OXFORD, CHELTENHAM, BATH, and SOUTHAMPTON.

THE Nobility, Gentry, and Public in general are most respectfully informed, that for their better Accommodation, the COACH will, in future, leave the RAM INN, NORTHAMPTON, after the Arrival of the Oxford Coach, every MONDAY, WEDNESDAY, and FRIDAY AFTERNOON, at a Quarter before Three o'Clock, over the New Road, through KETTERING and WELDON, to the BULL and SWAN INN, STAMFORD, and return from thence every TUESDAY, THURSDAY, and SATURDAY MORNING, at a Quarter before Six, and arrive at the Ram Inn, Northampton, at a Quarter before Eleven.

(To Insure Promptitude) was placed on the sideboard of the main reception room, for patrons to leave a token of their appreciation to employees for the service given during their stay or visit. A typical trade advertisement was:

'Inside this inn you will find, everything to suit your mind – good wine, good fish and flesh in courses; coaches, chaises, harness horses'.

With the new-found fashion for drinking gin sweeping the country at an alarming rate during the eighteenth century, vast 'gin palaces' began to spring up, moving out of London into the counties by 1800. These were large buildings, gaudy in appearance with ornate features, the plain floors of the one large room covered in sawdust to soak up spittle and vomit, and a large wooden counter, behind which rows of barrels of cheap gin were placed. The clientele would be a mix of men, women and children, although for the more genteel 'lady' a separate room was sometimes provided. These buildings provided ideal subject matter for contemporary writers, such as Max Schlesinger, who wrote in 'Saunterings in and about London' in 1853:

'The landlord is locked up behind his "bar," a snug place enough, with painted casks and a fire and an arm-chair; but the guests stand in front of the bar in a narrow dirty place, exposed to the draught of the door, which is continually opening and shutting. Now and then an old barrel, flung in a corner, serves as a seat. But nevertheless the "palace" is always crowded with guests, who, standing, staggering, crouching, or lying down, groaning, and cursing, drink and forget...'.

During the century a number of clubs were founded, where drinking would play an integral part of the socialising. Friendly societies, sports-orientated groups and political clubs had their roots in hostelries, eventually having their own building for their meetings. One important organisation, the Club and Institute Union (CIU) was founded in 1862 for the working classes, originally to promote abstinence and to educate in a recreational capacity. This original aim gradually dissipated, as the sale of alcohol was seen as an appealing and vital way of attracting members, especially when available at a slightly lower price than elsewhere (the average price in hostelries at the time being twopence halfpenny – less than 1p in today's money – for a pint of beer). The union gradually evolved into the Working Men's Club and Institute Union, made up of many social clubs – of all types – which had been springing up in towns and villages all around the country.

By the 1850s, many had at least two grades of room: the cheapest form being the public bar for standing, and the saloon/lounge for sitting, the drink costing an extra penny a pint for the extra comfort. Additionally there might be small partitioned area, the 'snug' or smoke room, between the two, with frosted glass, for more privacy and for the ladies. Some of the larger town public houses copied features of the old gin palaces such as large etched plate-glass windows, large lamps or chandeliers, and decorative mirrors.

Communications had been enhanced earlier in the nineteenth century with the opening of the Grand Union Canal linking London with Birmingham via Northamptonshire, with an arm being added from Blisworth to Northampton in 1815. Seeing the commercial potential of such an enterprise, a number of new hostelries sprang up in places like

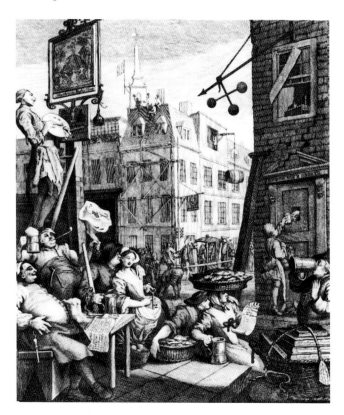

Beer Street. Part of a famous print (1751) by William Hogarth which contrasted the effects of good English beer, with the worst of the 'gin epidemic' (illustrated in Gin Lane).

Cosgrove, Stoke Bruerne and Braunston, the latter having the added advantage of being at the junction of the Oxford Canal (which had been built between 1774 and 1790 to link Coventry with Oxford, and the Thames).

It was the coming of the railway in the middle years of that century however that was to deliver a mighty blow to another kind of hostelry: the coaching inn. Unable to compete with the faster travelling time and relative comfort of the train, many went slowly into decline. The first towns to suffer in the county were the important coaching towns of Daventry and Towcester, when the London to Birmingham line, via Weedon, Roade, Welton and Blisworth, operated by LNWR, arrived nearby in September 1838. Northampton's first railway station opened in 1845 at Cotton End, later followed by other stations in 1859 and 1872. The process was virtually complete in the county by the 1870s, although Daventry itself was not connected until 1888. Many carried on offering accommodation to visitors, and acting as staging posts for local carriers who would carry goods to and from villages in the area, or providing horse 'buses' to their nemesis, the railway station, examples in Wellingborough being the *Angel* to the LMWR station in London Road, and the *Hind* to the MR station in Midland Road. But they would never return to their glory days, becoming a shadow of their former selves. The writer George DeWilde wrote in *Rambles Roundabout* (published in 1872):

'In the old coaching days, a town or a village and its name were associated together; now you may hear the name of a place duly announced hundreds of times, yet never get

an inkling of the place itself. Tour mail coaches penetrated the very heart of a town; you were familiar with its Guildhall, its market-place, its church, and its chief inn, though you never left your seat on the box. The mail train only skirts the places at which it professes to stop; the town itself may be a mile or two off, and even where you touch upon it the chances are that you are introduced only to its most squalid suburb.'

They were also beginning to suffer competition from hotels, some of which were built by the railway companies themselves, being conveniently situated to their point of departure and arrival. Hotels had started to appear in the last years of the previous century, as some of the larger inns developed their premises in order to cater for a more 'upmarket' travelling clientele. With the growth of trade and industry, they began to proliferate in the towns and fashionable coastal resorts. However, there were some who bemoaned the loss of the personal service, individuality and welcome that the older inn offered. The writer, Frederick Hackwood, expressed his feelings in 1910 about the perfunctory service and business-like manner of the staff, quoting another like-minded person:

'In England even the great tree opposite the inn-door, or the old-fashioned inn gardens at the back which used to sometimes make up for a homely entrance are fast disappearing without anything to take their place. There is no external grace or charm presented to the appearing or the disappearing stranger. You feel at once that

With the growing popularity of the car and increased mobility, elaborate inns known as *roadhouses* were established during the 1930s, in suburbs and on arterial roads, offering drinks, meals, accommodation, dancing, and in some cases during the summer, swimming and tennis. In addition, some of the old coaching inns were able to take advantage of the new age of motoring, with their you are looked upon by the eye of strict business, not by the eye of hospitality.'

By the end of the nineteenth century, the vast majority of those beer houses still flourishing applied for the new licences and became full public houses, being able to sell a complete range of drinks, including wines and spirits, as is the case today. Generous accommodation and parking facilities, one of them in particular, the *Saracen's Head* in Towcester, becoming the area headquarters for both the AA and RAC.

As class distinctions eroded and the function of the pub changed with time and fashion, so did the lay-out, with the introduction of one room establishments. In the second half of the last century, 'new' drinks like vodka and lager, as well as the much maligned keg beer were added to the range of drinks on offer. Large new pubs were built on the many housing estates springing up, to cater for the increased population in the area.

Countering this, several pubs have been closing in recent years, unable to survive the economic climate and social trends. In first six months of 2008, an estimated thirty six pubs closed every week nationally, rising to fifty two during the same period in 2009, with a fall to about thirty eight in 2010. At the time of writing (2010) there are an estimated 53,000 hostelries in the country. Against this, company-based pubs and café-style bars have been opening up on average, two per week. The decline has been mainly due to home sales with cheap supermarket offers of alcoholic drinks, and 'booze cruises' to France, and an increase in prices in pubs by the breweries, together with the usual budget rise in duty, but not necessarily (despite assertions by some) because of the

smoking ban. If anything the latter has since encouraged a great number of people who formerly shunned the unhealthy smoky atmosphere of bars, and has also brought out more families. Similarly in those countries such as Ireland where an earlier prohibition took place, has seen no decline as people adjust to the new conditions it is human nature to dislike change!

On a positive note, some county pubs which have had to close have subsequently been rescued and revived by local people who feel strongly about the loss of this traditional institution in the community, and have clubbed together to raise funds for reopening, usually as a consortium of individuals, either running the hostelry themselves, or employing staff to do so. This has given them a greater say in its usage, in some cases carrying out renovations, redecorating and refurnishing. They include the *King's Head* at Apethope, *Nag's Head* at Hargrave, *Bull's Head* (Arthingworth), *Rose & Crown* (Islip), and *Green Dragon* (Brigstock). Since then (March 2010) government initiatives have been launched to protect community pubs in an effort to stem the closures and encourage more trade, with over three million pounds being allocated for business support, which could make it easier for other communities buy into struggling premises to keep them open. Other pubs have made just a minor transition from their former use, one example being at Wootton where the *Old Red Lion* is now the Wootton Working Men's Club. Chains like J. D. Wetherspoon have also made pubs attractive once again, buying and converting large buildings, offering innovations, a competitive range of products and food, and often adding an element of local history to the premises.

Separate rooms are still an integral part of a hostelry, especially in the villages, acting mainly as dining areas, as it has become necessary, in order to attract custom, to offer a variety of meals, instead of the traditional nuts and crisps, and to cater for families. In addition, entertainment in the form of quizzes, karaoke, live music, satellite TV and theme nights, have become part of modern pub culture. It will be interesting to see how pubs will evolve in the twentieth first century.

DRINKING HABITS
AND TYPES OF DRINK

'Wine makes a man more pleased with himself – I do not say that it makes him more pleasant to others'.

(Samuel Johnson)

Throughout history, the villages of England, even those with small populations, had one or more hostelries to cater for their thirsts and which also, like the church or chapel, acted as a focal point for the community, where one could find a refuge from the rigours of life and work. That traditional role has changed today with an unprecedented growth in population, increased mobility, different lifestyles and a greater choice of leisure activities, which has led to villages in the county having lost at least one or most, if not all, of their hostelries. This trend is still continuing.

Ale came to be, like bread, a crucial form of daily sustenance and was built into the fabric of social life, be it a community event, family occasion or business transaction. It was easy to brew, and cheap to make, but could be inconsistent in both quality and flavour, and had to be drunk fairly quickly to avoid spoilage. For centuries it was made using malted barley (or other cereal plants such as oats) and water, together with a variety of flavourings such as costmary (alecost) or more usually, ground ivy (alehoof) which also gave clarity and acted as a very limited preservative. The result was a sweet tasting, almost syrupy end-product, though the addition of plants like mugwort would help to give a slightly more bitter taste. It was also widely believed that some of these plants, with a little divine intervention, might prevent evil influences from ruining the brew. The first extract was later known as 'strong beer' and was primarily the drink of men, whilst the second extract from the malt, after the ale had been drained off, was 'small beer' drunk by women and children as a weaker, refreshing beverage, called contemptuously by some tipplers 'rot stocking' or 'starve gut'.

Such was the importance of the drink to the nation, that the 1250 Assize of Ale, empowered local authorities to ensure an adequate supply which also had to be fairly priced and, to avoid fraud or dishonesty, served in a standard measure known as sealed quarts. Above all, each batch had to be of sufficiently good quality, which led to the recruitment of ale tasters, or ale conners who would inspect each new batch made by

anyone offering a brew for sale – for this there was surely no shortage of volunteers! Later, the father of William Shakespeare would become of these.

Perhaps there was something about the coarse, grainy diet of our ancestors that gave them such prodigious thirsts, or maybe like today it was a way of relieving oneself from the stresses of everyday life. Whatever the circumstances, for centuries, ale was the most popular drink for men, women and children, since water (and to a degree, milk) could be unsafe to drink, and there were no alternative beverages (except cider and mead in some areas). A gallon a day per adult would not have been unusual, and in higher circles, even larger quantities were consumed; for example, Henry VIII's maids in waiting had two gallons of ale (or two pitchers of wine) before breakfast.

In addition to various hostelries and the consumption of ale at home, there were widespread communal 'parish ales', or 'ale feasts', some held annually, others as and when the occasion demanded. They usually took place in the nave of the church (the secular portion which until the sixteenth century was an open space where the congregation stood), or if the weather was fine outside in the churchyard or where there was a village green or market place. Later, some counties, but not Northamptonshire, had church halls erected for the purpose, so as not to profane the precincts of the church itself.

These fund raising events had a religious connection that began in the early medieval era – when monastic institutions raised additional income by offering wayfarers and pilgrims accommodation and sustenance for a small fee. Thus the parish ales were a form of continuation of this practice. Common to all of them was strong ale specially brewed for the occasion by two or more churchwardens, the barley and malt (or money) provided by the villagers and townspeople. The ale was accompanied by a feast in the form of food taken along for one's own consumption (with some for the communal 'kitty'), dancing and general merriment. Most of these would take place during or close to the nearest holiday, ('holy day'), of which there were as many as sixty, until 1552 when Henry VIII reduced the number to twenty five, to discourage idleness and foster the work ethic and productivity.

In most villages, the highlight of the year were the Whit Ales, held in May (Pentecost) with a specially-elected Lord and Lady of the Ale in costume with retinue, who would oversee the feasting, and carefree abandonment. Like the Easter Ales and Clerk Ales, the profits would go towards the upkeep of the church fabric and furnishings. Bid Ales were similar, but attendance by members of the community was only possible by acceptance of an invitation, entailing some form of donation, the larger the gathering, the bigger the profit. Lamb-ales were celebrated at the time of sheep shearing.

In addition, provision for a particular group was sometimes made in the bequests of some of the more prosperous in the community, on their decease, in order to keep their memory green, known as 'Give Ales'. A typical example was that made by William Stanley in 1560 for Middleton Cheney, who stipulated: 'To the Young Men's Alle [Ale] at Myddleton, ij bushell of malt'. Similar bequests were made for the ale brewed for the 'beating the bounds' perambulation in May, such as that for Deene by James Wytt in 1529: 'I guyff a red heckfor [heifer] to the procession ale on Weymsdaye in the Rogation week'.

There were also a number of ales for charity, 'Help Ales', for the poor, sick or elderly. Bride Ales (from which we get the word 'bridal', OE: bryd-ealu) were held for weddings, to celebrate the nuptials, and to enable the community to join in the post-wedding

festivities, something like the modern wedding reception. There were also 'Christening Ales' held after the baptism of a new baby in the community.

Despite its encouragement of ale feasts, the church took a different view if parishioners preferred being in an alehouse instead of attending church. Churchwardens were empowered (until the late 1800s) to apprehend any offenders they caught tippling outside the church during the 'prohibited time', and from 1623, the miscreants had to spend six hours in the stocks. A few years later, during the Commonwealth era, the relatively short-lived 'Drunkard's Coat' was invented as a punishment. This was a wooden barrel worn by the offender, his head projecting from the open top, resting on his shoulders, and his arms projecting from a hole each side.

Under the Protestant Edward VI in the late 1540s, all types of ale feasts were suppressed, but briefly reappeared in the early part of the reign of Elizabeth I, until 1570, though still continuing sporadically until officialdom stepped in, such as the case of the church of All Saints in Northampton, in 1603 when it was directed that 'No plays, feasts, banquets, suppers, church ales, drinking, Temporal Courts or Leets to be held at All Saints.' Ale feasts were finally banned completely during the Puritan Commonwealth era, and never returned, the only vestiges thereafter being the church dedication feast, forerunner of today's village fete. The village feast was a jealously-protected social occasion by most communities, being the one real survivor of the many merrymaking opportunities once enjoyed, as shown above. One such example of how a community would react to any threat to their enjoyment occurred at Creaton in 1795. The church was dedicated to St Michael, and the feast always took place at the end of September, when it coincided with the harvest. Traditionally, the villagers would bake special cakes and puddings to be washed down with ale from the *Horseshoe Inn*, adjacent to which a booth would be erected for dancing. A vestry meeting that year decided 'for obvious and substantial reasons' to abolish the festivities henceforth with the excuse that the poor could not afford to participate, and the feasts 'produce waste and innumerable evils'. Village feeling was so strong that the idea never came to fruition and the custom continued in the traditional manner.

A huge challenge to the national drink was to occur with the introduction of hops into England from the Netherlands in 1420. It was soon to cause a furore when its use was seen as a potential threat to English ale making, or at least by those who had a vested interest in the traditional brew. Hops impart a bitter taste, give a better consistent flavour, can be reused for brewing several times (by increasing the alcohol content), and have excellent preservative properties enabling the product to last much longer. The new brew was called *beer*, to distinguish it from the older, sweeter ale. It had few fans at first, being thought poisonous – at one stage being called 'a wicked weed' by Henry VI (1422-1471), who forbade its use; and the City of London Council who petitioned Parliament about its bitterness and its endangering the lives of the citizens. Henry VIII also banned the drink, preferring 'the old spiced ale', a prohibition that lasted after his reign until but 1553, after which it rapidly rose in popularity, not only rivalling ale, but gradually overtaking it, and the two words 'ale' and 'beer' gradually becoming synonymous.

Inevitably, there was a decline in domestic brewing, mainly because more skill was needed in brewing the new drink, but as knowledge of the process increased, the number of alehouses selling the new brew rose significantly (from at least 20,000 in 1560 to over 33,000 in 1625), its cost initially being lower than that of the older ale. 'Potting' (drinking at an alehouse) became more widespread, with the *pottle*, a tankard

holding two quarts, being the favoured drinking vessel. The term 'malt-worm' came into being having a double meaning: beer weevils, and heavy drinkers. In addition to the ubiquitous alewife dispensing the drink, there were now several male equivalents, known as tapsters.

Copious amounts continued to be drunk everywhere, one clergyman making two hundred gallons a month, at a cost of twenty shillings each time, whilst Elizabeth I herself was drinking a quart at breakfast time. Inevitably, there would be some reaction to all these habits. In 'The Anatomie of Abuses' (1583) the Puritan writer, Philip Stubbes, criticised all forms of merriment like singing, dancing, acting and drinking, as destroying the soul, citing all hostelries as being crowded 'from morning to night with determined drunkards'.

Soon there were various types of beer such as clear (lithe) beer, single and double brewed beer ('doble-doble'), 'wort' (unfermented beer), and stronger beers like 'stingo', 'dagger ale', 'huff cap', 'dragon's milk' and 'merry-go-down'. These were the forerunners of the beers produced by the larger eighteenth century brewers – those we drink today.

New extremely popular 'concoctions' also began to appear during the late Tudor period, such as 'cock ale' (beer with the added jelly of minced boiled cock, sack – ie sherry – raisins, mace and cloves); and 'buttered' ale (boiled with sugar, butter and spices). A 'barley wine' also came into being as a beer made from barley, wheat and honey.

In the taverns of the Tudor and Stuart periods, a great variety of wines were available: 'Rhenish' was white wine, 'Bastard', 'Canary' and 'Malmsey' were sweet wines, 'sack' was dry sherry (not the fortified kind which was yet to be developed), 'Muscatel' was a strong wine, 'Alicant' (mulberry wine), 'Rumney' (a Spanish wine), and 'Stum', a general term for sharp new wine. There are frequent references to these and other hostelry terms in Shakespearean plays, like Othello and the Taming of the Shrew, but especially in the tavern scenes of Henry IV, Part One. Sugar was added to some wine as requested, but, like unscrupulous alehouse keepers, tavern owners were not averse to doctoring their wares, by adding lime to the wine or sack, a process known as 'liming'. The vintners, who had received their charter in 1483, at the same time as the Worshipful Company of Brewers (both of whom had coats of arms depicting three tuns) were also inclined to doctor the red wines to improve the colour, adding beetroot, madder, mulberries or similar colouring agent.

In addition to wine, a newly-arrived drink from Wales, metheglin, had arrived, a form of traditional mead with added spices and herbs, originally used in folk medicine. There was also *ipocras*, (deriving its name from Hippocrates, the Greek 'father of medicine'), which as the name suggests also had health benefits, and was red or white wine with added spices and honey, or sugar, believed to aid the digestion. They were joined in the seventeenth century by port, or 'blackstrap' as it was called at the time. A long-standing trade agreement with Portugal had fostered a lot of commerce between the two countries, including the shipping of wine. However the product was often spoilt as a result of the lengthy sea voyages that had to be made. The problem was later solved by fortifying some of the wine with added brandy, hence the birth of a new product, one whose popularity greatly increased after 1703, when a treaty was made giving its importation a favourable low rate of duty, at a time when antagonism with France was rife and its imports blocked.

Brandy had been available in England itself albeit not widespread, by sailors returning from the Low Countries since the late sixteenth century, and initially sold as a cordial.

In subsequent years it would be widely prescribed as a medicine, often in exceedingly large 'doses' such as that prescribed during March 1859 by a surgeon for Dinah Bird, an inmate of Oundle Workhouse, recommending a pint a day for six days (over a twelve-day period) to improve her constitution. The result was not recorded. Around the same time in 1857, an MP for Yorkshire fell ill, and was prescribed six pints of Brandy to be drunk over a period of three days. He subsequently died.

It had been originally been invented by a Dutch shipmaker for concentrating wine before shipment, to be watered down on arrival, but became popular by itself around Europe. Imports began flowing in from France in the following century, joined by rum imported from the English sugar plantations in the West Indies, and first recorded there in Barbados in 1650. These, like tea and coffee however, were luxuries and heavily taxed.

Meanwhile beer production had began to slump as a result of punitive excise duties put on the national beverage at the outbreak of the Civil War in 1643, again in 1650 (2/6d a barrel), continued by Charles II during the Restoration, and then under William III when it rose to a punitive five shillings a barrel, with the price being fixed at three pence a quart, in 1693. This was far too much for the majority of people and a cheaper alternative was sought for. The answer was gin.

Gin had been invented by a Dutch physician about 1652 by redistilling pure malt spirits with juniper berries, as a means of treating kidney ailments and alleviating stomach problems, but quickly caught on as a drink. By 1655 it was being produced commercially and cheaply, and had begun to flow into England. Under William and Mary home production was encouraged in this country, whilst the anti-French policy was in force, banning imports of brandy and other spirits from abroad. Therefore, in return for a small payment, or duty, anyone could distil and sell gin, made from home-grown corn.

Besides being cheap, it was east to make, leading to all kinds of people distilling and retailing what was often a product of dubious, if not unhealthy nature. Everyone seemed to be in on the act, with an estimated one in four houses being a gin shop. One such establishment in London sold gin from what was a very early form of slot machine, which was in the shape of a cat; by putting in a penny, placing a container in a small recess below and lifting the cat's paw, a measured amount of gin would be dispensed via a pipe from the inside. It was said that you could get drunk for a penny, and 'dead drunk' for two pence, and that seemed to be the case, with an appreciable effect on work, people lying in the streets, and mothers producing neglected, emaciated children. In the early 1720s 'proper' English distillers managed to develop a fairly palatable, less innocuous form of gin, using different additives, and helped by the better grains, like wheat which had seen an appreciable drop in prices. This only made things worse, and the government was forced in 1736 to take extreme measures by bringing in a tax of twenty shillings a gallon, and an exorbitant fifty pound licence. This had great effect but did not stop, distillers and chemists finding other ways of marketing the product – in disguise, such as 'cholick waters' in gin bottles; some distillers took out wine licences selling a gin concoction as wine; others went into brewing. In 1743, the Act was repealed, the licence reduced to one pound, and the duty on each gallon abolished. Future licences were only granted under strict conditions, among them that the proprietor allowed no drunkenness, gambling and prostitution to take place on the premises.

However, beer had not been forgotten as restrictions were slowly eased. In 1722 a 'new' drink had been created in London, called 'entire butt'. There had been a popular

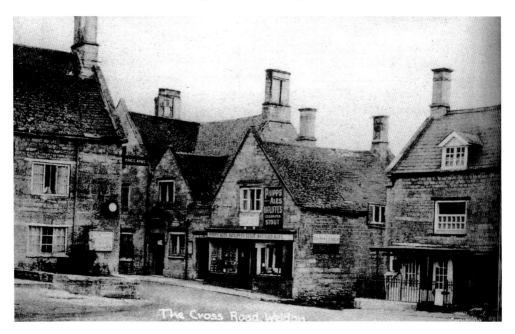

The former seventeenth-century coaching inn, the *King's Arms* at Weldon, in 1930. It was demolished for road widening in 1962, and subsequently rebuilt, demolished again in 2000 for housing development.

taste for a mixture of three different beers (pale, brown and old) but it necessitated getting them from three different casks. One brewer managed, as the name suggests, to reproduce the mixture using dark malts, roasted barley and generous hopping to get the desired colour and flavour. It caught on very quickly, being a third cheaper than ordinary beer (and went on for thirty years without a price change), especially with London porters, after who the brew was alternatively named. Very soon a stronger version of porter, called 'stout' became available, again reasonably priced since the tax was on malt not on strength.

In the following century, a drink somewhat 'new' to England was introduced: whisky. Although the drink was ancient, it had been mainly confined to its homeland in Ireland and Scotland, where, prohibitive taxes over the years had encouraged a lot of 'illegal' distilling. Though some had been trickled into the country in the sixteenth century, it was generally frowned upon, due to its 'raw' texture. Consignments of a better quality were subsequently exported to England in 1776, but it was only after the 1823 Excise Act, when a realistic level of duty was levelled at 2/3*d* a gallon, with a ten pound licence, that the wheels were set in motion for its enjoyment in English hostelries, with a smoother blended product being marketed after 1853. It was also helped by a blight in Europe in the 1870s that affected the production and export of both port and brandy. Thereafter its place among the nation's favourite drinks was assured.

Following the repeal of the Glass Tax, carbonated soft drinks offered an alternative to alcohol, especially for the growing number of advocates of temperance. The only problem was that the alternatives were not very pleasant at first, such as a mixture of

lemon squash, soda and milk. The most favoured drink was ginger beer, but since this was made with fermented sugar, it defeated the purpose, having an alcoholic content higher than a light beer, and almost as much as a stronger beer or cider! A later innovation for those who preferred lemonade was a machine that would dispense the soft drink in carbonated form if a bottle of water and a small tablet were placed in a larger gas bottle with a lever; when pressed, you would get sparkling lemonade. Some hostelries in the county had these devices, among them the *Plough* at Nassington.

That same century saw the introduction of casked mild ale in 1834 by the Whitbread Brewery, in response to a public wish for a less alcoholic beer. (The same brewery would also go on to produce bottled brown ale in 1927). Shortly after 1850, bottled pale (light) ale became popular, especially the stronger IPA originally made for export to India. These would become favourites, particularly when mixed, such as 'light and bitter', and 'brown and mild' until the 1960s, when the next major change occurred.

A popular drink at the time, usually made at home, was 'lambswool', a concoction of light ale or stout, sugar, brown sugar, nutmeg, cinnamon, ginger, heavy whipping cream, salt, heated up and added to a number of apples which had been separately prepared, either by broiling or baking, until the pulp burst out, giving the drink its name.

Lager (pilsner) had been the beer widely drunk on the continent for centuries, appearing in England where a small brewery was set up as early as 1864, and when Carlsberg began exporting to Britain from Denmark four years later, but these were in reality a small-scale affair at the time. Only in the 1950s did the chilled version suddenly become a serious challenger to the traditional English 'warm' beer. After 1953, when a new production process, 'continuous fermentation' was developed, allowing a more economic form of mass production, did it take off as the 1960s dawned, and the rest is history.

Simultaneously, the introduction of 'keg' beer in the 1950s also did little to help the cause and preservation of traditional beer. The invention of the beer engine in 1785 had enabled beer to be drawn from the wooden cask by pump, rather than from the tap, though for many years to come it would not be widely used until the middle years of the next century. Beer dispensed in this way was called 'draught' beer ie drawn, and the word 'dray', of similar origin and meaning, was applied to the method of transporting beer by horse and wagon. Now this was under threat as the large industrial brewers developed 'keg beer' with electric pumps to meet the needs of a growing population and to find a way of increasing shelf life (and profit). This entailed filtering and pasteurising the beer in metal 'kegs' – at the expense, in the opinion of many drinkers, of flavour, so much so that a group of aficionados of traditional beer met in 1971 to discuss the quality, weakness and high price of keg beer, and formed CAMRA (Campaign for Real Ale) the following year which today has a very large following (currently 87,000). In 1989, the Monopolies Commission ruled that any of the large breweries must be limited to no more than 2,000 public houses, and that tenants of tied houses could have a regularly changed guest beer. The lobbying by CAMRA and the persistence of other concerned parties eventually paid off and paved the way for the resurgence of traditional hand-pumped beer, accompanied by real ale festivals and the emergence of micro-breweries. In addition, the Cask Marque Trust, was set up in 1998, with a scheme (jointly funded by brewers and retailers), to regularly monitor the quality of cask ale. Visits are made to those pubs that join the scheme by an assessor who checks the temperature, appearance, aroma and taste of what is available at the time. If the pub passes the test it receives

a wall plaque and framed certificate on display for customers, who are encouraged to make their own comments on the quality of the beer.

Another innovation of 1970s was the emergence of local 'pubwatch' schemes, similar in nature to neighbourhood watch schemes. They were designed to help reduce anti-social behaviour in licensed premises by providing a safer drinking environment by reducing alcohol-fuelled crime and incidents, and tackling under-age drinking. Since then the trade-backed National Pubwatch Scheme has come into being, to support those areas which have existing schemes, and encourage the establishment of new schemes elsewhere, by providing help, information, and a regular newsletter. As the easy accessibility and cheapness of alcoholic drinks has encouraged binge drinking and other excesses this support can only be a good thing for the future and survival of hostelries.

One other change took place in 2007, when under an EU directive, beer glasses should be stamped with 'PINT' and 'CE', to certify that the customer is getting the correct measure. This is basically a continuation of the practice in England, dating back to 1699, with the introduction of the 'crown stamp' on a drinking vessel, which later appeared on glasses as a number surmounted by a crown, or in other cases, the wording 'pint to the line'.

DRINKING VESSELS
AND CONTAINERS

'St George, he was for England and before he slew the dragon, he drank a pint of English ale out of an English flagon'

(G. K. Chesterton)

What kind of vessels did our ancestors drink with? The earliest finds in the county are beakers from the beginning of the Bronze Age, *c.* 2600-1600BC, found as part of the grave goods in male burials or cremations. These were originally bell-shaped, later long-necked, some with handles, and decorated with cord patterns. They are believed to enable the departed to continue having a drink in the afterlife, be it water, milk or some kind of alcoholic beverage made with barley or honey, evidence of which has been detected on examination of some vessels.

The Romans used both glass for drinking vessels and bottles, but these would have been only affordable to the more elite in society, especially the more affluent among the Britons who had become romanised. The wealthy would also be able to afford a *cylix*, a stemmed cup made of bronze. For the majority however, ceramic forms were more common, the best being the finer forms of pottery such as glossy red Samian ware (plain and decorated) and 'hunt cups', a form of Nene Valley Ware, with a colour-coated slip, decorated with animals and plants *en barbotine*. There were also tankards, and several types of beaker more commonly used, some with colour-coated indented ('folded') bodies for grasping, and another, the motto beaker', would have painted scrolls with phrases such as 'BIBE' (Drink up!), and 'DA MERUM (Give me pure wine!).

The Angles and Saxons, great lovers of ale, tended to prefer wooden drinking vessels, known as *mazers* or *mazer bowls*. These were usually made of maple and had a metal band (usually silver) round the top. Being round-bottomed it was impossible to set them down when filled – a good excuse to down the contents and get a refill! In the late Saxon period there were also flat-bottomed wooden tankards, with handles and lids, and were constructed (like barrels in later years) with vertical curved wooden staves, bound together with hide or withies, and sealed externally against leaks with pitch, boiled birch sap or beeswax. A two quart 'peg tankard' or 'pin tankard' was also used for drinking between groups of friends, the inside of which had a set of vertical pegs evenly spaced

in half-pint measures from top to bottom, so that each person had the same amount of ale – but anyone going beyond their allocation, had to forfeit a penny, under a law made by King Edgar in 960, though this seems to have been generally ignored! At feasts, a wassail bowl or pledge cup was passed round, for everyone to drink to someone's health (the origin of the 'toast' at special events in more modern times). Drinking horns were also used by some of the elite and on special occasions, like the Vikings, either for mead or ale.

Mazers continued to be the dominant form of drinking vessel well into the Tudor period, some of which have been found in shipwrecks off the coast, and there were many pottery vessels of different kinds. The wealthy used imported glass goblets, and stemmed glasses, whilst the church would have used the silver chalice for containing the wine during Mass. There were also novelty drinking vessels, such as the ceramic tyg or 'fuddling cup', a group of vessels cemented together with a hole drilled between each compartment, so that to empty it one had to drink all the contents! It was the leather drinking cups that were also popular, made from a piece folded round and stitched at the side, with a circular piece at the base sewn onto the main body, sealed externally (sometimes internally) with pitch.

In 1348 the Worshipful Company of Pewterers had been set up in London, but it was not until the seventeenth century that pewter, an amalgam of tin and another metal (originally lead), was widely used for tankards and measures at hostelries, taking its place with leather and wood as the main forms of fabric for drinking vessels. The use of glass did not become widespread until after 1845. The middle years of that century also saw the rise of the coarse, semi-porous earthenware mug, produced to a biscuit texture, by low firing in the kiln.

The repeal of the hundred-year Glass Tax in 1845 however, led to glass becoming the predominant form of drinking vessel, initially as the straight sided, or sloping sided beer glass, in half-pint and pint form. It was not until the 1920s however, that the handled beer mug appeared, firstly with vertical fluted sides, followed in 1948, by the now familiar dimpled form.

CONTAINERS

The Romans tended to use amphorae, large two handled containers with a tapered base and made of pottery, were used to transport and store wine and other liquids. There were also flagons and jugs made of coarse pottery.

The Angles and Saxons used wooden ale buckets for communal festive occasions, and the metal bands of these have been excavated at Anglo-Saxon burial sites. Like the Bronze Age people, it seems that thirst needed to be quenched even after death!

In the medieval period, pottery became the most common form for all kinds of vessels, and green-glazed pitchers and jugs of were used for pouring out quantities of ale. Leather also predominated. As an easily worked material when wet, it was also strong and durable, capable of holding large quantities. The earliest form, the leather bottle, appeared at this time, and seems to have been a desirable or valuable item to leave in a will, such as that of a rector of the church of St Mary at Titchmarsh, who died in 1395. Hostelries were attracted to the image, and used it as a sign, later examples in Northamptonshire being the *Leather Bottle* at Glapthorn, Daventry and Wellingborough.

Blackpot Lane, Oundle, named after the former pub which stood on the corner of North Street.

In addition, three leather bottles were depicted on the arms of the Horners Company who amalgamated with the Bottlemakers Company in 1475. In the Tudor period and throughout the seventeenth century, smaller versions known as 'blackpots' were popular, as were larger versions: the 'black jacks' (supposedly named after the heavy jerkin of English archers, but equally to 'jackboots'), which could hold up to a gallon; and its massive cousin, the bombard (shaped like the barrel of a cannon). These were both sometimes inscribed with insignia and initials. The 'black' element referred to the pitch used as a sealant. Significantly, such large containers led to the expression 'to have had a skinful' after a binge with these. A popular song, 'The Leather Bottel' was used to extol the virtues of leather over other materials used for drink containers, and one version, with words first recorded in the seventeenth century, would certainly have been sung in Northamptonshire:

> 'God bless the cow and the old cow's hide,
> And ev'ry thing in the world beside,
> For when we've said and done all we can,
> 'Tis all for the good and use of man;
> So I hope his soul in heaven may dwell,
> That first found out the leather bottle.'

Now, what do you say to these cans of wood?
Oh no, in faith, they cannot be good
For if the bearer fall by the way
Why, on the ground your liquor doth lay;
But had it been in a leather bottel
Although he had fallen, all would be well
So I wish etc.

Then what do you say to these glasses fine?
Oh, they shall have no praise of mine
For if you chance to touch the brim
Down alls the liquor and all therein;
But had it been in a leather bottel
And the stopple in, all would be well,
So I wish etc.

Then what do you say to these black pots three?
If a man and his wife should disagree
Why they'll tug and they'll pull till their liquor doth spill
In a leather bottel they may tug their fill.
And pull away till their hearts do ache
And yet the liquor no harm can take
So I wish etc.

Then what do you say to these flagons fine?
Oh, they shall have no praise of mine
For when a Lord is about to dine
He sends them to be filled with wine,
The man with the flagons doth run away
Because they are silver most gallant and gay
So I wish etc.

A leather bottel we know is good
Far better than glasses or cans of wood
For when a man's at work in the field
You glasses and pots no comfort will yield;
But a good leather bottel standing by
Will raise his spirits, whenever he's dry
So I wish etc.

At noon, the haymakers sit them down
To drink from their bottles of ale, nut-brown;
In summer, too, when the weather is warm
A good bottle full will do them no harm.
Then the lads and the lasses begin to tattle
But what would they do without this bottle?
So I wish etc.

> There's never a Lord, an Earl, or Knight,
> But in this bottle doth take delight
> For when he's hunting of the deer
> He oft doth wish for a bottle of beer;
> Likewise the man that works in the wood
> A bottle beer will oft do him good
> So I wish etc.

> And when the leather bottel grows old
> And will good liquor no longer hold,
> Out of its side you may make a clout
> To mend your shoes when they're worn out;
> Or take it and hang it up on a pin
> 'Twill do to put hinges and odd things in
> So I wish etc.

One of the most popular containers were ceramic Bellarmine (Beardman) Jars which were originally made in Germany during the sixteenth century to contain wine or beer, but were exported to England, where they were later manufactured well into the seventeenth century. They were of a very hard fabric called 'stoneware' that had been given a salt-glaze, resulting in a mottled 'orange peel' effect. The body was often decorated with a medallion or some other ornate motif, and the neck of the jars was decorated with a bearded face, supposedly that of Cardinal Robert Bellarmine, a fierce opponent of the reformed church. They often had a dual purpose in that superstitious age as 'witch bottles', containing a 'magic formula' (pins, hair, nails, urine) designed to ward off any evil, such as a witch, from entering a building to cause harm. Consequently they were hidden near openings such as entrances and the hearth.

It was wood however that was the main material as a container over the centuries, and a variety of different sizes came into being for storing and dispensing ale and beer. Most alehouses and inns would have had barrels which could hold between 30 and 40 gallons, with 34 gallons being the norm. The smallest container would be a *pottle*, holding half a gallon (four pints), followed by the *keg* (up to ten gallons). Next in size was the *kilderkin*, containing between sixteen and eighteen gallons. The largest size held by a hostelry was the *hogshead*, holding fifty gallons, whilst the largest wholesale containers were *the butt* (108 gallons) and the *tun*, the equivalent of four hogsheads (200 gallons). Before and even after bottled beer became commonly available after 1850, anyone wishing to drink at home would take along their own container (something like a paint can in appearance) to be filled at an off licence or beer retailer. Field workers would take refreshment in the fields with beer carried in *costerels*, small wooden or leather barrel-shaped containers, with a loop for carrying at the waist, if need be, after filling up from a large container, usually a hogshead, at the farm before going to work.

Taverns had a different kind of container for wine, known as a *pipe*, which was the equivalent of two hogsheads, or 105 gallons. These would have provided an ample supply for patrons, since wine was usually watered down after being drawn.

Glass bottles were expensive, therefore were only found among the wealthier members of society, and religious institutions. They were so valuable that when empty,

A stone tablet depicting the Three Tuns of the former Smith's Brewery in Oundle, now in the courtyard of the *Talbot*.

they were taken to a tavern or vintner to be filled. Because of the delicate nature of the material, few early examples survive intact, but the earliest dated (complete) English bottle, 1657, is to be found in the county at the Northampton Museum. In 1674, an English glassmaker, George Ravenscroft invented a clearer, less fragile form of glass, made with the addition of lead, called 'flint glass', which was ideal for heavier items like bottles. Beer in bottles became a novelty, and those innkeepers wanting to be the height of fashion, would put up a display, to attract custom. However, a tax imposed in 1745 on both glass and bottle (ie. on weight, not the area covered) was prohibitive for the vast majority of drinkers. It was not until the repeal of the Glass Tax in 1845 that bottles became much cheaper, mass-produced, and the main form of container, the half pint size being the most popular, helped a few years later with the invention of the first *practical* bottle blowing machine in 1886. They were produced in brown or green glass until well into the twentieth century, when clear glass was a popular alternative.

Clear glass however was the desirable form for soft drinks. Carbonated water had been produced by an English scientist, Joseph Priestley, in 1767, by dripping distilled water over a vat of beer. This led to others improving the process, either trying to replicate invigorating spa water, adding flavourings and sweeteners, or developing a form of mass production. (The modern process involves passing pressurised carbon dioxide through water, to produce the fizziness). Mineral waters became a phenomenal success in the following century, partly as a 'healthier' rival to alcoholic beverages. The Wellingborough brewers, Dulley and Woolston, made use of the fine spring water in

the area (35 wells/springs recorded in 1830), for its soft drinks (as well as its renowned Redwell Stout). Interestingly, sparkling wine had been invented by some monks centuries before, but by accident, when a cork was put in wine flasks instead of the standard stopper they used. The wine mixed with the cork created carbonic acid needed for carbonation. However, the church became alarmed, believing that the Devil had been the cause, and the process was banned for several years afterwards.

This mass production was only made possible with the development of a series of clear glass bottles, which needed a secure form of seal. Initially cork proved hazardous, since when used with upright bottles, it dried out easily and let air into the drink, causing it to go flat. To overcome this problem, a torpedo/egg-shaped bottle was devised that could only lie on its side, allowing the liquid contents to keep the cork moist. This remained popular until the First World War. A little later, in 1872, Hiram Codd, a London soft drink manufacturer, came up with the idea of a bottle filled under gas pressure which pushed a marble against a rubber washer in the neck, creating a perfect seal. This meant that if a bottle was standing upright, the pressure would hold the marble in place; if upside down, the contents would not gush out. This too proved popular, though the glass ball inside the bottle would later be removed by enthusiastic boys, wanting to have a game of marbles, for free! At the same time, the term 'codswallop' came to be used by strong beer drinkers as a derogatory term for those who enjoyed soft drinks.

That same year, the screw stopper was invented, becoming a standard form still used today. Three years later, an American developed the swing stopper using a spring and rubber gasket, such as was once used on Corona soft drink bottles in England,

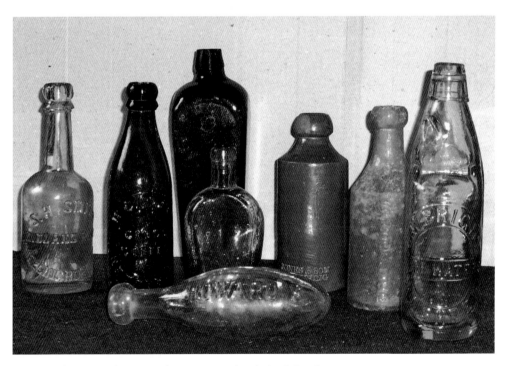

A range of nineteenth-century beer, spirit and soft drink bottles.

and currently by certain brewers like Grolsch. Finally, in 1892, another American, William Painter, invented the crown cap, which was pressed on the top of the bottle, with a set of teeth gripping the rim, and is as popular today as ever, needing just a bottle opener to get to the contents.

Another form of container that also came into its own during the nineteenth century was the stone bottle. After the Stone Bottle Tax was abolished in 1834, stoneware jars became the favourite container for ginger beer until the 1920s, providing an ideal method of keeping the contents cool, until the development of modern refrigeration led to a decline in their production. These were given a distinctive slip-glazed finish and usually displayed the bottler's name and provenance. A slightly inferior form, earthenware, was used for selling small quantities of cider which traditionally, like wine was stored in large 'pipes' (120 gallon casks), or smaller barrels.

Although glass still remains a favoured form of container, it has been overtaken somewhat by plastic, and the aluminium can. The latter came into its own as a beer and soft drink container in 1957, using a can-opener, followed five years later in a ring-pull version.

LICENSING AND LAWS

The Assize of Bread and Ale was brought in during the reign of Henry III in 1267, to ensure that a fair, fixed price was set by statute, and to prevent fraud by making sure that the correct quantity being given. This was done using a standard measurement known as the 'sealed quart'. Quality was also important and 'ale conners' or ale tasters were employed in villages and towns to make sure the product was drinkable, often inscribing their mark, or initials on the sealed quart containers. If anyone brewing, whether as an individual or as a commercial enterprise, failed to keep to the law, they were subject to a fine and even corporal punishment – such was the importance of the national brew in the eyes of the king and authorities, who wanted a contented, hard-working and loyal population. Yet there were astounding cases in Northamptonshire where the Assize had been broken over a period of time, one such example being at Brigstock, where 3,796 fines were issued between 1287 and 1349.

Some people however managed to get away scot-free with dishonest practices. These were the foresters who acted in a combined role of 'policeman' and gamekeeper within the medieval royal forests. Receiving little income, they resorted to other means, one of which was brewing their own ale, setting up 'scotale-booths', and coercing the local populace into buying the dubious product at an inflated price. In Rockingham Forest this led to complaints by the villagers of Geddington to Henry III in 1279:

'The foresters come with horses at harvest time and collect every kind of corn in sheaves...Then they make their ale from what they have collected and those who do not come there to drink, or do not give as money at the forester's will, are sorely punished at their pleas for dead wood...nor does anyone dare to brew when the foresters brew or sell ale, so long as the foresters have any kind of ale to sell.'

Throughout the medieval period, a hostelry did not require a licence, brewing and selling ale being seen as an honest way of making a living, and contributing to the well-being of the nation. By 1496 however, the number of alehouses in England had reached alarming numbers, with associated problems, so much so that Henry VII stipulated that any two justices could refuse permission to sell ale. This procedure continued until 1552, when in the reign of Edward VI, the first licensing law was introduced, making it illegal to run an alehouse without a licence from the justices at the Quarter Sessions,

the penalty for non-compliance being a three-day period of imprisonment and a fine. Even with a licence, there were penalties for disorderly conduct, games and gambling on the premises, and not paying due notice to other regulations. However fairs and markets selling ale were exempt from licences (until as late as 1874). By 1572, with a population of fourteen million, there were 17,000 alehouses, 2,000 inns and 400 taverns in England.

Quarter Sessions had been created with justices of the peace in 1326 to deal with the administration of local law and order. They were to meet four times a year, at Epiphany, Easter, Midsummer and Michaelmas, for that purpose. A typical session in the county, albeit a 'squeaky-clean' model one, was recorded in 1651, at Aldwincle All Saints, where the constables and 'third boroughs' [under constables] declared that the village contained no ale house nor Sabbath breakers, common drunkards, that it was well provided with churches in a state of repair, its highways and bridges were in good repair and there was provision for the poor. This session was held during the Interregnum, a time of chaos and lawlessness, when Puritan fervour was at its most influential, restricting entertainment (opposing the theatre, banning singing (except in church) and Maypole dancing, and attempting to get rid of Christmas Day as a time of festivity). There was particular severity in the way court cases were conducted, and licensing lapses were no exception, as the constables of Helmdon, Syresham and Whitfield found during the January 1657 sessions for the Kings Sutton Hundred, when they were charged for not presenting law-breaking unlicensed sellers of ale.

Another form of licensing was by way of Alehouse Recognisances. A standard form of wording, which would have had slight variations in some areas, can be seen in this late seventeenth century example:

'The condition of these aforesaid Recognizances is suche that whereas the above bounden were admitted and allowed by the above named Justices to keepe Common Alehouses and to use common sellinge of Ale or Beere within their severall dwellinge houses wherein they now dwell. If therefore every of them respectively dureinge suche tymes as they shall keepe suche common Alehouses shall not permit or suffer any unlawfull games to be used in their saide houses or any parte of them, nor shall suffer to be or remaine in their said houses anie person or persons yt they well knowe not to lodge or staye in their houses above one day and one nighte without acquainteing one of the Constables of the parishe where they or anie of them dwell, Nor shall suffer to be or remaine in their said houses anie person or persons not beinge their householde servants upon anie sundaye or holidaye dureinge the tyme of divine service or sermon Nor shall suffer aine person or persons by their drinkeinge after Nine of the clocke in the nighte tyme, nor buy or take to pawne any stolen goodes, nor willingly harbour any Vacabondes Sturdie Beggers Masterless men or other notorious offenders whatsoever And alsoe every of them respectively shall & will in everye their severall dwellinge houses maintaine good Order and rule Nor suffer anie fleshe to bee dressed uttered or eaten in their houses in the time of Lent or upon anie the daies prohibited by the lawes & Statutes of this Realme And alsoe shall not utter or selle anie stronge beere above a pennie the Quart'.

Like the Quarter Sessions, manorial courts also dealt with dishonest practice in the locality. These courts were held around the county for centuries, and existed in some

localities well into the 1800s. In 1778, the villagers of Great Oakley had complained to two designated aletasters about being given short measures by Jonathan Littles at the *Chequers*. At the court he was accused of breaking the Assize of Ale by selling beer 'in an unsealed measure' and fined sixpence. This did seem to deter him, for in the following year he committed the same offence again, with another guilty beer retailer, George Stow, both having a similar fine imposed.

During the reign of James I, the widespread habit of 'tippling' – excessive drinking – had become of such great concern that in 1604, a new law was brought in to restrain such an occurrence. Innkeepers were not allowed to serve 'outsiders', unless invited in by guests staying on the premises. Any offending landlord was issued with a fine of ten shillings, to be given to the local poor. This effectively drove would-be tipplers into unlicensed alehouses so much so, that two years later, these establishments were the next to be targeted with the same fine imposed on the offending 'victuallers'. Local constables were given the power to imprison any victualler not paying the fine, and a subsequent ban on keeping an alehouse for three years. In 1623, officials of every town and village were legally and duty bound to inform on any tippler. In 1625, the law went one stage further, issuing penalties to *all* hostelries for allowing tipplers, until the problem was finally solved two years later with a catch-all law introduced forcing any person selling beer or ale to have an alehouse licence. Anyone abusing the conditions of their licence would forfeit twenty one shillings or be whipped for the first offence, and a month in the house of correction for a subsequent offence.

Between 1617 and 1620, attention was turned towards the inns of the realm. It resulted in one of the biggest scandals in the history of hostelry licensing. In 1616 Sir Giles Mompasson, a young career opportunist, related by marriage to George Villiers, Duke of Buckingham (favourite courtier of James), had hit on a 'get rich quick' scheme, namely to instigate a licensing framework for inns, which hitherto, unlike alehouses and taverns, had not been licensed, due to their multi-functional nature. He set forth his scheme to Villiers so that the latter could use his influence on the king to give him a patent as a commissioner of the realm, collecting licensing fees ('fines') and an annual 'rent' around the counties. His idea was accepted, and, along with two other commissioners, began his dubious work using agents to help him collect the money. The fees were extortionate for the time: an incredible five pounds for a licence and an annual fee in two payments of five shillings, one on Lady Day (25 March), and the other at Michaelmas (29 September). To offset such a burden, landlords were forced to increased charges for those staying at their hostelry.

Identification of 'inns' was arbitrary, and five hostelries were 'licensed' in Northamptonshire in 1618: the Greyhound at Middleton Cheney, the *'Hynde'* at Gretton, the *Bull's Head* at Kingscliffe, the *King's Head* in Oundle, and the *'Red Lyon'* at Creaton. The following year, four more were added to the records: the *Talbot* at Collyweston, the *Talbot* at Kelmarsh, the *Plough* at Daventry, and the *Reindeer* at Towcester (Potterspury). Notable by their absence are some of the major inns at the time such as the *Saracen's Head* at Towcester, the *King's Arms* at Weldon, and the *Talbot* at Oundle, the *White Horse* at Kettering and none at Northampton or Peterborough.

His practice of extortion and innovation knew no bounds. New establishments began to spring up as 'inns', to the chagrin of the landlords of established hostelries, whose livelihood felt threatened by the new competition.

He then began to go beyond his remit by targeting taverns for licensing, something traditionally carried out by JPs, who could and would take away the licence and close

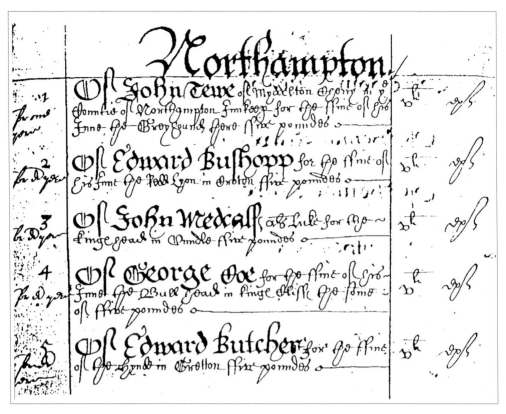

Part of the notorious Mompasson licensing records for 1620.

any tavern transgressing the rules of respectability. Mompasson would snub the JPs once more by allowing the offending taverns to reopen – for a considerable sum. In another scandalous case, one of his agents begged for a place to sleep at a tavern, and then prosecuted the owner the next day for running an unlicensed inn.

This system continued until February 1621, when a government investigation into his malpractice took place after a massive wave of complaints, citing aggression, threatening behaviour and greed. The House of Lords discovered that he and his agents had prosecuted well over 3,300 inns and taverns around the country, for failing to comply with traditional regulations.

He subsequently pleaded guilty, but not without blaming others, and asked for mercy. Whilst waiting for the verdict he fled to France, during which time heavy penalties were exacted on his estate, punishments imposed and he was declared to be a notorious criminal. He eventually returned, chastened, and died some years later in 1663.

In 1643 at the beginning of the Civil War the first tax was imposed on ale, strong beer and (to a lesser degree in Northamptonshire) cider and perry. This subsequently set a trend that continues today.

The Ale Measures Act 1698/9 stated that beer should be sold in pints or quarts and that anyone selling short measures was to be branded 'of evil consequence' and deemed guilty of 'a great wrong and prejudice to wayfaring men, travellers, manufacturers, labourers'.

After the excesses, ravages and licensing failures of the eighteenth century 'gin epidemic', measures were taken to encourage free trade and restore beer as the national beverage and to check for the illegal consumption of spirits, so in 1828 the Alehouse Act came into being, specifying that an special annual session of the Justices of the Peace should take place 'for the purpose of granting licenses to persons keeping inns, alehouses, and victualling houses, to sell excisable liquors by retail to be drink or consumed in such house or the premises thereunto belonging.' This meant in effect that all types of hostelry had to have a licence issued by local justices. In some cases, full licences for all types of alcoholic beverages could be granted to certain 'better class' establishments with a good track record of conduct. There were various conditions: inns were duty bound to take in all travellers and look after their goods; all hostelries were obliged to billet troops if and when they were in the vicinity. As an incentive, a billiard table was granted, 'licence free' in any alehouse.

This was followed in 1830 by the Beer Act which allowed anyone (in the rate book/ with a tenement of a certain value) to sell beer (and cider only) without licence, for a small one-off fee of two guineas. Prior to this, a licence fee had been based on the size of the premises, and required annual renewal. This resulted in an unprecedented number of outlets selling beer, far exceeding the expectation of the authorities, in fact it had been so overwhelming that four years later the licence was increased to three guineas. Many of the new licensees just used the kitchen of their home as a taproom for serving beer. Some of them however began to use other space such as the parlour. Others prospered sufficiently to be able to afford a new building or extension specifically for the purpose of storing and selling beer, whilst others later became fully-licensed public houses. An interesting variety of names were chosen for the new establishment, some traditional, others of novelty value, to stand out from competitors. In trade directories, henceforth, licensees would now be listed as innkeepers (usually their sole occupation), and 'victuallers', though the majority of the latter carried on with their main or original occupation, often leaving the running of the 'business' to another member of the family, many of whom, especially women, would take over the licence on the decease of the proprietor. Examples at different ends of the county in 1874, give some idea of the various trades: in Corby village, Thomas Clow of the *White Hart* is listed as a slater, Joseph Dixon of the *Black Horse* as a stonemason, and Isaac Gibson of the *Nag's Head* as engaging in three trades – butcher, baker and grocer; whilst at Abthorpe, James Henson of the *Stocking Frame* is listed as brick and tile maker, and wheelwright; and Charles Matthews of the *New Inn* as blacksmith and shopkeeper

Also in 1834, 'off licenses' had been granted for the sale of beer for consumption off the premises – the beginning of unnamed beer-houses run by 'beer retailers'. Like taprooms, they enabled those wanting to drink at home, to take along a container of some kind (the most common being something like paint can in appearance with a handle for carrying), and get a quantity of beer to take away.

Initially, the signs above the entrance of fully-licensed hostelries showed the landlord's name and the wording 'licensed to sell beer, cider and porter, wines and spirituous liquors of all kinds to be drunk on the premises'. This was frequently misinterpreted as meaning that it was the customer who was 'licensed to be drunk on the premises'! This inevitably led to the legal change of the wording from 'to be drunk' to 'to be consumed' to avoid further abuse by ignorant licensees who had previously been summonsed for allowing such excesses!

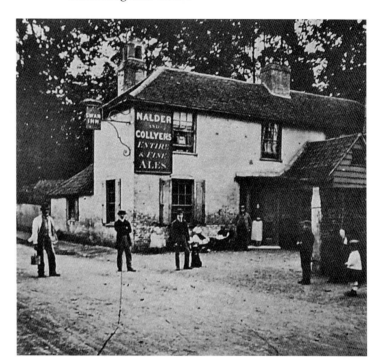

The man on the left in this 1870 street scene is carrying a typical container for taking home beer from a beer retailer, or taproom.

Some local authorities however wanted opening hours restricted. At the Petty Sessions in Kettering in 1835, opening hours for the seventeen hostelries in the town were ordered to be from six in the morning until nine in the evening, but on Sundays, Christmas Day, Good Friday and Feast Days, to prevent drunkenness during church services, they were limited, to 6am-10am, 1pm-2pm, and 5pm-8pm.

The manner in which a hostelry was run could also determine the amount of its annual rent. Such an example was Wadenhoe, a typical 'closed' village (with a resident lord of the manor to keep an eye on things). In the Estate Record books for 1897 the rent for the *King's Head* was £50 a year; in 1947, it was £60, with a £5 'allowance' given, provided 'no police complaints were made against the house'. Closed villages (though not Wadenhoe) often looked on enviously at their 'open' neighbours, where there was less restriction (often having more than one hostelry) – a situation which sometimes gave rise to 'folk rhymes', between rival settlements, as was the case of Dingley referring to nearby Stoke Albany and Wilbarston as 'Sodom and Gomorrah'!

Until the 1830s when many traditional forms of punishment like the pillory were technically abolished as a result of the reforms of Robert Peel, the lock-up and the stocks were the means of dealing with drunken offenders. The lock-up was used in Northamptonshire in places like Corby, Rushden and Weldon. The latter is the only survivor in the county today, and was of a type often referred to as a 'roundhouse', being similar in appearance to a circular dovecote, and could hold up to four prisoners standing up, its thick limestone walls having a grille at the top for ventilation. It stands by the large village green where a weekly market and four annual fairs had been held since 1685, and was a necessary presence, being surrounded by four hostelries, only two of which, the *Woolpack* and the *George*, still exist today.

A standard nineteenth-century Northamptonshire punishment form for drunkenness.

More common however, were the stocks, often with a whipping post attached. These were the ideal place for a tippler to spend the night, and get back to normality. Despite their official abolition years earlier, they continued to be used around the county well into the 1850s. At Geddington, their last recorded use was in 1857 when Edward Allsopp chose to sit in them rather than pay five shillings and fifteen shillings costs for being drunk and disorderly after a club feast. At Gretton they were last used in 1858, when a villager was placed in them for six hours, also for failing to pay a fine for the same offence.

Fines had indeed now become the norm, the standard fine in the county being five shillings for being drunk and disorderly in the street, likewise for tippling during a church service. Heavier fines were imposed on landlords permitting drunkenness on their premises, with a penalty of two pounds ten shillings for the first offence, and five pounds for the second. The Kettering Petty Sessions record a number of interesting cases involving various other drink-related offences. At the November 1836 Sessions an even larger fine was imposed on the landlord of the *New White Horse* for allowing gambling in the inn, and who was ordered to pay ten shillings for the offence. There were also a few concerns raised about the number of beer retailers springing up everywhere: at an earlier session (March that year) the Rector of Kettering urged the justices not to issue

The only surviving village lock-up in the county, at Weldon, dating from the eighteenth century.

any more licences, as there were already twenty premises flourishing around the town. To not have a licence however, was an even worse crime as was the case of a villager in Weldon who was fined five pounds at another sitting of the sessions for 'serving a mug of beer.' Yet another person who may well have felt aggrieved was a trader who had not declared sixteen gallons of rum that he had amongst his stock. The drink was subsequently confiscated and sold by public auction in the town.

This may have been necessary in some cases, as with 'Tinker Joe', landlord of the *Bluebell* in Gretton, where it is said that customers would make half a pint of beer last all night! However, he could also limit what was drunk, as was the case with local quarry workers, using the pub as a breakfast stop, where they were allowed a maximum of just two pints. Take away sales from the same hostelry could also cause some problems as in the case of one customer who took in a jug, asking for one pint of bitter and a pint of mild, with the bitter poured in first, and the mild on top. When asked why, she replied, presumably preferring the mild, that she was the first to drink from the jug when she got home!

Fighting of course was an inevitable occurrence at hostelries, and not the fault of the landlord. Drunken brawls would be commonplace on Friday or Saturday nights with men spending some of their hard-earned weekly wages. A typical example was at

49

Syresham, where these were a regular occurrence on Saturday nights, especially during the mid-nineteenth century, as witnessed by one villager:

'I have seen as many as four couples fighting outside the Bell at once. In the winter time once when the snow was on the ground, a man was fighting and tore every shred of clothes off him and it was about 11pm...It was a regular occurrence and nothing was thought of it. They even pulled a watch and chain to atoms – a silver one – and always there was a black eye about for few days. They used to kick one another in the face and often had two black eyes besides scratches on their faces. Plenty of them was not fit to be seen. One night every window in the Bell was smashed and sacks was nailed up to serve over Sunday.'

Of course there were those who felt that hostelries had an important and necessary role in society, especially for the working classes. Among them was the Victorian social reformer, Sir Walter Besant (1836-1901) who wrote several books including the three-volume *All Sorts and Conditions of Men* in 1882 in which he wrote:

'Perhaps the workman spends night after night, more than he should upon beer. Let us remember, if he needs excuse, that his employers have found him no better place and no better amusement than to sit in a tavern, drink beer (generally in moderation), and talk and smoke tobacco. Why not? A respectable tavern is a very harmless place; the society which meets there is the society of the workman; it is his life; without it he might as well have been a factory hand of the good old time – such as hands were forty years ago; and then he should have made but two journeys a day – one from bed to mill, and the other from mill to bed'.

Over the next few years the government regretted what had happened, as the number grew out of proportion because of the ease of getting a licence and the profits to be made, especially in towns. Once again some kind of action was required and so the Wine and Beerhouse Act came into force in 1869. Annual licensing returned under strict magisterial control. Restrictions on new licences were made, and applications for renewal carefully scrutinised, before and if permission was given. This was effective in removing some of the excesses such as the adulteration of drinks, out of hours drinking and in reducing some of the drunkenness and crime. However, there was one devastating effect of the reforms: the prohibitive costs that resulted, forced many small alehouses and beer retailers to get help from the powerful large brewers. In return for financial help in the form of loans, they became tied houses (a process that had begun in the eighteenth century), no longer able to sell their own beer, and enabling the brewery to extend its range of outlets. The lucky few who could afford to stay afloat became freehouses.

Three years later in 1872 the reforms were complete when pubs, as they were now generally known, could no longer open all day as had been the case since time immemorial. They were now legally restricted to two hours at lunchtime and four to five hours in the evening.

During the First World War, these hours were restricted even further from seven to five hours to ensure that munitions workers were able to work diligently and soberly. The Liquor Control Act of 1916 stipulated that alcohol was not to be sold before noon, opening only permitted for any two hours between noon and two thirty; and reopening for three hours after six or six thirty with compulsory closure at nine thirty at the latest.

Off licence sales were to stop at 8.30pm, and no trading allowed on Saturday or Sunday. Higher duty was imposed on alcohol, weaker beer was sold and spirits were watered down. It worked – consumption was cut by half.

Even after the war the reduced opening hours were maintained but in 1921 were relaxed on weekdays, with a compulsory three hour break between the lunchtime and evening sessions. Sundays however remained at five hours.

In 1923, concern was expressed about the age of those being served alcohol by Lady Astor, the first-ever woman MP in England, and as a result an Act for the 'Prevention of Sales of Intoxicating Liquours to People Under the Age of 18' was introduced. Interestingly, there was a clause permitting a minor to be served if he/she had parental approval.

During the Second World War, there were none of the draconian measures of the previous war. Alcohol was seen as instrumental in boosting the national morale and increasing patriotism during the long period of hostilities. A notable example was the habit of Spitfires taking beer over to British troops stationed in France after D-day, in their spare fuel tanks!

As the twentieth century wore on, licensing laws needed to change with the times and the closer ties with Europe. In 1988 a new Licensing Act was brought in extending standard Sunday opening (12 to 2, 7 to 10.30) by one hour. This was followed in 1995, by a new act plugging the remaining four-hour gap between sessions during Sunday afternoons.

In 2005, restrictions were finally lifted with licensed premises being given flexible opening hours with the potential of being open (subject to the effect on the local community) for twenty four hours, seven days a week. In addition bureaucracy was reduced by the introduction of an all-inclusive 'single premises' licence (for alcohol, public entertainment, cinemas, theatres, late night refreshment houses, and night cafés). The final great reform was a new Act in 2007, banning smoking in public places, marking a return to the pre-Elizabethan days before tobacco was introduced into hostelries.

NORTHAMPTONSHIRE HOSTELRY LIFE:
Features and Uses

What would a typical Northamptonshire village hostelry have looked like in the days when the pace of life was slower and simpler? The following description of the *King's Head* at the 'chocolate box' hamlet of Wadenhoe gives some idea of what more or less would have once been a common situation around the county:

'During the week its opening times were irregular, depending on the whim of the landlady, and whether she had gone shopping to Oundle and Peterborough. In those days the King's Head was as peaceful as a country cottage. The two rooms within were parlours more than bars. There were no beer engines, indeed, no sign of anything to drink. Customers sat in a state of tranquillity and waited patiently. Eventually the Landlady would make an appearance and take an order. Then she would disappear down a flight of stone steps in the cellar where barrels of beer were stored, draw the beer and then ascend the steps with the drinks on a tray. Customers needed to be patient but one more kindly than the others said at least the beer was properly kept.'

However, over the ages hostelries have had a variety of other uses, other than being just a place for refreshment, relaxation and gossip.

TOBACCO AND SMOKING

The introduction of smoking in hostelries came much later after the introduction of tobacco into England, supposedly by the slave trader, John Hawkins, with his younger kinsman Francis Drake in 1565, and popularised by Sir Walter Raleigh in 1586. It was violently opposed by many at the time with James I describing it as 'a branch of sin and drunkeness'. Originally it was smoked in clay pipes, some with long-stems, fragments of which have commonly been found in the vicinity of old hostelries. It only appeared in this country in cigarette form during the 1880s, after encounters by British officers with European allies during the Crimean War. Earlier that century, cigars had made their appearance, after the Napoleonic Wars. It was in powdered form as *snuff* however, that it

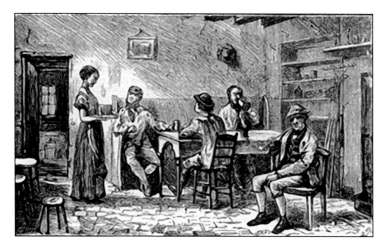

An illustration from 'The Graphic', June 1872, showing the interior of 'a village inn, Burton Latimer', believed to be the former *Thatchers Arms*.

had its greatest popularity, particularly in the eighteenth century, with the more fashionable establishments providing a snuff box on their counters. It was commonly believed to have medical benefits, being especially good for the nose, throat and to help prevent snoring!

GAMES AND GAMBLING

Hostelries also attracted various games, many of which were officially frowned upon. Cards appeared in England around 1450, but their importation was banned in 1464, because, like many other games they were a form of gambling which was considered to be a distraction from archery practice, which had been necessary training for many men since 1245, in the event of war. This did nothing to prevent their widespread popularity especially in taverns and ordinaries. Officialdom acted in a dual role during Elizabethan times, opening up licensed gambling houses whilst on the surface, gaming whether cards or dice, remained technically illegal.

Skittles or nine pins appeared in thirteenth century inns and soon established themselves, with many hostelries having a bowling alley adjacent to the premises, or within. The game was different from bowling, in that wooden 'cheeses' were used instead of balls, and were thrown, not rolled. This game and quoits (rubber rings thrown over stakes, or 'hobs') were particularly popular in the county, the latter game especially so in the locality of Northampton, with several inter-pub teams taking part at one time. Similarly the *Ship Inn* and the *Swan Inn* at Oundle also had flourishing 'bowling and quoits grounds' as seen in this advertisement in the Peterborough Advertiser, 15 May 1858: (William Curtis was landlord of the *Ship*, and Christopher Swann' (aptly) was landlord of the *Swan*):

'The friends of this old-established ground met together on the 7th inst. to inaugurate the season by a supper, which was served up in host Curtis's usual good style.

Nearly twenty gentlemen sat down, and a succession of toasts and songs rendered the entertainment pleasing to all parties. We hope that both Mr Curtis's and Mr Swann's exertions in catering for the amusement of the gentlemen of the town and neighbourhood will be duly appreciated and patronised.'

The *Queens Head* in Wellingborough still has one of the few surviving ancient quoit alleys.

'Aunt Sally' was another old pub team game, something like the coconut shy at fairgrounds, but originally using a model head of an elderly woman with a clay pipe in her mouth, mounted on a pole, the object being to throw a stick to break the pipe. It is a rarity today, but there is one at the *Barley Mow* in Upper Heyford.

Darts were a form of indoor archery, stemming back to the sixteenth century, using primitive spikes and feathered flights, with the rounded ends of barrels acting as boards; it was only after 1896 when the rules were formalised that it came into its own as the most popular pub game. Dominoes, however, were a relatively late introduction, from Italy, and initially played at inns in the mid-nineteenth century. They were also used in rural areas as a means of settling grazing disputes.

The earliest form of 'table' game was billiards, brought over from France in the sixteenth century, but was usually played in fashionable circles at court or the great houses. In the eighteenth century, the billiard table was a feature of town assembly rooms, some of which were attached to inns. The game got a boost in hostelries as a result of the 1828 Alehouse Act which permitted a billiard table as part of the licence. In the 1880s, snooker was developed from billiards by army officers stationed in India, and quickly caught on. A later introduction, evolving from bagatelle, was bar billiards, which came into being during the 1930s. The board game, shove ha'penny, began to be played in taverns and inns during the fourteenth century.

COCK FIGHTING

One form of activity that was very popular at some hostelries was cock fighting. The breeding and training of cockerels was a flourishing industry by the 1600s. Hostelries would either have their own cockpit, use the bar room, or more usually, the yard, where large groups would gather, making wagers as to which bird would win. Cock spurs have often been found during the demolition of old hostelries, such as the *Dolphin Inn* in Gold Street in Northampton (1890). Other hostelries in Northampton with their own cockfighting pits were the *Fleece*, *Black Lion*, *Goat*, and *Wheatsheaf*. A typical eighteenth-century advertisement for such an event, albeit one on a more grandiose scale, is the following item, which appeared in the *Northampton Mercury* for the *George Inn*. Note the provision of an 'ordinary' (meal) on each occasion:

'It will be Weighed a Maine of Cocks to begin the day following, between the Earls of Sandwich and Halifax, for Five Guineas a Battle, and 200 the odd. With Ordinaries provided daily.'

It also took place around the county in such places as the *Squirrel Inn* in Gayton. The *Robin Hood* in Kettering was also a renowned cock-fighting venue which additionally provided accommodation for travelling showmen and space for dancing bears.

A typical eighteenth-century
cockfighting scene.

Sometimes the activity was reflected in the name of the establishment, such as the *Old
Three Cocks* at Brigstock, the *Cock* at Daventry, Raunds, Roade, Kingsthorpe, Denford,
Kettering and Northampton (where there was also the *Bantam Cock*). One must beware
however of generalising, for example, The *Three Cocks* at Rushton, was named after the
Cockayne family, lords of the manor for two centuries, who had three cocks depicted on
their coat of arms. Sometimes however, cock fighting and other cruel sports such as bull/
bear/badger baiting would not be allowed under any circumstances, as in the case of the
Fox and Hounds at Great Brington, where a licence was granted in 1777, on condition
that no such activities took place. Cockfighting was eventually banned, along with bear
baiting, under the Cruelty to Animals Act of 1835, but continued illicitly, necessitating
another Act in 1849.

BADGER BAITING

Another 'sport' banned in 1835 was badger baiting. A common method was for
someone to stand on an upturned wheelbarrow, with a piece of string about eight feet
long, one end fastened to his hands, the other tied to the hind legs of the badger, so that
it could easily creep under the barrow. A dog would be unleashed to go underneath, and
draw the creature out. Many a dog would be wary and receive a bite for its effort. The
Oundle carpenter, John Clifton, wrote in his diary for 9 January 1782:

> 'A Badger Baiting this Afternoon at Jinks little yard at the White Hart, and most of the
> sliving, leering, looty Wallens gave their Attendance. Some of them gave a penny to be
> let in to see it.'

BULL RIDING

Bull running was also a common spectacle, which involved letting a bull loose in the
streets of a town, often goading it with dogs and sharp sticks to encourage him to

rampage through the streets just for the fun of the chase, but a strange variation took place on at least one occasion in Northampton, on a Tuesday afternoon during Whit Week, 1724. Known as 'Bull Riding' it involved entrants paying a one shilling fee, to ride a bull, bullock or cow of any age or size, using a standard-size goad and wearing 'boot and spur' from the northern outskirts of the town to the centre, whereupon the winner was to make his way to the George via the Hind to collect his prize, a plate worth five pounds. One can imagine the vast crowds gathering to witness such a strange spectacle, no doubt buoyed up with copious quantities of beer available from the many hostelries passed *en route*. The following information to the townspeople was also given before the 'The event will start from the Bridge near Swallbrook Spring, run down Abbington Street into Northampton, and end at the Pump upon the Com-Market-Hill. The winning Bull, Ox or Cow to be rid by the rider from the said Pump, by the Hind Inn, and down the Drapery to the George Inn, where the Treasurer will be to deliver the Plate, Five Pounds in Money ;and the Stakes [the one shilling fees] to the second best Bull, etc. Prizes: a plate of £5 in value. The winning beast is to be sold for £20.'

MUSIC HALL

Music Hall had its genesis in the hostelry. It evolved with small groups of drinking companions in the parlour of a pub, who would include a sing-song during their chatter and bonhomie, with an elected chairman. Noting this, many a landlord would see a potential profit in the making, and some began extending the room, perhaps with the provision of a piano or some other musical instrument. This would then attract a wider clientele and public 'concerts' would take place, with the addition of a small stage for the different entertainers. Thereafter, having outgrown its original home, the nascent 'music hall' moved into a larger premises with fine decor, scenery and a balcony, to accommodate large crowds including women; evolving later into a major enterprise with grand-scale buildings, some of theatre-like proportions, with big name entertainers, supper tables, and waiters. The rest is history, as it became the major form of entertainment with the masses, until the coming of 'electric palaces', or cinema. During the twentieth century a former music hall artiste who also toured with various performing animals, took on the licence of the *Two Brewers* in Northampton. Among his animals was a boxing kangaroo, which on its decease was stuffed, and given pride of place in the bar of his pub.

OTHER USES

In addition to serving food or drink, and providing accommodation and entertainment, hostelries have served a variety of other needs. Exhibitions such as bird shows or dog shows, and displays of old coins, fossils and weapons were often part and parcel of the premises, sometimes permanent, designed to attract interest and custom, among them The *Bell* at Finedon (bottles), the *White Swan* at Harringworth (agricultural implements) and more recently, the *Old Sun* at Nether Heyford (advertising and bygone memorabilia).

Collections of wild animals were often transported around the county and stationed outside a chosen inn, one particular favourite place being the *Crown Inn* at Oundle.

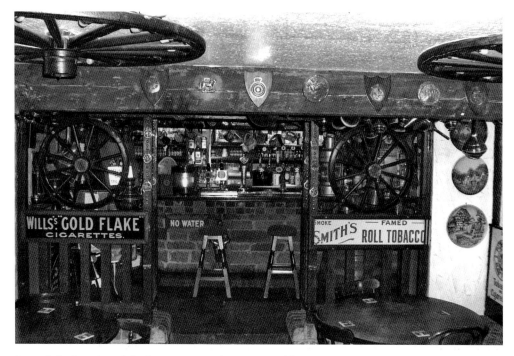

Part of the interior of the late seventeenth-century *Old Sun Inn* at Nether Heyford as it is today.

Challenges were offered and accepted, such as prize fighting (outside in a courtyard), pipe smoking, pie eating, or singing contests. Many a business transaction or property auction was conducted within their walls, sealed with a glass or two of wine or beer, some of the visiting traders or entertainers taking a room during their stay at the larger premises of Northampton such as the *White Lion* and *Spread Eagle*, or in certain villages such as Brigstock where the *Northamptonshire Yeoman* was auctioned in 1910 at the *Angel*.

They were frequently a hotbed of political fervour, where many a scheme, even conspiracy, was hatched, usually in relative privacy. Others were more open in their political stance. Among them were 'mug houses', named after the rows of pewter mugs displayed in the windows of town hostelries in early years after the decease of Anne, last of the Stuart monarchs. They were a means of showing loyalty to the new House of Hanover in the reign of George I, at a time when a large Jacobite faction, mainly Tories and country squires, supporting the 'Old Pretender', James Stuart son of James II, raised the possibility of a Catholic resurgence under the restoration of that line. The Hanoverian loyalists (mainly middle-class Whigs) would use violent measures to put down any potential confrontation by the Tories, using the hostelry as a base and storage for cudgels. On a more peaceful, if not rowdier note, hostelries were centres of fervent political activity during elections, where in the midst of hot political debate, canvassing would include the distribution of small gifts such as baubles, or ribbons to wear as a show of support or allegiance, or even a puppet show put on lampooning political figures, with 'Punch' giving out coins to the potential supporter. In Northampton, the *Red Lion, George, and Peacock* were notable for such political meetings. In the 2010 General Election, the *Chequered*

> To be LETT, or SOLD,
> At Lady-Day next, or sooner if required;
> A Well-accustomed PUBLICK-HOUSE, known by the
> Name of the GREEN-MAN, situate near the Market-Place in
> Rowell, in the County of Northampton; containing six Chambers, two
> Parlours, Kitchen, Brew-house, very good arch'd Cellars, Stabling for
> more than 20 Horses, Barns, and all other Conveniences; together with a
> little Close adjoining to the Homestead. The said House stands well for the
> Fair, either as a Publick-House or for a Tradesman.
> For further Particulars, enquire of Mr. John Dexter, Attorney at Law,
> at Desborough, in the same County; or at the George Inn in Kettering,
> where he attends every Market-Day.

An auction notice in the *Northampton Mercury*, February 1757 for the sale of the *Green Man* at Rothwell.

Skipper at Ashton was used as a polling station, as was the Red Lion Lodge at Clopton (formerly the *Red Lion*), and the car park of the *Ock n' Dough* in Wellingborough.

Similarly, 'press gangs' and recruitment officers found hostelries ideal targets for getting unwary drinkers to join the army or navy which were frequently undermanned, especially in the eighteenth century. Groups would go round looking for conscripts aged between fifteen and forty-five, ideally, but not necessarily, those who had military, maritime, or riverboat experience. One trick used by press gangs and recruitment officers was to drop *prest money* (the King's shilling) into a tippler's drink. Finding the shilling in his possession was proof that he had volunteered. Many proprietors were averse to this practice on their premises, and came up with ways to help their patrons, such as putting glass bottoms in their tankards, with the hope that, if not too drunk, they would see through the ploy. However, press gangs could also be a subject of a practical joke. For his diary entry, 9 November 1776, the Oundle diarist, John Clifton wrote about one group of friends who:

'dress'd themselves in the Masquerade task and set off as a Press Gang and searched the Three Lasts house, and appeared in some more [hostelries]...'

Fighting also took place in hostelries, organised in the form of prize fighting in the yard, or resulting from an altercation fired by drink. One such occasion was recorded (aptly) on Boxing Day in December 1778, once again by John Clifton in his diary, with his usual added wit:

'A Good Battle was fought to-night at the Dolphin between John Henson, Alias Fow Tankard, and Sam: Barnes Watchmaker, who after some fairish knocks, Victory declared in favour of Henson, but his shirt was torn all to pieces which caused him to get his Wife's Blessing...'

Religion also had a place in hostelries. Weslyans were known to use them in their early days for meetings and services at a time they had no purpose-built chapel. Before it

became a hostelry, the *Red Lion* at Isham was a house used by the Quakers for their meetings. They were also a place for relatives of a deceased person to meet and refresh after coming from the burial ground, or after weddings as they often do today. Many were also used for the vestry meetings of churches, and by the parish council. Perhaps the most unusual use occurred during the harsh winter of 1962/3 at Syresham, when the antiquated heating system of the parish church completely broke down, with the boiler in danger of exploding. There was additional concern when ice began to appear on the walls. The landlord of the *Bell Inn* kindly came to the rescue, offering the use of the Smoke Room of the pub for church services. This was gratefully accepted by the vicar and congregation.

Hostelries also provided a base for various aspects of the law, local government and manorial administration, acting as occasional courts, places for the conducting of coroners' inquests, use as overnight morgues, and even as temporary accommodation for criminals being transferred to prison or prior to an appearance before a magistrate. In Kettering, the Petty Sessions for the area were held alternately at the George and the White Hart from the first decade of the 1800s until 1840 when a courthouse and constabulary were built, at the same time the county police force was created. At one of these sessions, in 1837, a Corby publican was fined 8/6d, with 11/6d costs for depositing manure on a public highway, and refusing to remove it.

In March and September (Lady Day and Michaelmas) tenants of many manorial estates around the county paid their half-yearly rents to the land steward, and received free pints of beer and a special meal for the occasion either inside the premises, or outside on the lawn where one existed, as at the *Spread Eagle* at Great Oakley. Manorial courts were also held at many other hostelries in the county including the *Star* at Geddington, the *Swan* in Kettering, and in Oundle, at the *Talbot* or *Swan*.

Village constables, originally appointed by the manorial courts, were responsible amongst other things, for compiling militia lists of all those between sixteen and forty-five who were able-bodied and therefore eligible for selection should hostilities commence. The annual drawing of names from the lists, were made at a hostelry such as the *White Hart* in Kettering, the *Angel* in Wellingborough, and the *Talbot* in Oundle. Normally those with an infirmity, such as 'one eye dark' (blindness), or the use of only one arm, would be recorded as such. A right of appeal was possible during the event, for anyone who 'thought themselves aggrieved', but unless they had mitigating circumstances they would have to remain part of the lottery.

Traditionally certain hostelries were the last port of call for condemned criminals on the way to the gallows, where they could have one last drink before execution. In the county, this was at the *Bantam Cock* in Northampton.

They were also home to various types of clubs, debating societies and friendly societies. The latter had been formed in the eighteenth and nineteenth centuries to provide social amenities for their predominately working-class members, and to give aid in times of hardship such as illness and poverty. It was customary for the proprietor to provide a room rent-free, instead arranging a 'wet rent', whereby a monetary contribution was given each time a drink was bought, therefore everyone who came was expected to have at least a pint 'for the good of the house'. The Buffaloes went one stage further by having a designated 'taster' whose function was try the ale before the evening's session: if it was found to be 'wanting' the host or landlord was 'fined' two gallons of ale which was consumed by all in attendance at the meeting without payment. Many of the societies

began meeting this way: in Geddington for example two friendly societies initially had their clubrooms in hostelries, the Oddfellows in the *White Hart* (from 1846 until 1870), and the Foresters meeting in the *Star* (from 1850 until 1893), after which time they both gained their own premises. In Daventry, the hostelry took on the name itself, becoming The *Oddfellows Arms*. In Oundle, three hostelries played host to different societies, the Oddfellows being based at the *Red Lion*, the Oundle Provident Society at the *Nag's Head* and the Oundle Tradesmen's Friendly Society at the Ship Inn. At Wellingborough the Royal Antediluvian Order of Buffaloes were based at the *New Inn*. Perhaps the most unusual self-help group however, was the Association for the Prosecution of Felons at the *White Hart* in Gretton, formed to protect and compensate its members against theft or fraud. The first meeting took place in November 1826 with ten men present, during which an annual subscription of five shillings was agreed upon and the following declaration:

'If any member of this Society shall be robbed or feloniously defrauded in his or her property, the member shall use his or her best endeavours to apprehend the offenders and in doing so, the person so robbed or defrauded shall be immediately paid such charges and expenses as to the committee for the time being, or any seven of them deem reasonable.'

Some hostelries have also been associated with various sports. From March 1880 until the 1930s, football clubs and cricket teams made use of the facilities of the *Royal George* in Geddington. In the early years two football teams, the Montrose, and the Stars, used a large high-roofed outbuilding at the rear of the premises for training. From 1914, the hostelry itself played host to visiting cricket teams, who were looked after generously by the landlord's wife who laid on delicious meals, often of rabbit pie, and who also provided a large tin bath and copper for heating water, so that the men could wash off their exertions. She was also known to wash the kit of the home team. The sporting associations of the pub were further enhanced by the internal walls being covered with pages from Sporting Life and similar magazines, given rise to its nickname, 'The Picture Gallery'.

Another hostelry with cricket associations was the old coaching inn, the *Spread Eagle*, at Oakley Hay. The former cricket pitch of the Great Oakley club lay close by, where in the early days, the team wore top hats when fielding. In 1896 they had won the Kettering and District Cricket League Shield, and celebrated at their usual after-match venue, the *Spread Eagle*. The *Kettering Leader* reported:

'About fifty members and friends sat down at 6.30 to the substantial repast provided by 'mine host and hostess' Crowsons in their well known style. The large room had a most artistic appearance, being gaily festooned with bunting, foliage, etc., and at one end the challenge shield was given a conspicuous place, surmounted by a huge wreath of olive branches, whilst at the other end of the room an arrangement of cricketing 'kit' was very efficiently displayed...After the health of the president had been enthusiastically drunk with musical honours, Mr Kirby gave the toast of the evening... The winner of the batting prize was A. J. Woolston with an average of thirteen, three others being over eleven...an excellent evening's enjoyment was only too soon brought to a close near midnight by the singing of the National Anthem and Auld Lang Syne.'

Other uses include acting as a printing and publishing house and warehouse. The founder of the *Northampton Mercury*, William Dicey, had a branch of his business in London, operating from the *Maiden-Head*, which stood opposite the south door of Bow church, sometimes listed as '10 Bow Church Yard' on some of their publications.

Today a reverse situation seems to have occurred, with previously existing public buildings such as cinemas, banks and clubs being converted into hostelries. At Thrapston, the former police station and magistrate court, built in 1860, is now the *Court House Inn*, whilst at Kettering the former liberal club building (1889) is currently a sports-orientated pub, the *Xtra*, whilst the adjacent *Earl of Dalkeith* is housed in a building that was formerly a leather merchants and billiards hall. The Ritz Ballroom at Desborough is another place that began life as the Oddfellows Hall, subsequently becoming a cinema (showing the first silent films to appear in the town), a roller skating rink and finally a ballroom with a large dining area and three licensed bars, one of which was originally surrounded with old enamel advertising signs from shops, garages, and railway stations. At Barnwell, the former water mill was later converted into a restaurant and lounge and is now known as The *Mill at Oundle*.

Another tradition carried on today is the hostelry as a place for music and singing, live or recorded. The *Bell* in Finedon, in the early years of the twentieth century, can claim to have been the first pub to have 'piped music', when it installed a forerunner of the juke box, in the form of a large melodeon which stood in a stone archway, using a mechanical cylinder to produce the music, after inserting a penny in the slot.

NORTHAMPTONSHIRE HOSTELRY LIFE:
Incidents, Events and Curios

'It is a cold and stormy night, I'm wetted to the skin, But I'll bear it with contentment until I reach the inn, And then I'll get a drinking with the landlord and his kin...'
(The Jolly Waggoner)

As might be expected, many an incident has occurred or started within the walls of a hostelry, one of the most colourful, if not boisterous of which occurred during election time at Northampton, in 1768. Prior to the election itself, the two groups of rival parties were carousing at the *Red Lion* in Sheep Street, and the *George*, respectively. Present at the Red Lion were Lord Halifax, Lord Northampton, two baronets, the Mayor, various bailiffs and a large group of supporters. Martin Lucas, the landlord of the *Red Lion*, and witness to subsequent events, later gave an account of what happened, part of which appeared in the *Northampton Mercury*, as follows:

'...(the Company) was jolly, and many good healths drunk, till about seven o'clock at night it was agreed to march round the town, to shew [sic] their friends that they were in high spirits, and to carry with them half a hogshead of ale, drawn upon a truck, in order to drink some healths at the Market Cross, and animate their friends. For this purpose about 200 links or torches were prepared, and lighted, and they all set out (the witness in company), the lords, candidates, and the Mayor at the head of them, with the Militia drums and fifes in full tune and colours flying; they paraded through many of the streets and lanes, and as they passed by the houses of Mr. Hamilton, Mr. Clarke, Captain Atkinson, or any other in the opposite interest, they stopt, howled, hissed, with other demonstrations of contempt and disapprobation of their conduct. This was repeated at the *George Inn*, where a few of the committee and friends of the opposite party were assembled, and then they went on to the Cross, and the lords, candidates, &c., each drank a mug of ale in a bumper — Success to the Town and Corporation of Northampton."

Returning by the *George*, a scuffle took place between the two parties, in which a few heads were broken, and the Lords' party had to retreat in confusion to their head-quarters, the *Red Lyon*. Mr. Summerfield did not observe whether the Mayor either gave or received a broken head. At the *Red Lyon* a debate was held (the parties, what

with the dinner, the bumpers at the Market Cross, and the broken heads, being in an obviously peculiar condition for deliberation), the question being whether they should put up with the insult or revenge it. The conclusion at which they arrived was exactly what might have been, under the circumstances, anticipated.

War was declared for, and everybody was ordered to arm with mop-sticks, brooms, faggots, or whatever they could get, and to put a piece of white paper in their hats to distinguish them. Some cooler head, however, than those of the majority, suggested that the Mayor should first go to the *George*, as ambassador to ascertain whether it should be peace or war; and the Mayor, accompanied by Mr. Watts, went to the *George* accordingly. On his return he reported that the hostile committee would give no answer to the embassy, so out they sallied, armed as described. At the *George* they found the best part of a hundred persons of the opposite party standing in the gateway, about the house, and in the street, many of them armed with sticks. The *Red Lyon* party, however, numbered above two hundred, and Mr. Gardiner, Chaplain to Lord Northampton, making a blow at some person (the first the witness observed given), a general engagement ensued. The Spencer party, finding themselves too weak for their opponents, retreated into the *George* gateway, leaving their antagonists in possession of the field.

Lord Halifax then made a speech signifying that the town was his patrimony, and he would pitch his standard there. Then the friends of the Lords broke the windows of the *George* with stones and sticks, but the great gate being shut, they marched down Bridge Street, and then returned to the *Red Lyon*, breaking several windows as they passed.'

The violence continued the next morning before the election took place, when a large mob of people from the surrounding countryside assembled in the town, armed with clubs and other weapons. They were dispersed however by the arrival of Lord Spencer, who from the balcony of the *George*, promised a thousand pounds to be distributed in the form of bread, flour and coal among all those present, who desisted from any form of aggression. Apparently the offer was too hard to refuse, and the mob consequently left the town en masse.

Yet another witness gave his account of what happened during the election itself, with a different hostelry involved in the chaotic proceedings. This was the *Peacock*, where three strong gates had been erected to keep a crowd of voters inside safe from any intrusion. The earlier violence had now been replaced by a barrage of insults on both sides, not helped by the Mayor and an alderman intimidating their rivals, repeatedly calling out the names of their candidates. One observer became alarmed and intervened when:

'perceiving a rude lad with a torch endeavouring to set fire to the Mayor's wig, the witness took a great deal of pains to prevent him, and to protect the Mayor's person from insult, upon which Mr. Breton, turning round, and seeing him so near him, as the witness apprehends, mistaking his real intent, with great vehemence and passion, thrust his hat in the witness's face, perfectly gnashing his teeth with fury. At the George he found many of his friends washing the blood from their heads, and bathing their bruises with brandy.'

In November 1844 the young Queen Victoria and Prince Albert were invited to attend the christening of the daughter of the Marquis and Marchioness of Exeter at Burghley House, near Stamford. The journey would take them through the county, firstly by train from London to Weedon, and thence by horse-drawn carriage via Northampton.

Triumphal arches were erected, and houses and streets were specially festooned for the occasion in those towns and villages along the route which the royal couple were travelling. At Kettering, flags, foliage and floral compositions could be seen everywhere, some in the form of crowns and hearts, others in lettering. Crowds lined the streets including 1,100 Sunday school children from the area, standing in wagons to get a better view. The bells of the parish church rang as the entourage entered the market place, accompanied by the Northamptonshire Yeomanry. A change of horses and refreshments were needed and the town's main coaching inn, the White Hart, was the chosen stopping point, before the party moved on via Weekley, Geddington, Weldon (where another stop was made at the King's Arms), Duddington, Collyweston and Easton on the Hill. The landlord of the White Hart felt so honoured of the patronage he had received that he duly renamed the hostelry, the Royal, a name that has been retained to this day. The hostelry had an earlier claim to 'fame' in 1824, when the body of the Romantic poet Lord Byron lay there overnight on its way for burial in Nottinghamshire.

Flooding could cause problems to any village hostelry that stood close to a water source such as a spring or river. Even those that were situated on higher ground could be caught out by flash flooding in the event of exceptionally heavy rainfall. Such a case was the *Talbot* in Gretton. In her diary for June 17, 1916, the daughter of Wally Fowkes, the landlord, wrote in her diary the following account:

'We had a terrible thunderstorm on Sunday. It was awfully hot all day. About half past six it started to thunder and lightning very hard though it had been rumbling all afternoon. All of a sudden it started to rain very hard and before we were aware, the house was flooding. As soon as we saw this, we were soon looking for brushes, but we could only find the house brush. Then my dad set to work to brush it out, but the more he brushed, the more it came in. At last we found the other two yard brushes so that three men could now try and get it out. By this time, my dad was wet through, so he had to go and change himself. The water was all over the front room, down the passage, in the bar, in the kitchen and in the taproom about an inch deep...'

Of course, flash floods could affect anyone with cellars. The Oundle diarist, John Clifton, wrote on 17 November 1770:

'All hands in the morning getting the barrels out of my own and Nelly's cellars. On this day my own cellar and Nelly's were full of water to the third step from the top...'

At least three hostelries have had enforced closure on Sundays, all instigated by a disapproving, resident lord of the manor. The first occurrence was at Harrington during the mid-nineteenth century. Hugh Tollemache, rector of the village church and a member of the manorial family, being a particularly pious man, with extreme views on excessive drinking, installed his coachman as the landlord of the eponymous *Tollemache Arms* and consequently ordered Sunday closure, a situation that persisted for several years thereafter. The second occurrence was at Bulwick in 1890, when a member of the Tryon family was passing by the *Queen's Head*, which stands opposite the village church. He encountered boisterous drinkers spilling out of the pub and, enraged at such a scene on the day of rest, he promptly had the premises closed on that day, a situation that remained in force for sixty six years, finally ending in 1951. The final occurrence took place one

Sunday during the First World War at Great Cransley whilst work was in progress on the railway line from the nearby furnaces at Loddington. As the lord of the manor was about to pass by the *Three Cranes* in his carriage with his daughter, a rowdy group of navvies spilled out into the road which quickly turned into a free-for-all fight. He was so upset by this behaviour, especially in front of his daughter, that he ordered Sunday closure, as a deterrent to any future repetition. This lasted for twenty years. Another hostelry which suffered for a time, albeit not from Sunday closure, was the *Falcon* in Castle Ashby, where the Marquis of Northampton banned the sale of alcohol – an odd situation for a pub to experience, reminding one perhaps, of the Australian song, A Pub with No Beer!

Another hostelry was closed for a different reason. In 1874, a mother left her baby in a pram outside the *Duke's Arms* in Warkton, whilst she had a drink or two. Shortly afterwards, a pig had got loose in the yard outside, and in the mayhem, collided with the pram causing it to overturn and the baby to fall out, killing it instantly. Thereafter, it was only allowed to open for home sales, and the village never had a pub again.

In 1906, a drunken customer fell down the steep bank outside the *Queen's Head* in Wilbarston, and died as a result of his injuries. It was consequently closed permanently as a result, though there were some in the village who were sceptical as to the real reason for its closure, perhaps listening to the village constable who asserted 'there were too many pubs to keep an eye on' (yet there were only three in the village at the time, compared with nine in 1796, whilst today there is only one survivor, the *Fox*).

Drinking offences or licence abuse (gambling, out of hours drinking, etc) were usually dealt with by the Petty Sessions in each locality. One particularly interesting case was

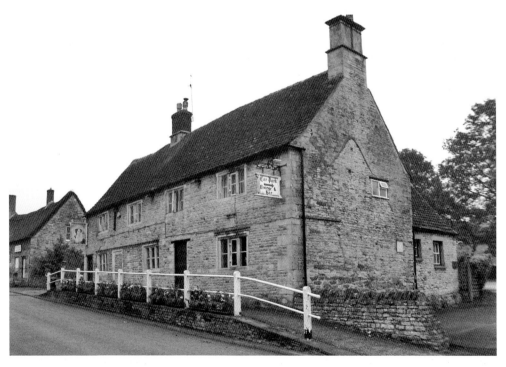

The *Queen's Head*, Bulwick, one of three pubs once having enforced Sunday closures.

heard in Oundle, in July 1867, after 'a group of prisoners' had spent a whole day drinking at the *Angel* which resulted in one man lying on his back in the passageway of the hostelry repeatedly hiccoughing between non-stop mutterings such as wishing he had someone with him. Out in the street, soaking wet from the heavy rain, was another of the drinkers, Mary Cotton, who had to be taken in a wheelbarrow to the lock-up, to get back to normality.

An effective way of dealing with tippling took place in the early years of the nineteenth century at Moreton Pinkney, where the lord of the manor gave the church curate the task of ensuring that his tenements were kept in good repair and to collect the rents (which had fallen behind) of those tenants occupying them. Years later in December 1853, a correspondent in the Northampton Herald reported what subsequently happened, describing how the curate had set the rent at a reasonable rate assuring the tenants that most of the money would be used for the maintenance of their cottages. Being successful in this ploy, he had then made it known that if any tenant could afford to squander money by tippling at a public house, then that person's rent would be raised, adding that any man who robbed his family of their victuals by tippling, 'should not receive any encouragement or charity'. The correspondent finished by reporting how the 'speedy and great' effect of this threat had since changed things so much for the better: 'scores of children are witnessing every day the good examples of fathers that under the old system, evidenced nothing but drunkenness, disorder and crime'.

Not so lucky was Anne Gardner of Maidwell who in 1842 had been drinking heavily in the *Chequers* to such an extent that her behaviour got out of hand, including amongst other things, standing on her head. For her conduct she did not receive the usual punishment of being placed in the stocks, but was harshly dealt with, being publicly whipped and banished from the village. Probably, luckier was Ann Tyrell who in January 1759 at the Kettering Quarter Sessions, was ordered to be whipped from the *White Horse Inn* to the church gate in the town, most likely tied to the rear of a cart as was normal practice with 'mobile' rather than static whippings.

At Syresham, after the Second World War, an elderly couple would regularly make a short journey on foot every Friday evening from their home at nearby Crowfield. The husband would go for a drink in the Bell, while his wife would visit her sister. On one occasion the man had one drink too many and stumbled into a ditch, whilst his wife continued on her way. When she arrived home, she was asked why her husband was not with her, to which she replied that she had left him in the ditch, and that since he had got drunk himself, he could find his way home by himself!

The 1920s witnessed some comical events. During one particularly hot summer day, drinkers in the *White Hart* in Corby village were startled by the entrance of an unusual 'customer'. The track outside was used to drive cattle from one field to another, and one particular cow left the herd and made its way into the bar! During the same period, it was customary for the churchwarden of the church of St James in Gretton, to slip out after the start of the Sunday evening service, into the *Fox* which was situated conveniently close by, for a pint of Bass. He managed to time his absence to perfection, managing to return as the last sermon was being read, and the final hymn sung. On another occasion, the landlady of the *Queen's Head* in Yarwell was doing the weekly wash, when she encountered a problem with the copper. To remedy the situation, she put some gunpowder on the fire which consequently exploded, blowing off the copper door and scattering soot all over the wash-house and previously washed clothes.

An interesting novel and amusing way of making business more attractive seems to have come into being at the turn of the twentieth century in the case of at least two county hostelries. In 1905, Alfred Tilley, the landlord of the *Nag's Head Inn* in Corby village printed business cards listing Ten Commandments to be obeyed by customers drinking in his establishment. In the inter-war years, this idea was developed further by Alan Jones, the landlord of the *Cardigan Arms* at Deenethorpe who displayed a large notice in the bar also listing Ten Commandments, with the additional offer of a 'free pass valid on all railroads – providing the bearer walks, carries his own luggage, swims all rivers and stops for all Drinks and Smokes at my Pub', to anyone who could manage to successfully obey to all of the ten rules which were:

'When thirsty thou shalt come to my house and drink, but not to excess, that thou mayest live long in the land and enjoy thyself for ever.'

'Thou shalt not take anything from me that is unjust, for I need all I have – and more too.'

'Thou shalt not expect too large glasses nor filled too full, for we must pay our rent'.

'Thou shalt not sing or dance except when thy spirit moveth thee to do thy best'.

'Thou shalt honour me and mine, and thou mayest live long and see me again'.

'Thou shalt not destroy or break anything on my premises, else thou shalt pay for double the value and thou shalt not care to pay me in bad money, nor even say 'chalk', 'slate' or 'it'll be alright.'

'Thou shalt call at my place daily. If unable to come we shall feel it an insult unless thou send a substitute or an apology'.

'Thou shalt not abuse thy fellow bummers, nor cast base insinuations upon their characters by hinting they cannot drink much'.

'Thou shalt not take the name of my goods in vain by calling my beer 'slops', for I always keep 'Low, Son and Cobbold's Noted Beers', and am always at home to my friends'.

'Thou shalt not so far forget thine honourable position and high standing in the community as to ask the Landlord to treat'.

The notice began with 'essential information' and ended in a jolly verse, both recorded as follows:

'A man is kept engaged in the yard to do all Cursing, Swearing and Bad Language that is required in the Establishment. A dog is kept to do all the barking. Our pot-man (or Chucker Out), has won 75 prizes and is an excellent shot with a revolver. An undertaker calls every morning for orders.'

'Here's to the working man who fears no master's frown.
May his Beef and Beer increase and wages never go down.
May his dear homely wife be the joy of his life,
Never kick up a racket, but love and respect the jolly old man
Who wears a workman's jacket.'

Fires have also taken their toll on towns and villages around the county throughout the centuries. Two examples were the similarly-named *Fox and Hounds* in Brigstock and Weedon, the latter burning down in the 1880s. Apart from the Great Fire of Northampton in 1675, there was a devastating fire in Thrapston in 1718 which destroyed much of the town – over fifty houses including hostelries, and another at Wellingborough in July 1738 which is said to have destroyed eight hundred buildings, and involved the heroics of the aptly-named Hannah Sparke, who ran a beerhouse in Butchers Row, and managed to save a building with blankets soaked in beer from her cellar, and went on to live until the ripe old age of 107. One hostelry that did survive that fire was the *White Hart*. Shortly afterwards, the following notice was given by the landlord:

'This is to give notice to all Gentlemen, Farmers, Bakers, Millers, etc., that at the White Hart Inn, in Wellingborough, which hath escaped the dreadful Fire, there is good Entertainment, with Stabling for Horses, and Store-room for Corn, etc.'

More recently, in 2000, a fire broke out at the *Chequered Skipper* which overlooks the village green at Ashton, near Oundle, where the International Conker Championships are held, but reopened afterwards. Hostelries can sometimes be the casualty of a more modern form of mishap, as was the case of the *Red Lion* at Isham and the *Woolpack* at Middleton. The former was due to reopen after renovation as the *Monk and Minstrel* in November 1995, but was hit by a lorry, which had collided with two cars. It finally opened seven weeks later, after repairs costing £60,000. The *Woolpack* however, which had also been hit by a heavy vehicle some years earlier, never opened for business again after the collision.

Sometimes a hostelry could be the victim of an unexplained natural occurrence, possibly a meteorite, such as that experienced by the *Fitzwilliam Arms* at Castor in June 1862. The *Peterborough Advertiser* reported:

'On Tuesday afternoon, about 2.30pm, a singular occurrence took place at Mr Samuel Poppel's at the Fitzwilliam Arms. Mrs Poppel and her servant were in the lower room, when they were startled by what appeared to be a loud explosion in the upper part of the house, which caused the doors to slam and the house to vibrate as though it would fall. They found in one bedroom that a large piece of the ceiling about a foot square had been smashed as though a heavy body had fallen upon it, a greater part of the remainder being left in a cracked state. There has been nothing to clear up the mystery.'

At least two murders have actually taken place in view of a crowd at a hostelry. In May 1687 a group of gypsies camped at the tiny village of Laxton in the north of the county. After a heavy drinking session at one of the two hostelries, they were asked to pay their reckoning by the landlord, Thomas Milley. A furious argument broke out resulting in him being stabbed to death by the wife of the gypsy leader. A badly-eroded headstone in the churchyard by the tower records the event.

'NAG'S HEAD' INN,
CORBY.

PROPRIETOR - A. TILLEY.

𝔓𝔥𝔦𝔭𝔭𝔰' 𝔑𝔬𝔱𝔢𝔡 𝔄𝔩𝔢𝔰 𝔞𝔫𝔡 𝔖𝔱𝔬𝔲𝔱.

GOOD ACCOMMODATION FOR CYCLISTS & PRIVATE PARTIES.

BEST CIGARS.

WINES & SPIRITS OF THE FINEST QUALITY.

Ten Commandments of A. TILLEY'S Establishment.

1.—Thou shalt come to mine house when thou art thirsty.
2.—Thou shalt always keep my name in thy memory.
3.—Thou shalt visit me often on week days.
4.—Thou shalt honour me when I deserve it, so that thou mayest live long, and continue drinking in my house.
5.—Thou shalt neither break nor destroy anything in my house ; if thou dost, thou shalt pay me each time double for it.
6.—Thou shalt not make any disturbance in my house, for such things are distasteful to me.
7.—Thou shalt not steal anything from me. I need all I have myself.
8.—Thou shalt not dare to pass counterfeit coin or money on me.
9.—Thou shalt not expect large or full glasses, because the landlord has to live off the profit.
10.—Thou shalt, after thou hast been eating or drinking at my house, pay me honestly for it, for the landlord never likes to have anything to do in the chalk line.

Right: 'The Ten Commandments' at the *Nag's Head*, Corby, in 1905.

Below: The *Chequered Skipper*, Ashton, near Oundle, as it looks today.

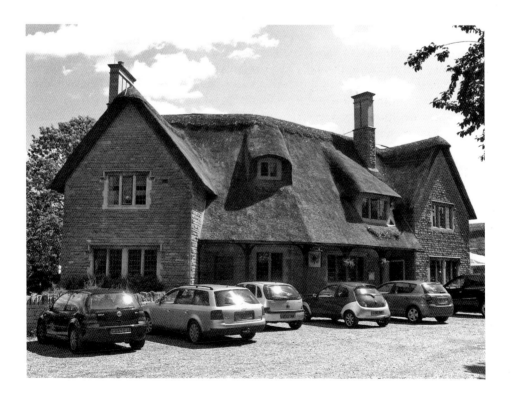

In January 1743, a fight broke out in the *Blackamoor's Head* in Kettering, between three men, one of whom, Benjamin Meadows, was stabbed to death. The two assailants paid a heavy price for their altercation at the pub and were hanged for the crime, which had been witnessed by so many fellow drinkers.

Another more grisly murder took place in Kettering in 1912, when Mary Pursglove had her throat cut in a fit of jealousy by her lover, Isaac Sewell, at their home. After the deed had been done, he walked along to the nearby *Three Cocks* where he spent time drinking whisky, before heading over to the *Old White Horse*, where he steadily got more and more drunk, and during which time the body had been discovered. He was found senseless outside the pub, and arrested for the murder, later paying the ultimate penalty on the gallows.

Two more hostelries featured in the aftermath of another murder. In February 1893, twenty-nine year old Louisa Johnson had travelled down with her baby from Liverpool to burton latimer to stay with her sister at Burton Latimer, to escape from Richard Sabey, her lover, whose absent wife and children had suddenly reappeared. Shortly afterwards, he followed her and found out where she was staying. As she came out of the house to get some water from the well, he appeared and managed to persuade her to take a walk to discuss matters. A row broke out during which she was stabbed to death, after which he ran off. She was found 'with her head half-severed from her body'. A group of men pursued Rabey across the fields towards Finedon. Realising the game was up, he subsequently walked into the *Gate Inn*, where he was arrested and later paid the ultimate price for the crime. The body of the woman was taken to the *Red Cow* in Burton Latimer where an inquest was held. The crime shocked the villagers who lined the streets as the funeral cortege left the *Red Cow* for the church. Her headstone later recorded her demise with the words: 'He brought down my strength in my journey and shortened my days.'

Another notorious crime which took place in Burton Latimer was that which occurred outside the *Thatcher's Arms* in October 1875. A group of four men drinking in the pub decided to play a little music, one on penny whistle, one on 'bones', and Josiah Denton on tambourine. The fourth man George Westley, who had missed out, later caused an altercation during which he took out a pocket knife and slit the skin of the instrument. Denton began using threatening behaviour towards Westley who was asked by the landlord to leave the premises, which he did, but was followed a short time afterwards by the three others. He was approached by Denton who in the process was fatally stabbed in the stomach. Denton died a few days later leaving his young family bereft of a father. At the subsequent inquest in the *Red Cow*, Westley was found guilty and sent for trial.

Strangely, an ancestor of Josiah Denton, with the same name was involved in an earlier crime at Flore in November 1835. At an unnamed hostelry in the village, three men had been drinking together for nearly six hours, when one of them by the name of Bull, the worse for wear, decided he wanted to climb the chimney. One of the others offered to blacken his face with soot instead, which duly happened. They then left to try to other pubs in the village, the *Royal Oak* and the *Dun Cow*, but found them closed. Shortly afterwards on the Brockhall Lane, Bull was robbed by Denton of his silver pocket watch and a shilling. The case came before the court resulting in Denton being transported to Australia, where after he had served his time, he became one of the founders of the town of Toowoomba in Queensland.

Drunkenness once again was the cause of another crime in June 1858. At Westrup, Marston St Lawrence, James Bazeley picked on one of the other customers, offering to

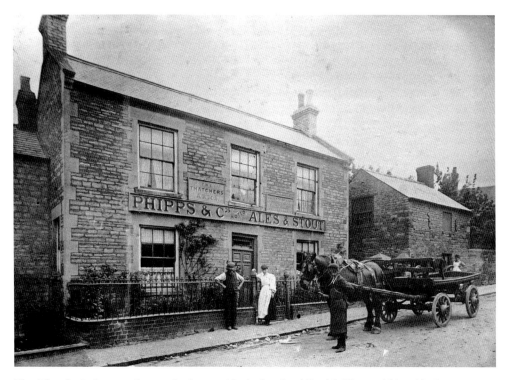

The *Thatcher's Arms* at Burton Latimer, with the landlord Fred Miller and his wife, in 1905.

fight him for a sovereign, the latter man refusing. The following week, he offered the challenge a second time to the same man, who once again declined, but this time was knocked to the ground. At a court hearing Bazeley was found guilty of assault, and fined the large sum of five shillings with costs.

The Temperance Movement began to have influence in the county. One memorable event was the visit to Kettering by an early teetotal reformer, Thomas Whitaker, in the spring of 1837. It is worth noting that at this time there was a deep-rooted suspicion and adversity to the idea of temperance in many quarters. The British School Room was booked for the meeting, but things did not go to plan, as recorded by the speaker in a contemporary leaflet:

'It was taken possession of by the rowdies of the town and they had the meeting conducted after their own fashion. The Revd John Jenkinson was in the chair and after saying that he hoped they would hear what I had to say, he announced that at the close of my address, they would be allowed to put questions, and if they did not do so, he should take me in hand instead. He concluded by saying that he hoped the day would come when every working man would have at least 'two pints a day'. Upon that, several of the men began to flourish bottles and ask questions before I could begin. The interruption was continuous, but I spoke for an hour, and I think I made some impression...'

What happened next was disastrous, when someone set light to some woodshavings left on the floor by some carpenters, leading to a shout of 'fire' and general mayhem. The meeting broke up in disorder, with some of the crowd pinning the speaker to the wall, necessitating an escort away from the premises for his safety.

Things did not go much better at neighbouring Corby, five years later, as reported at the Kettering Petty Sessions in 1842. On the afternoon before a temperance meeting, two local clergymen had provided a large barrel of beer for 'free and general consumption' on an adjoining field so that the villagers would be in a fit state to attend the meeting! During the meeting the visiting speaker, John Hockings, was constantly interrupted by one 'Streather'. A policeman was called to take him away, but the two clerics objected to a police presence, causing the drunken miscreant to get more aggressive, damning the police, speaker and chairman. The meeting was halted. At the subsequent hearing, Streather was fined five shillings for being drunk and disorderly, and a shilling for each of the utterances he had made against the three men. The clerics however got off scot-free, but were reprimanded by the magistrate, and viewed with contempt by those attending the court.

Being a village policeman could be a harrowing experience when it came to tipplers who had got out of hand. At Gretton in August 1846, the constable was brought in by the landlord of the *Hatton Arms* to remove an aggressive, abusive customer. He tried using persuasion to get him to go home quietly, but met with strong resistance, and the man had to be forcibly ejected, only to re-enter immediately afterwards. This tactic was repeated and had the same result. At a fourth attempt, the tippler threatened the policeman with violence and assaulted him, whereupon he was restrained and taken into custody. It later emerged that he had caused similar problems at the nearby *Talbot*. He was subsequently ordered to pay five shillings for each offence or be imprisoned for a total of five weeks.

At Tansor, the *White Horse* was the sole village pub for many years. There is a tradition that two brothers, one of whom ran the hostelry, had a heated argument, whereupon the other brother subsequently opened the *Black Horse* in close proximity as a token of fraternal rivalry. This was only a short-lived venture however and the village went back to normal. A similar situation seems to have occurred at Ashley – not between two brothers – but more friendly rivalry between two men, running the *Black Horse* and the unusually-named *Brown Horse* respectively, a situation that lasted for many years, the latter building still surviving on the edge of the village, albeit as a dwelling.

The *White Horse* at Lowick (now the Snooty Fox) has an interesting legend attached to its origins and name. One version states that during the Wars of the Roses, the horse carrying a local knight was wounded in a battle. It somehow managed to get within sight of the village, where it stumbled, throwing its master to the ground, killing him. A little further on in the village itself, it succumbed to its wound and dropped dead. A hostelry was later built on the spot in honour of the faithful steed. (Other versions give the action as taking place during the Civil War or the Crusades).

The *Swan* in Kettering was the scene of an incriminating discovery in June 1595. It all started in the hamlet of Little Oakley where it was alleged that a prosperous villager, Edward Bentley 'hath a seminary priest in his house continually'. These were dangerous times for recusants – those illegally adhering to the old faith, Catholicism – who stubbornly retained items associated with Mass which they carried on attending in secret, usually with a priest who they would conceal somewhere in their home. The recusant in question had another home – in Derbyshire where he employed a local mason and carpenter to

make rosary beads in small boxes – another act of defiance against the state religion. An official searcher was sent to Sir Edward Watson at Rockingham Castle, after which both men went to Little Oakley to seek out the incriminating evidence. Inside the house they made a thorough search, during which they could not find the priest, referred to as 'my chicken' by Bentley's wife! Eventually however, they turned up trumps with the discovery of a chalice and a small coffer which she refused to open. They took the items to the *Swan* where they opened the coffer, and found another silver chalice, a jet crucifix, a surplice, a Mass book and other items of 'the old faith'. Bentley, who had carried on nonchalantly reading a book in the garden during the search, was subsequently ordered to attend a hearing, at the *Swan* and to ensure his appearance £1000 bail was imposed upon him. The 'chicken' was never found, having escaped to carry out Mass secretly elsewhere.

Also in Kettering, albeit several years later, there was a major talking point in all of the town's hostelries, and in nearby villages, the subject causing alarm in many quarters, and much resentment in general against King Charles I. In 1637 he had revived the old Forest Law for the Rockingham Forest area, imposing it on Kettering and other settlements that had been released from its jurisdiction since 1299. At courts various fines, some punitive, were given for transgressions dating back many years. The following year, suspecting that the Kettering area was a hotbed of illegal poaching, he ordered officials to make a search for nets, weapons and certain 'illegal' breeds of dog in every dwelling within a five-mile radius of the town. No doubt this accentuated anti-monarchy feeling locally in subsequent years and the Civil War, whilst supporting the Parliamentary cause, and possibly culminated with many a celebration in local hostelries after the unpopular king was executed in January 1649.

Parish constables' disbursements often contain items of interest concerning hostelries. A constable would be an ordinary villager who had his own occupation or trade, and who was elected by a justice of the peace to serve the parish on an annual basis on Easter Monday of each year, maintaining law and order such as raising a hue and cry (summoning help in the pursuit of malefactors), carrying out different types of supervision and inspections, and issuing warrants. He was unpaid, although he was permitted by law to levy a modest rate of 1*d* or 2*d* in the pound to cover his expenditure, for which he kept a record of the rate levied for each of his actions. It was quite common for prisoners or undesirables to be given victuals, drink and overnight accommodation, before removal from a village, the costs initially borne by the constable, and recouped after recording in his disbursements. The following are from those of the constable of Farthinghoe between 1711 and 1730, concerning a persistent offender, Ann 'Goody' Whitmill, who was hauled before the justices at Edgcote for selling unlicensed ale in 1720. Prior to this she had a string of crimes stretching back to 1708 when she was whipped for an unrecorded misdemeanour (her husband had been placed in custody the year before), whilst three years later, she stayed at an unnamed hostelry run by Richard Lovell, ready to appear before the court in Northampton, either for the murder of a child, or the concealment of its birth. The constable also paid Richard Lovell for the bread and beer consumed by the coroner, jurymen and witnesses. (Seven years later, the same woman was before the justices for 'pulling the hay of Mr Woolf'). In the same period, the constable was involved in three alehouse searches in Charlton (October 1716), and one in Crowton (Croughton) 'where we lay all night'. It would be interesting to know if any ale had been consumed to make the stay necessary – or equally, coming back from Brackley a while later, when he and another constable had to pay 2*d* for a guide because, as he explained, they had lost their way!

The coming of the railway, like the development of the canal system, was a time of opportunism for small village traders who could and would make great profit, among them brewers. The vicar of Nassington, David Barrett, gave a bird's eye view of the scene in his 1880 book *Life Among the Navvies*, when navvies were working on the Midland Railway's Kettering to Manton line, and digging the Corby tunnel from November 1875 to January 1878. The men were accommodated in two hundred huts, with seven men plus women and children per hut. Such heavy work involved equally heavy drinking, and their thirsts were certainly well-catered for, with local brewers providing copious amounts of beer and whisky. The writer estimated that half a gallon of whisky, and thirty gallons of beer a week per hut was the norm, the latter costing 3*d* a pint. He was amazed at the amount of consumption, expenditure and profit involved at the time:

'I looked with horror and astonishment at the figures and said "I can't believe it!" But a friend of mine remarked at once, "You needn't be astonished for I know that for many months, a single brewer's agent in one district alone used to send back between fifty and sixty eighteen-gallon casks back empty every week." (This was exclusive of <u>two</u> other brewers who regularly brought in supplies).'

THE SECOND WORLD WAR

In one incident during the Second World War, a hostelry in Corby played a role in tracing the whereabouts of a wanted man. A policeman stationed at Kettering, had finished his shift, changed into his everyday clothes and was making his way back home on the bus to Corby when he was approached by a shifty character with a large suitcase, who offered him a jar of Brylcreem, and for his wife, a pair of silk stockings – at a 'fair' price. Feeling elated he bought them both and was told that if he wanted more, he should go to the *Cardigan Arms* that Friday evening. Back at work the next day, he showed the inspector what he had bought and told him about the man and his offer. The response and subsequent events were as follows:

"You, me and Acting Detective Percy Jones of Weldon will go down to the Cardigan Arms with Sergeant Bolding, our police instructor from Kettering, to stand by in a car. This man has been selling those items around Kettering and the police would like to meet him, now he's starting to come to Corby!"... 'We both went into the Cardigan Arms, sitting apart. We saw the man I'd met on the bus, selling the stuff to someone. When he'd finished the deal, Jones and I walked over and arrested him...'

During the war, American airbases were set up in Polebrook, Deenethorpe, Grafton Underwood, Kings Cliffe, Spanhoe (Wakerley), Harrington and Chelveston. It was common to see airmen in many of the local hostelries, enjoying the novelty of an English pub and trying to work out the strange currency in use at the time. One particularly popular hostelry was the *Vane Arms* in Sudborough. Visitors today will see a number of coins wedged into cracks in the beams of the ceiling. There is an unsubstantiated tradition, that those airmen due to fly out on a bombing mission, would leave the coins there, and only remove them if they returned safely. Needless to say, many never did

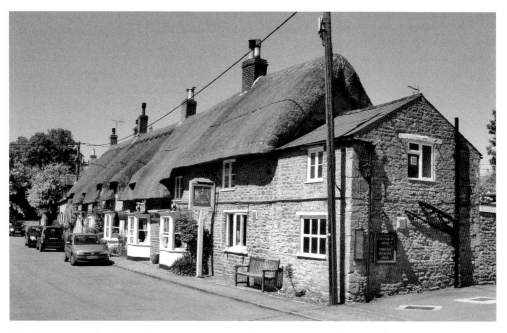

The *Vane Arms*, Sudborough, wartime haunt of US airmen, as it looks today.

come back, as can be seen by the number of personnel missing from the bases – over 1,500, and in excess of five hundred lost aircraft.

A similar situation occurred at the *Bell Inn* in Syresham, where a four-man crew from a neighbouring airfield, who regularly patronised the pub always sat in the same place. Before leaving they would turn their empty glasses upside down – perhaps some form of superstitious act. The landlord or his wife would never remove them, at the request of the four men, until they returned the next time, perhaps from a bombing mission. It is said, by those then living in the village, that on one auspicious evening the men stayed for just a short time, hurriedly finishing their beer, and contrary to their normal routine, left their glasses upright on the table. They never returned.

Many celebrities flew in from USA to entertain the troops, whilst others were stationed at one of the bases. Clark Gable was stationed for a while at Polebrook. At the *Old Three Cocks* in Brigstock, he had his own private room for entertaining friends and guests. One of the barmaids working at the pub was regularly assigned to take their orders up to the room. Just before the end of his stay, he gave the girl a wartime blue pound note which he signed with his name, and took her to the Odeon in Kettering to see – *Gone With the Wind*! Unfortunately with the austerity of wartime life, the pound note, which would be worth a considerable amount today, was spent some time later. Clark Gable is also said to be one of many American servicemen who left their signatures on the larger fireplace of the *Royal George* in Geddington.

The former *Cardigan Arms* at Deenethorpe witnessed three interesting, inter-related incidents two of which occurred within eighteen hours of each other in December 1943. The first was when the commander of the 401st Bomber Group at the nearby US airbase suggested to his ground crew who had been extremely busy preparing aircraft

for a mission, that they go for a drink before the pub closed, at 9pm. Arriving at 8.50, they were told 'Sorry, we're closing'. The officer promised they would be out within ten minutes if they could have a quick one, but the landlord stood his ground and they all went away thirstier than ever.

What happened the following morning is beyond belief – almost a form of retribution – when the village was shaken by a 6,000lb bomb load landing in the village. It was from a US B17 Flying Fortress which had been attempting to take off for a daylight bombing raid on Germany, and had crashed on top of a cottage, which fortunately was unoccupied at the time, and had caught fire. The crew of ten scrambled clear of the wreckage and tore through the street yelling at the villagers to get into the fields before the bombs exploded. Most of them were still in bed, but within seconds were fleeing for their lives, hiding behind haystacks and mangold clamps. About ten minutes later the bombs went off, detonated by the heat from the flames of the burning aircraft. Miraculously, only one villager suffered any injury, from flying splintered glass – but all thirty-two cottages were damaged in some way, whose occupants had to be temporarily rehoused locally. Strangely however, the *Cardigan Arms*, whose proprietor, George Smith, had refused to serve the Americans the evening before, was the only building left untouched. Determined to open as usual, the landlord said:

'The amazing thing is that although my cow house was blown down, all my cows remained standing as though nothing had happened. I expected to see them all go down like ninepins. And as for the pub, not a bottle of beer was broke. That was luck if you like!'

The story does not end there however, for a few weeks later, the same commander who had been refused a drink the previous December was invited to a cocktail party at a nearby Land Army camp. With his first glass of beer half full, he was given a tray with another one, then another, and another...until after a while, he pointed out to the girl serving him that he would like to stay sober to enjoy the hospitality, but was met with the tongue-in-cheek remark:

'Oh sir, we've heard about you. If you don't get all you want to drink, you blow the place up!'

At another local hostelry, a group of US servicemen were socialising with some local girls, spending lots of money, when one of them asked: "How do you feel about us being in your country?" He received the witty reply: "Well, you're overpaid, overfed, over-sexed and you're over here!"

The US airmen from the airbase at Chelveston would make their way to the *Morning Star* at Earls Barton, some distance away, which for some reason seemed a popular hangout with them. Being only a beer retailer, with one part of the building being a shop, they initially attempted to sit in the taproom which was too small to accommodate them, so benches were put outside where many an inebriated session would take place. Here they would give out chewing gum and chocolate to the grateful younger element in the village.

During the war, precautions were taken around the country for a possible invasion, amongst which many road signs were being obscured and roads kept under constant observation. Great Oakley was no exception, and a rota system was devised to keep an eye on all activity in the area, particularly the road leading to and from Kettering, situated four miles away. The rota was supervised by the lord of the manor, Lord Brooke, chairman of the county council at the time. One of those appointed to keep watch was the village chimney sweep and woodsman, Charlie 'Nibby' Bradshaw, who was not

averse to a tipple or two, and was well-known in the district for riding a penny farthing bicycle in his spare time. His look-out post was close to the village pub, the *Spread Eagle*, an old coaching inn, where he had a favourite seat, which no-one occupied 'at their peril'. On one occasion his relief had not arrived at the appointed time, and in his anger and rush to get to the pub for his drink and his lunch, he deserted his post. He was interrupted later by the chauffeur at the Hall who asked him why he had left the entrance to the village exposed, to which he retorted, 'No-one turned up so I cut down a few of the smaller trees to block the road instead!'

Another colourful local character was 'Old Toggy' who was a regular customer at the *Woolpack* in Rothwell during the last century. On one occasion the landlady of the pub told him to stop pushing his way around the crowded bar, to which he retorted: 'You're no pretty sight yourself – pull the beer that you're paid for!"

STRANGE HAPPENINGS

Inevitably, older hostelries like any other buildings of antiquity, are ripe for hearsay and legend, none more so than hauntings. All round the county there have been reports in the past of apparitions, strange sensations, uncanny sounds, doors opening and closing for no apparent reason on windless days, etc caused by previous occupants, either who either died prematurely of some misfortune, or who were so attached or connected to the place, they left some form of imprint, such as sightings of 'grey ladies' in hostelries like the former seventeenth-century *Sea Horse* at Deene. Whether credible or not, like the relics of saints in medieval religious institutions attracting pilgrims, they give an extra boost to the reputation and appeal of a place and its trade, encouraging a larger number of visitors and other potential patrons.

The most interesting of these hostelries is the *Talbot* in Oundle, part of which dates back to 1552 and stands on the site of an earlier hostelry, the *Tabret*. It was rebuilt in 1626 using stone, it is popularly believed, from nearby Fotheringhay Castle, birthplace of Richard III and where Mary Queen of Scots was beheaded in 1587, which had been demolished a short time before. Among other items supposedly brought from the castle were stone fireplaces, wooden panelling and a staircase which Mary Queen of Scots is said to have descended from her chamber to meet her fate. This traumatic occasion was believed by many to have left some kind of psychic imprint on the fabric of the castle. Over subsequent centuries, strange happenings have been reported within the walls of the hostelry by guests and staff, such as fires breaking out for no apparent reason, a female figure standing at the foot of a bed staring at the occupant, sobbing being heard in an adjoining bedroom (with no visible evidence on investigation), invisible forces preventing a door from being opened or creating pressure on the bodies of sleeping guests. Most significantly, on one occasion, a group of diners sitting in the lounge were joking about Mary's connection with the inn, when suddenly her portrait fell off the wall behind them.

Certain hostelries in the county have been the scene of murders or witnessed their aftermath. One of the most gruesome was that which took place in the cellar of the *Black Lion* (now the *Wig and Pen*) in St Giles Street at Northampton, on Christmas Eve, 1892, when the occupier, Andrew McRae murdered his mistress, Annie Pritchard and then boiled her head and some of her bones in a copper which he used for preparing

bacon for sale. Their child also disappeared at the same time and was never found. Remains of a body were later found in a bacon sack in Bull Head Lane. He was caught, tried and duly hanged, but this did not prevent strange occurrences in the building thereafter, such as the sounds of a heavy barrel being moved from the ramp to the cellar gangway, the appearance of strange vapours, sudden chilled air, and years later, lights switching themselves on and off for no apparent reason.

The Battle of Naseby (which is surprisingly not mentioned in the village records) on 14 June 1645, has given rise to a number of traditions over the years, among them where Oliver Cromwell stayed the night before the decisive conflict. He must have been a magician to stay in all of them at the same time, among them Hazelrigg House in Northampton, and the *Hind* in Wellingborough, where he is said to have drawn up plans for the battle. However, like all such claims, none can be substantiated, his exact movements having been traced and well documented by Civil War researchers. Another implausible tradition is supposed to have taken place at the *George* in Brixworth, where there is a small single light window with a moulded stone surround at the rear of the building, known as 'Cromwell's Eye'. It is said that Cromwell arrived at the inn prior to the battle and locked up the landlord in the cellar so that his men would not be served with drink before the all-important battle. Looking out of the window he saw a messenger on his way from Lamport Hall, the home of the Royalist Isham family, to inform the landlord of the imminent arrival of Parliamentary forces. The unfortunate person was seized and accordingly dealt with severely. A good story, but easily disproved: the earliest parts of the building date from a few years *after* the Civil War, and the window faces away from the main Harborough-Northampton road. Of interest is that Sir John Isham, although a Royalist, frequently allowed Parliamentarian troops to use the Hall, which was left virtually intact – a unique situation that few other pro-Royalist properties could claim.

More plausible however is what was recorded three years earlier, in 1642, when Parliamentarian troops caused havoc at the *White Swan* in Wellingborough where they are said to have murdered one of the chambermaids and shot another for resisting rape. Similarly, Charles I stayed in Daventry either at the *Wheatsheaf* Inn, or the *Plough and Bell* (records vary), after storming the Parliamentary garrison at Leicester, and in the process of making his way to Oxford to relieve the siege of the city. It was whilst he was sleeping at the inn however that he was disturbed by the ghost of a trusted colleague, Sir Thomas Wentworth, who gave him warnings and advice about what his next move should be.

Many a scheme or plot was also hatched in a hostelry, the most spectacular perhaps being that which took place in the former *Cleveland Arms* at Sudborough in 1837. A group of twenty-five would-be poachers from the village and neighbouring Brigstock got together to plan a daring trip to the vast estate of the Brudenell family in the area around Deene, a few miles away, which was considered to be an easy target with a large rabbit population. Unfortunately for the men, according to one version, their conversation was overheard by a keeper of the estate who happened to be drinking there at the time, who subsequently planned to thwart their ambitions. He arranged for fourteen estate workers to position themselves at Burnt Coppice, close to where the men would be heading at the appointed time in the evening. The men duly appeared and managed to bag a good catch of 180 rabbits. As they walked across Slade Field at Deenethorpe they were pounced on by the keeper's men. In the ensuing confrontation, they fled leaving the large amount of netting they had employed, and three of their colleagues who were taken into custody. The following morning an inspection was made of the site, during which the disembowelled

corpse of another poacher was discovered. At an inquest it was pronounced he had died of over-exertion! The three offenders were later tried at Northampton and found guilty, but because they had large families and had been given good character references, their sentence was reduced from transportation to a year's hard labour.

More hilarious however was another plot hatched at an unnamed hostelry in Northampton in 1830, where one of the tipplers, worse for wear, announced to everyone present that one of the fields in Little Houghton had been given to the poor by the vicar, and that it was full of turnips – more than enough for the villagers there. The crowd cheered, drank his health, and decided to meet him in the village the next morning. Men, women and children began helping themselves to as much as they could, until they were interrupted by the arrival of the angry vicar and his servant, both carrying whips. They all cheered when they saw him, but fled in panic as he rode furiously towards them, shouting and cussing in an 'un-vicar like' manner. Scattering in all directions, they left their farming implements and other items lying on the field, but managed to get away with a few turnips for their families.

The *Hatton Arms* in Gretton is one of the oldest buildings in the village and as the name implies was named after Christopher Hatton, a great favourite of Elizabeth I and lord of the manor of the village from *c.* 1587. A descendant, Christopher Hatton IV became governor of Guernsey Castle in 1672. A violent storm hit the island whilst he was there, during which lightning struck the gunpowder magazine, killing his wife and mother. It was only through the intervention of his twenty-seven year-old black servant, James Chapple, that his daughter was saved. In gratitude he gave him £20 as a pension – a vast sum in those times – and 'retired' him to England, where he lived at the *Hatton Arms*. This later gave rise to a local legend that he was the first black landlord of an English hostelry, but whilst he may have helped out on occasions, there is no record of him being a licensee in the alehouse recognizances or quarter session papers. More intriguingly, there is no headstone for him in the village churchyard, believed by some, to be an early case of racial prejudice.

A situation which a Yorkshire clergyman found himself at the turn of the nineteenth century, may well have also occurred in Northamptonshire. Whilst the majority may well have had a comfortable living, there were exceptions, especially if there a large number of mouths to feed, as in the case of the Reverend Carter of Lastingham, whose wife ran a hostelry to help make ends meet for her family of thirteen children. When visited by the bishop's representative to account for this unchurch-like activity, he vigorously defended himself, by stating that since his parish was spread over almost fifteen miles, his parishioners would need refreshment after church and before their long journey back home (often on foot). He tempered this by adding he played a few tunes on the violin to distract them from drinking too much, and that his actions had the triple benefit of his congregation being instructed, fed and amused at the same time!

Before wheeled transportation became commonplace, riding or walking were the only means of getting around, especially if you wanted to visit a hostelry, but lived in a 'dry' village, on an isolated farm, or preferred drinking in elsewhere. Things got better when motorised transport became commonplace, but at first this was the prerogative of the more affluent, and less common in rural areas at first, but for the average person, especially the young, the development of the bicycle was a dream come true – cheap, easy to use, and quicker than going on foot. In the 1920s and 1930s it would be useful for meeting friends at a pub, but could create a tricky situation in the winter, as this account shows, from the memoirs of a man who lived in the Great Oakley area at the time:

'The Harrison lads needed to cycle across the fields to join the main road near Kingswood: this they did all the year round, creating a well-worn path to the pub or village hall. They were among the first to acquire carbide (acetylene) lamps for their cycles, replacing the normal old-fashioned and messy black oil lamps that provided little light. The new lamps gave a better, more reliable light – the faster the drip feed of the water, the better the light, since more gas was created and flowed to the lighted jet in the lamp. However, they could be frustrating in frosty weather, since the water in the cylinder would easily freeze when not in use. Therefore, it was necessary to remove them and keep them in a warm room. Coming out of the Spread Eagle two or three hours later could lead to problems of thawing out, since a supply of hot water would be needed to thaw the lamps out. A problem? Not at all – if the lads had been drinking the local ale – Smith's of Oundle (the water of which some locals swore came from the River Nene!) they would empty their bladders on the lamps!'

In the 1920s, a group of friends would travel by pony and trap from Corby to Weldon every Saturday evening to drink at the *King's Arms*, leaving the pony tethered to a gate in the yard. On one occasion, two local lads seeing the pony, decided to have a bit of fun. Unharnessing the pony, they removed it from the trap, undid the five-bar gate, and led the pony through to the field beyond. Closing the gate, they then pushed the shafts of the trap through the bars. Climbing over it, they then backed the pony into the shafts and harnessed it to the trap again, after which they walked away, leaving the pony one side of the gate, the trap on the other. When the friends left the pub at closing time, they went to their trap to untie the pony for the journey home, but they were soon dumbfounded at what they saw. At last, one of them said in amazement to the pony, 'How the devil did you get through that gate?'

Since 1204, Rothwell has held its annual Charter Fair in May. Although it has changed in form with modern amusements positioned around the market square area, and now lasts a week, the custom and ceremony of reading the charter has not. At six o' clock on the first day of the fair it is read out by an elected 'bailiff' outside the church of the Holy Trinity. Thereafter accompanied by six halberdier-carrying guards, he visits each of the town hostelries (and the sites of those that no longer flourish) for a drink of rum and milk after subsequent readings – which can be an intoxicating experience by the end of the rounds! The hostelries open to the public for breakfast, including rum and milk for those wanting it, and remain open all day for the duration of the fair. Significantly, one of the five hostelries in the town, the *Sun* – where the second reading takes place – has undergone a name change in recent years, and is now known as the *Rowell Charter Inn*. At each hostelry it is a tradition for the younger element of the town to attempt wresting the halberds away from the guards, and prevent them from getting through the streets, things in the past often turning violent, with flour and eggs thrown, and general tussling – and all this before the drinking began in earnest! On one occasion a local man had promised to take his wife on a picnic, after attending the Proclamation and then going for just one drink – which became several – and after he was found the worse for wear by his brother-in-law, managed to stagger home – but then the brother in law also disappeared after popping into the *Woolpack* for a quick drink. The two wives were displeased at having their day spoilt by their spouses, and the first man was barred thereafter from attending another Proclamation!

Rothwell was also once the scene of an amazing escapade. The Market House, built by Thomas Tresham in 1577, has acted variously as council offices, library, and

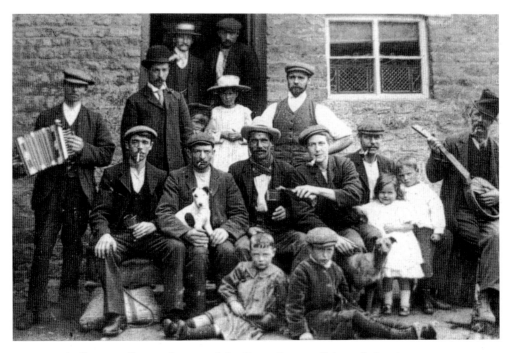

A group of village revellers at the rear of the *Green Dragon*, Brigstock, in 1870.

'pensioners' parliament'. It has also been used as a lock-up, especially for those who have had one too many drinks. In the 1880s, one such person woke up from his drunken stupor in the middle of the night, completely disorientated, clueless to where he was. Seeing the iron bars in the door, he attempted to get out, by squeezing his body through the narrow gaps. Not having any success, he took off his clothes, and tried again, this time wrenching the bars forcefully, and achieving a wider gap. This time he somehow managed to achieve his aim, and leaving his clothes inside, made a speedy exit, stark naked back towards his home in Kettering!

Hostelries have always been witness to a great deal of frivolity, none more so than the festivities which took place at the *Swan* in Oundle in October 1776, as noted in the diary of the town carpenter John Clifton, who loved to add a touch of humour to his entries, whilst giving a fascinating glimpse of life in his day and age:

'(there) was a very Elegant Supper at the Swan for a great number of both Sexes who spent the Whole night afterwards in Dancing, and now and then a cheerful glass; and there was a rank of Old Matrons to look on the performance...and in their turn came in for a kiss or two which was a motion that some of them had not gone thro' a great while...but they liked it! Frisky, eh?'

During the Victorian era, Thomas Bagshaw, the land steward at Home Farm in Great Oakley, would make a weekly visit to the Cornmarket in Kettering, leaving his pony at trap at the *Royal*. During and after the market he would have a drink or two at various hostelries around the market place, chatting with colleagues about corn prices,

agricultural matters, politics and other issues. After a long tiring day he would return to the Royal, where the ostler would have his pony and trap ready for him. If he felt drowsy or even fell asleep it is said that the pony would make the five-mile journey back to the village, and to the farmhouse gate, without any guidance.

A similar situation occurred during the 1930s, albeit with a tall story attached. A carrier from Wappenham, would call at several villages with his van *en route* to the market at Northampton, taking orders for goods or victuals that anyone needed. A local tradition stated that he knew every hostelry on his route – a considerable number – and would call in at each one on the way back, gradually getting to the point where he would be incapable of being in control of his vehicle. Locals would joke that the van was so familiar with the route, that it could get him home safely by itself!

Another carrier, from the previous century, Samuel Beesley, was renowned enough to have an engraving made of him by George Cruickshank, the celebrated caricaturist. He was well-known in the area, travelling between Aldwincle and Thrapston for nearly forty years with his donkey and cart, stopping at the *King's Arms*, where he always had a welcome drink or two. He was depicted in old clothes, with a mug of beer in one hand, reins in the other, in conversation with a pipe-smoking bystander, outside the pub with its notice above the entrance: 'Wm. Dines, Licensed Victualler, Wines, Tobacco, etc'.

In the days of coaching and turnpikes, it is inevitable that certain legends would come into being, especially with highwaymen – none more so than with the infamous Dick Turpin who was eventually hanged for his crimes at the age of thirty-three in 1739. One story recounts that Turpin frequently stayed at the *Black Horse* along Watling Street, on the county boundary at Old Stratford, where it is said that he would jump the six-foot

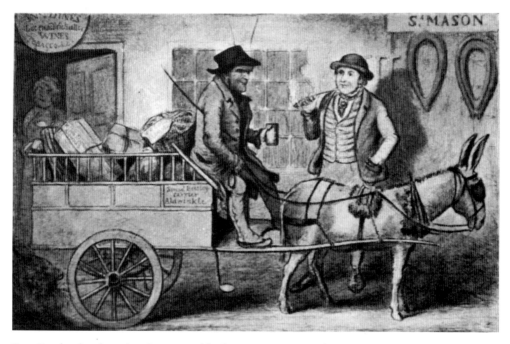

Sam Beasley, local carrier, shown outside the *King's Arms* in Thrapston, *c.* 1830.

high turnpike gates after being refused access by the tollgate keeper. However, two other incidents are said to have taken place at opposite ends of the county – both at hostelries, and both as outrageous in claims as each other. The first was recalled in an edition of the *Gentleman's Magazine* in 1850, involving a genuine person, Elizabeth Freeman, who worked at the *Bull and Swan* in Stamford St Martin and who served the highwayman with a quart of ale near the door of the hostelry, where he would be inconspicuous. When he had emptied the silver tankard, he put it in his pocket, and galloped off on Black Bess, his favourite mare, to the amazement and vexation of the landlord. Elizabeth Freeman went on to become landlady at the *White Swan* in Collyweston. Unfortunately, she had not even been born at the time he was hanged!

The second, more well-known, incident occurred on the old stagecoach route from Oxford to Peterborough via Brackley, Towcester and Northampton, now the A43, along which lies the former posting house and coaching inn, the *Green Man*, which still flourishes today at Brackley Hatch. Turpin and another highwayman, Jack Shepherd (who was also later hanged, but at the early age of twenty two) had been creating havoc along the road. One evening it is said that the Bow Street Runners were on his trail, having come up from London to put a stop to his crimes, and were waiting for him inside the inn and ostler's house, where they were expecting his arrival, after a tip-off. Turpin had just dismounted, in order to get some refreshment inside, but immediately sensed danger, quickly got back on his horse and sped off into the night, to the chagrin of the lawmen. Once again however, this never could have happened, for the Bow Street Runners were only formed by Henry Fielding, the novelist and magistrate, with his half-brother, ten years after Turpin was hanged!

In 1937, William Frost, a seventy-six year-old resident of Paulerspury, described what life had been like in his younger days in the village. Among his reminiscences, he recalled William 'Perk' Smith, landlord of the *Barley Mow*, and 'a bit of a daredevil' who would indulge in the brutal 'sport' of kick-shins, which involved clasping your opponent by the shoulders, indulging in vigorous kicking, and seeing who could 'fetch the other down first.' He then goes on to describe other incidents involving the same man:

'Another foolhardy thing he did for a wager. He went up the church tower, got over the battlements and clambered along a narrow ledge while clinging to the battlements. He used to brew his own beer. One day, when brewing, he had just got the wort in the copper and had just put the hops in, but they had not sunk when he got to hear of a prize fight about to start in a field close to. Away he went to see this fight. It lasted over an hour. When he got back the copper had boiled dry and he saw his beer running down the street. That did not trouble him; he said it had been one of the best fights he'd seen for a long time. He too was a great poacher. It was his boast he had kept count of several hundred hares. He was always game for a fight.'

Curios

Nassington had seven hostelries in 1889. In one of them the following cryptic inscription was found inscribed on the walls:

Pay	my	deed	men
day	and	wood	man
trust	ask	should	so

morrow	borrow	trust	just
to	to	not	un
and	never	you	is
to	advice	or	to
but	take	in	since

Rearranged, the words make an interesting piece of philosophy: 'Since man to men is so unjust in deed or word, you must not trust. Take my advice and never ask to borrow, but pay today and trust tomorrow.' One wonders if this was the idea of a canny landlord not wishing his patrons to have drinks 'on the slate'. It would be a little tricky for an inebriated customer to untangle and decipher such a message!

At Fosters Booth, between Cold Higham and Pattishall, the former *George Inn*, was believed to have been part of a seventeenth-century lodge used by hunters in nearby purlieu woods (private woodland freed from Forest Law). The walls were covered in pargetted plasterwork depicting various hunting scenes. The building subsequently fell into disuse and by the mid-nineteenth century, had become an inn. In 1842 sketches were made of what remained of the plasterwork, much of which had eroded or disappeared and was in a precarious condition (and which too would suffer the same fate). The figures on the south west wall had all but vanished, but were believed to depict a pack of hounds and a stag. Elsewhere there were two hunting scenes with a buck, a hare and men in seventeenth-century dress, one of whom was blowing a horn. A shield with the date 1637 was engraved at the top of one wall.

At one time, even children at play it seems included a hostelry in one of their counting out rhymes, such as this old Daventry example:

'A fox went into a public house, To fetch a pint of beer. Where's your money? In my pocket! Where's your pocket? I've forgot it! – Please walk out...'

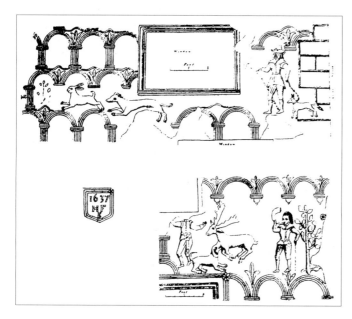

Sketches made of the remnants of seventeenth-century hunting scenes in plaster at Foster's Booth.

84

LITERARY REFERENCES
TO THE HOSTELRIES
OF THE COUNTY

'When you have lost your inns, drown your empty selves, for you will have lost the
last of England!'

(Hilaire Beloc)

'The world's an inn, and death the journey's end'

(John Dryden)

We are fortunate that a number of eighteenth and nineteenth century visitors (and certain
residents) to the county wrote down their impressions and invaluable descriptions of what
was in existence at the time, a world we have since lost, a victim of time, change, custom and
circumstance. Hostelries feature strongly among their observations, if not always by name.

An intriguing book of verse, *Tales of Drunken Barnaby*, was published in 1716,
describing the exploits and escapades of an inebriated traveller, making his way from
London to Westmorland, via Wisbech. The book was published posthumously, the
writer being 'Coryambaeus', alias Richard Braithwait (1588-1673). His protagonist,
Barnaby, makes his way into Northamptonshire, staying at Daventry, Weedon, and
Towcester, enjoying bouts of wenching and drunken revelry at each place, and giving a
(not to be exaggerated) glimpse of hostelry life in the county at the time:

'Thence to Daintree with my Jewell, Famous for a Nobel Duell, Where I drunk and
took my Common, In a Taphouse with my Woman; While I had it, there I paid it; Till
long chalk broke my credit.

At Daintree early might you find me, But not th' Wench I Left behind me, Near the
Schoole-house where I boused, Her I sought, but she was spoused, Which I having
heard that night-a, 'Farewell (quoth I) Proselyta'.

Thence to Wedon, there I tarried, In a Waggon to be carried; Carriers there are to be
found-a, Who will drink til th' world run round-a: 'Pay good fellows, I'le pay nought
here, I have left more than I brought heere'.

Thence to Tosseter on a Tuesday, Where an artfull Batchler chus'd I To consort with;
we ne're budged, But to Bacchus revels trudged; All the Night-long sat we at it, Till we
both grew heavy pated.'

William Stukeley (1687-1765), the renowned antiquarian, pioneer of scientific field research, and rector of All Saints, Stamford, made periodic visits to Boughton House, home of his friend John Montagu. He was also an inveterate traveller, making several 'itineraries' around the country, recording and sketching ancient monuments and archaeological features, and later publishing the results of his findings (which later aroused a public interest in Druidry). On one such journey, which took him through Northamptonshire in 1710, he commented 'we met with some excellent Ale' at Geddington, where there were five hostelries at the time.

Horace Walpole (1717-1797), youngest son of the prime minister, and a major figure in the Gothic Revival, writing the first novel of that genre, and building the remarkable folly, Strawberry Hill, stayed in the county on occasion, being particularly impressed with Drayton at Lowick. The same did not apply to Wellingborough, or more specifically, the *White Swan*, where he advised any traveller to avoid staying there, calling it 'the beastliest inn', and describing his bedroom as 'a club room, for it stank of tobacco, like a justice of the peace!'

Preceding these glimpses of Northamptonshire however is a rare early description contained in a manuscript held at the British Library (Lansdowne Collection, 213, f.347-384), dating from 1635, and based on the observations of a lieutenant-general of 'The Military Company' who arrived in the county, after leaving Bicester. Included in his itinerary were these brief descriptions of the *Swan* in Wellingborough and the *Talbot* in Oundle:

'...(I arrived at) Willingbrooke [Wellingborough] Market where I marked a fayre Inn that was lately grac'd by the Queen's Highnesse [Henrietta Maria], to the Inn of Court, during her Maties stay there, to drinke of that medecinable spring water...at Owndell my Lodging here was at the Signe of the Talbot where I found a good Inne, and good vsage...'

Charles Dickens stayed in the county many times, especially at Rockingham Castle, the home of his friends, Richard and Lavinia Watson. The other one was in Kettering, where he stayed at the *White Hart* during December 1835, as a young journalist covering a by-election for the now-defunct *Morning Chronicle*. He could not believe the coarseness and rowdy behaviour of the townspeople which he witnessed in the streets, patronising the seventeen hostelries and some of the clubs flourishing in the town at the time, almost the same as there are today! Writing in a letter to his wife, Kate, he describes the scene:

> 'the voters here are drinking and guzzling and guzzling, howling and roaring, in every house of entertainment...such a ruthless set of bloody-minded villains have I never set eyes on in my life...they were perfect savages.'

He goes on to express his fear that if a foreign visitor came there on his first visit to England, he would never set foot in the country again!

However it is one particular hostelry in the county which particularly inspired him when he was writing his first novel *The Posthumous Papers of the Pickwick Club*, better known as *The Pickwick Papers* (1856/7). In chapter 51, the founder Samuel Pickwick with his two travelling companions, his personal servant, Sam Weller and a student, Bob Sawyer are travelling across the country via Dunchurch where, after a change of horses, they proceed on their journey accompanied by heavy incessant rain via Daventry to Towcester:

'I say,' remonstrated Bob Sawyer, looking in at the coach window, as they pulled up before the door of the Saracen's Head, Towcester, 'this won't do, you know.'

'Bless me!' said Mr. Pickwick, just awakening from a nap, 'I'm afraid you're wet.'

'Oh, you are, are you?' returned Bob. 'Yes, I am, a little that way, Uncomfortably damp, perhaps.'

Bob did look dampish, inasmuch as the rain was streaming from his neck, elbows, cuffs, skirts, and knees; and his whole apparel shone so with the wet, that it might have been mistaken for a full suit of prepared oilskin.

'I am rather wet,' said Bob, giving himself a shake and casting a little hydraulic shower around, like a Newfoundland dog just emerged from the water.

'I think it's quite impossible to go on to-night,' interposed Ben.

'Out of the question, sir,' remarked Sam Weller, coming to assist in the conference; 'it's a cruelty to animals, sir, to ask 'em to do it. There's beds here, sir,' said Sam, addressing his master, 'everything clean and comfortable. Wery good little dinner, sir, they can get ready in half an hour—pair of fowls, sir, and a weal cutlet; French beans, 'taturs, tart, and tidiness. You'd better stop vere you are, sir, if I might recommend. Take adwice, sir, as the doctor said.'

The host of the Saracen's Head opportunely appeared at this moment, to confirm Mr. Weller's statement relative to the accommodations of the establishment, and to back his entreaties with a variety of dismal conjectures regarding the state of the roads, the doubt of fresh horses being to be had at the next stage, the dead certainty of its raining all night, the equally mortal certainty of its clearing up in the morning, and other topics of inducement familiar to innkeepers.

'Well,' said Mr. Pickwick; 'but I must send a letter to London by some conveyance, so that it may be delivered the very first thing in the morning, or I must go forwards at all hazards.'

The landlord smiled his delight. Nothing could be easier than for the gentleman to inclose a letter in a sheet of brown paper, and send it on, either by the mail or the night coach from Birmingham. If the gentleman were particularly anxious to have it left as soon as possible, he might write outside, 'To be delivered immediately,' which was sure to be attended to; or 'Pay the bearer half-a-crown extra for instant delivery,' which was surer still.

'Very well,' said Mr. Pickwick, 'then we will stop here.'

'Lights in the Sun, John; make up the fire; the gentlemen are wet!' cried the landlord. 'This way, gentlemen; don't trouble yourselves about the postboy now, sir. I'll send him to you when you ring for him, sir. Now, John, the candles.'

The candles were brought, the fire was stirred up, and a fresh log of wood thrown on. In ten minutes' time, a waiter was laying the cloth for dinner, the curtains were drawn, the fire was blazing brightly, and everything looked (as everything always does, in all decent English inns) as if the travellers had been expected, and their comforts prepared, for days beforehand'.

Daniel Defoe in his *A Tour thro' the Whole Island of Great Britain* (published 1724-1727) commented on his journey through the county and was particularly complimentary about Northampton and the George Inn and its founder in particular:

'The great inn at the George, the corner of the High Street, looks more like a palace

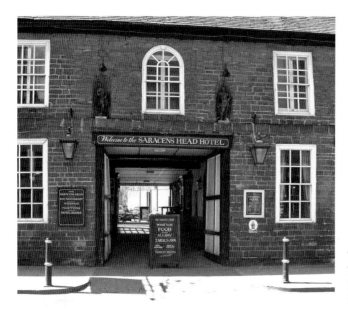

The *Saracen's Head*,
Towcester, made famous
by Charles Dickens in *The
Pickwick Papers*.

than an inn and cost above 2000L building; and so generous was the owner, that...he gives to the poor of the town.'

In 1843, a Lancashire mill owner, Sam Barford, published the two-volume 'Passages in the Life of a Radical', about his travels around much of Britain. What was unique is that he did these long-distance journeys on foot – something uncommon at the time. *En route* to London he passed through Northampton. In the second volume (chapter thirty-three) he describes his experiences in the town, at a time when troops were billeted whilst *en route* to Ireland via Liverpool:

'I scarcely knew where to apply for lodgings; there were so many snug-looking public houses that I was stuck for choice. At length I entered one of the said neat-looking places and asked a decent elderly woman if I had could have lodgings there. She frankly said at once that I could not; they were full of soldiers; and in fact, I had seen a large number on parade, as I came through the town. I asked if she could direct me to a place and she pointed to a respectable-looking house a little higher up the street. I went there, but received the same reply...I now was directed to a public house where coaching guards stopped, and where many travellers were in the habit of resting...I entered a rather handsome bar parlour where a numerous company was sitting, apparently farmers, who were taking their pipes and glasses, after the fair or market...[after the same response and scrutiny of his travel-tarnished appearance] I sat down and ale was brought and I gave it a hearty pull, and then asked for a pipe and tobacco, which were placed before me. My next order was for something to eat, intimating that a chop or a steak with a hot potato, would be preferred.

Meanwhile, I drank my ale, and called for another pint, sat smoking and chatting with the farmers in quite a comfortable way...When my supper was brought in I despatched it with hearty relish, and then having ordered some brandy and water, I called the landlady to receive my shot [bill] observing that it was time I was looking

out for lodgings, for I wished to try what fair means would do first. 'Oh,' she said, 'make yourself comfortable young man; you seem very good company, and we'll make you a bed somehow or other, you shall see. Another glass, sir, did you say?

The writer George James DeWilde, who was related to the Dicey family, that had established a printing and publishing business in Northampton and London, and co-founded the *Northampton Mercury* in the eighteenth century, came to live in Northampton. He was encouraged to write about his travels through the county and beyond, and the result was 'Rambles Roundabout' published in 1872. He gives a colourful glimpse of life in the county, the changes taking place, and a vivid contemporary description of certain hostelries, some of which have since ceased to function. The following is a charming description of one such long-defunct hostelry, the *Swan*, in the hamlet of Dodford, near Daventry:

'Even if the month were not August, and the sunshine not hot upon your back, and your walk had not been a longish one, you might be tempted to enter so clean and so secluded a resting-place, but, combining all these arguments, the invitation is irresistible. There are rooms right and left: the tap, we believe, is to the left. We turn to the right, and passing a little private parlour, enter an old-fashioned room, with seats all round, and a large, ample fire-place. A casemented window looks into a little garden that slopes upwards, and is all flowers and shrubs. , The neatness and cleanliness of the place are an example for inn-parlours. In short, the interior of 'The Swan' more than realises the promise of its exterior. If ever you relished a country crust of good bread and excellent cheese, you will relish it here, and Mr. Foster's home-brew'd does credit to the house. The Swan is just the inn for the bright summer time. The scent of flowers fills the air, and the brook babbles music as it flows. One thinks how balmy there the night air must be, and how the little rill tumbles over the miniature dam...'

Another hostelry had already succumbed to time not long before his visit was the *White Swan* at Kingsthorpe. It was a grand west-facing building that had seen much activity and patronage during the heyday of the coaching inn, but had since ceased functioning, a victim of the railway age. When he arrived it had been newly taken-over as a home by a clerk to the county magistrates, who had embellished the tree-lined grounds with greenery and roses. The former inn still had its ample bowling green, and had been renowned for its speciality cheesecakes and home-brewed 'amber' ale. Though regretting its closure, he feels there is some compensation in that the nearby *Cock Inn* was still flourishing, 'an inn to glad the Rambler's eye'. He describes its frontage covered with vine, the porch with seats and balcony above, the old-fashioned door with through – passage that afforded a glimpse of a back yard with trees and flowers, and its ample bay windows with seats.

Some of the hostelries he mentions still exist today, among them *Golden Lion* at Wellingborough, about which he takes delight in describing a low room with a ceiling of black oak and 'ponderous beams' with elaborate mouldings; an immense piece of oak timber across the fireplace; a Tudor fireplace in an upstairs room with ornamented spandrels; and the stables and granaries at the rear, with finial-crowned gables. He also visited some of the county's villages, and mentions the *Butcher's Arms* at Greens Norton:

'Nothing in the village calls for remark, except 'The Butchers Arms' which faces you as you descend the hill from the church. A pleasanter rural inn one would not desire; with a bow window commanding the street up and down, and one of those capacious old-fashioned lure-places which have seats in them, and give one the intensest [sic] idea of snugness and shelter and cosy warmth, and all that weary pedestrianism can desire in chilly weather. Grave is the mistake of landlords who, with a view to a little more room, or for the sake of being more spruce and modem, abolish these ample shelterings of our ancestors, which are none the less comfortable because the substitution of the coal fire in the grate for the wood on the hearth leaves more space for the sitters in the comers. Then, too, 'The Butcher's Arms' is as spotlessly clean as a Dutch hotel, and, as the saying is, you might eat off the slabs of its flooring. A glass of excellent ale and perfect courteousness and attention are the climax to the other merits of this agreeable halting-place.'

Another hostelry that he visited in the 1860s also still exists today: the *Chequers* at Rothersthorpe. Again he is very complimentary in general about features and service, with just one small quibble:

Perhaps the merry countenance and sufficient proportions of mine host of the Chequers is suggestive of it. No true rambler is exacting in the matter of his inn accommodation. So that the interior is clean, and the hostess good-humoured, and the host wears a proper host's welcome in his visage, almost any modest refreshment will pass. One objects only to a room that is at once very new, very formal, very bare, and very pretentious, with nothing to support its pretence. Rusticity and antiquity, the older and the more rustic the better, are sure to content us. Give us a room so old that we can people it with guests of past generations, and link it with some point of historical interest, and we care not how humble its present estate may be... it is a pleasant place to dream in and to bring before us the 'forefathers of the hamlet' for generations gone by. Its exterior shows a rambling thatched cottage, which is approached through a sort of fore-court, partaking of the character of a stair yard. On the right is a cow-house; on the left some excellent pig-sties. A pebbled pathway leads to the inn door, which has a wicket before it, to protect it, we suppose, from possible invasions of the denizens of the straw-yard. Lift the latch of the door on the left within the wicket, and you will find yourself in a room decidedly of other days, a 'settle', which gives an air of snugness to its huge fire-place. The chimney-piece is of black oak, and low enough to make you cautious how you lift your head when you pass under it. The 'chimney-corner' of the cosy comforts of which we know rather in books than in reality, is here before us, though one is apt to think it might have been pleasanter when wood was burnt on this hearth than now that coal feeds the gate. The windows are deeply recessed in the thick walls, and the shutter loops up to the ceiling, the black oaken rafters of which are crossed with bars to hold in the bacon. Artists love such "interiors"; and think how the Dutch masters would have treated them, and how surely, if some of our living good men and true were to drop in here, they would turn the scene to account...'

In 1957, Joan Wake, editor of *Northamptonshire Past and Present*, asked the former editor of the *Northampton Mercury*, William Hadley who was ninety-one years old at the time, if he would write a feature about his early life as a young reporter in the 1880s and 1890s. He obliged by writing a lengthy piece which included his stay at various

places whilst covering certain events. Amongst them was a sojourn at an un-named hostelry in Kingscliffe, at which he had a pleasant surprise:

'In Kingscliffe, at the eastern end of the old Rockingham Forest, I found a charming inn, though it did not look like one. There I was given a simple but delightful supper, a cosy spotless bedroom, and a substantial breakfast. In reply to my inquiry of payment, the old landlady hoped that half a crown might not be too much! That was exceptional of course. A good country hotel usually charged 5/6d for bed and breakfast...'

In the later years of the eighteenth century, a pioneering agriculturalist from Wolverhampton, William Pitt (not to be confused with the prime minister of that name) had experimented with mangolds as cattle food, developed new ways of sowing and of harvesting crops with mechanisation, and improved the fertility and productivity of his fields by liming and marling them. Following these successes, he embarked on a series of travels during the early years of the following century to view the farming landscape of other counties, whilst simultaneously taking note of local building materials. In his 'General View of Agriculture in the county of Northamptonshire for consideration of the Board of Agricultural and National Improvement (1813), he refers to 'respectable' inns, among them a description of the *Swan* on the turnpike road at Lamport:

'The Swan inn, Lamport, which contains several decent parlours, and furnishes tea, coffee, spirits, or wine as well as good lodging, stabling, post-horses and chaises, to the travelling customer, and where a very respectable agricultural society holds its meetings, is covered with thatch; however, in the better and more modern houses, stone walls and slated roofs are become more general...'

The great Northamptonshire poet, John Clare, was born in a thatched cottage next door to the *Blue Bell* in Helpston (now in Cambridgeshire). His father, Parker, had a great knowledge of ballads and folk songs which he would sing regularly in the bar. John himself worked in the pub in 1806 as a pot-boy, collecting, emptying and washing drinking vessels, and acting as horse boy collecting grain etc, for the landlord, Francis Gregory, at the age of thirteen. He was also billeted whilst in the militia in Oundle for a short period in 1812 where he was a frequent visitor to the *Rose & Crown*. In his writings he later recalled a conversation he and his friends had with the 'alewife' of the *Exeter Arms*, after they had all seen will o' the wisps in the neighbourhood. She asserted she had seen as many as fifteen 'in and out in a company as if dancing reels and dances'. One hopes that drink was not the cause of such sightings!

It is little wonder then that some of his poetry, like 'The Drinking Song' (written in Northampton in the 1850s) would be concerned with ale and hostelries. The following poem is entitled 'The Toper's Rant', written at Helpstone between 1821 and 1824, about a protracted epic binge with any suitable like-minded companion, and extolling the virtues of honest English ale, whilst being dismissive of wine:

'Give me an old crone of a fellow
Who loves to drink ale in a horn,
And sing racy songs when he's mellow,
Which topers sung ere he was born.

For such a friend fate shall be thanked
And, line but our pockets with brass,
We'd sooner suck ale through a blanket
Than thimbles of wine from a glass.

Away with your proud thimble-glasses
Of wine foreign nations supply,
A toper ne'er drinks to the lasses
O'er a draught scarce enough for a fly.
Club me with the hedger and ditcher
Or beggar that makes his own horn,
To join o'er an old gallon pitcher
Foaming over with the essence of corn.

I care not with whom I get tipsy
Or where with brown stout I regale,
I'll weather the storm with a gipsy
If he be a lover of ale.
I'll weather the toughest storm weary
Altho' I get wet to the skin,
For my outside I never need fear me
While warm with real stingo within.

We'll sit till the bushes are dropping
Like the spout of a watering pan,
And till the cag's drained there's no stopping,
We'll keep up the ring to a man.
We'll sit till Dame Nature is feeling
The breath of our stingo so warm,
And bushes and trees begin reeling
In our eyes like to ships in a storm.

We'll start it three hours before seven,
When larks wake the morning to dance,
And we'll stand it till night's black eleven,
When witches ride over to France;
And we'll sit it in spite of the weather
Till we tumble dead drunk on the plain,
When the morning shall find us together,
All willing to stand it again.'

Finally, here is a local saying current around the Wilbarston area in the early years of
the twentieth century:

'Put four men round a barrel of beer, they'll talk more work than they'll do in a year; put
four women around four cups of tea, they'll talk more scandal than you'll ever hear'.

OLD NORTHAMPTON

As the town of Northampton grew in population, affluence and importance through the ages, the number of hostelries increased to cater for, and reflect, that growth and the various functions performed within its precincts.

There would of course have been hostelries from ancient times but the earliest recorded by name appeared in a rent document for 1504 (forming part of the Andrews MSS, in Northampton Corporation Records) being the Angel, le Bell, le Crown, le Tabard, le Bulle, le Swan, le Fawkon, and le Hart. The Checker was first recorded in 1570 (though the name itself had been applied to what is now the Market Square in the fourteenth century), whilst at Peterborough it was recorded even earlier, in 1390.

By 1585, the following inns were in existence in Northampton, and brewing their own beer: The *Talbot* and the *Peacock* (in the Market Square), *Sallet* (Cow Lane), *Lion* (The Drapery), *Swan* (The Drapery), *George* (George's Row), *Bull* (George's Row), *Green Dragon* (Bearward Street), *Angel* (Bridge Street), *Bell* (Bridge Street), *Dolphin* (Gold Street), *Katherine Wheel* (Gold Street), and the *Bantam Cock* (Abington Square).

Merchants and artisans established themselves in clusters around the market square area, giving their names to the Tailory, Fullers Street, Weavers Street, Woolmongers Street, Wimplers Row, Mercers Row, Glovers Row, Retailers Row, Barbers Row, Shoemakers Street/Cobblers Row, Potters Hill, Cooks Row, Malt Row, Cornmongers Row, and there was Bakers Hill, Butchers Row, Fishers Row, Barley Hill, Gold Street, Sheep Street, and Horse Market.

In addition to these hives of activity, and the weekly market, there were, by 1599, seven annual fairs, each lasting three days, in September, November, December, March, April, July and August, (with six more fairs being added by 1849).

At the time of the Restoration, Northampton had forty or so hostelries, rising to sixty in the second quarter of the next century as the town grew in importance and status.

It is no wonder therefore that such a flourishing town needed a great deal of refreshment, and by the eighteenth century several hostelries were in existence, the most notable of which are listed here as follows.

A stone tablet on the wall of the former *Black Lion*, now the *Wig and Pen*, St Giles Street, Northampton.

Abington Street:

The *Chequer Inn* was situated at the bottom of Abington Street, opposite what was the old town hall. It gave its name to the old Chequer Ward of the town, covering a large area including the Drapery, the Parade and Market Square, for land tax assessment purposes. As its name implies and in line with other hostelries of similar name in the realm, it had an early association with accounting, a kind of exchequer, where taxes and tolls were levied on goods or other items. It is recorded in 1676, following the Great Fire, as '*The Chequer lying neere vnto a place there called Newland*' in the 'Book of Records of the Commissioners Applications by Act of Parliament for the better and more easy Rebuilding of the Town of Northampton'.

In addition to its original role, it had several rooms, one acting as a place of storage for cheeses, or 'a place for Wild Beasts to be in'. It was also, at various times, the home of a shoemaker, and a whitawer (a curer of skins for glove-making) and his family.

The *Saracen's Head*. In the eighteenth century this inn played an important role in the town as a place of audit for the Duchy of Lancaster for rents and arrears; as the 'Post-Office'; and as a centre for political and social gatherings, who made use of its large assembly room. It stood on the south side of the street at the western end.

Like many of the other hostelries, it acted as a trading or consultancy point for various professionals and those of other occupations. One such person was a London 'silk-dyer', Edward Thorne, who in 1745, offered the following service for goods requiring attention to be sent to the inn for forwarding to him for carrying out the necessary work. He stated that he:

'scours all Sorts of rich Brocaded Silks, of Gold and Silver, and all other Colours, after the best Method; likewise Velvets, Damasks, Tabbies, Ducapees, Plain and Flower'd Sattins or Lute-strings, and all Sorts of Silks scour'd or dy'd to the best Perfection, likewise...all sorts of Stuffs and Houshold [sic] Furniture, Wrought Beds, Tapestry and Blankets etc. done at the lowest Price...'

The hostelry was described in an advertisement of October 1753, when it was offered for letting by the present landlord, Richard Morris, as 'being an old and good-accustomed Inn, standing near the Market-Place, and in the Stamford, Peterborough and Cambridge Road; it is a very commodious House, with good Cellars and Stabling for near 150 Horses...'. In 1859, the licence was transferred to a new premises on the corner of Lawrence Street, but within a year it became a Temperance Hotel.

The *Catherine Wheel* (one of two so-named, the other being in Gold Street), stood on the north side of Abington Street. This was a typical town hostelry used as a place of auction, such as that in August 1753, when 'an ass and foal, newly milch'd and just five weeks old' were offered for sale.

The *Stag's Head* stood on the north side of the street, within fifty yards of the Market Square, and the old post office. It was a large hostelry (some 8,800 square feet) as recorded in an advertisement for its sale in 1890, including 'a yard, ten loose boxes, additional stabling for twenty horses, two covered carriage sheds, lofts, a saddle room, brew house and other items. It sold for six thousand pounds.

The *Vine* stood on the south side of the street. It was a smaller hostelry, or beerhouse, that had switched from its original location, with its name, to the house next door

(which had been an unnamed hostelry) in 1830.

The *Cock Inn* was situated on the corner of Wood Street. The street had gone under various other names through time, variously White Friars Lane, St Michael's Lane and Cock Lane, after the name of the inn. It was subsequently changed to Wood Street (presumably because of sawmills operating in the vicinity) after a tragic incident involving a young apprentice who had been grossly mistreated and starved by his master who was located there. The boy ultimately succumbed and after his master disposed of the body, tales of the street being haunted became widespread.

The *White Lion* was one of the great coaching inns of the town. A typical advertisement from November 1728 for its services ran: 'The Northampton Waggon sets out from the Whyte-Lyon every Monday about Twelve a-clock to Smithfield Ram Inn, and returns every Thursday. Passengers are taken and Parcels received.'

Before the Great Fire, it was famed for its extensive wine cellars, stretching underground from Abington Street to Dychurch Lane, many of which remained well into the nineteenth century. It also stored other alcoholic drinks. This advertisement from June 1745 refers to Henry Sims, a cider maker from Braybrooke, who plied his trade from there, offering tastings and items for purchase:

> '[from] the Cyder Vault at the White Lion, at the Back Gate in Dye-Church Lane in Northampton, a large Quantity of Cyder of Beverage Sorts viz. Rough, Smooth and Redstreak, both old and new, neat and of great Body, also Cyder Royal. Attendance there on Market and Fair Days, from Ten in the morning till Four in the Afternoon'.

Also facing the street (north side, top end, by Abington Square) is the former *Bantam Cock* among the oldest surviving buildings, escaping the Great Fire of 1675, and supposedly built on the site of an unnamed hostelry that existed in 1486, was one of only four still thatched in the town at the time of a survey carried out in the late 1880s, and last port of call for the condemned on their way to Abington Gallows. Also in the vicinity were the *Hen and Chickens*; and the *Two Brewers*.

The Market Square:

> The *Shoulder of Mutton* stood on the west side of Market Square, known as 'the Barley-Hill'. The first recorded reference to the hostelry was in June 1745, when an advertisement appeared in the *Northampton Mercury* on behalf of Richard Woolley, landlord and local musician, who intended setting up a booth at the annual midsummer fair at Boughton Green 'to acquaint all Gentlemen, Ladies and Others, that they may depend on very good Usage as well as Eating and Drinking; and the Favour of their Company will be most thankfully acknowledg'd...NB. Neat Wines will be sold there. And for the Sign, there will be a French Horn at each End of the Booth.'

The demise of the hostelry came in Feb 1792, when a disastrous and tragic fire broke out in which lives were lost and other buildings in the vicinity narrowly averted the same fate. A description later appeared in a tract 'Relations of Remarkable Fires in Northamptonshire, from the eleventh to the eighteenth centuries' edited and published by the Northampton printer and antiquarian, John Taylor, in 1866:

'Soon after one o'clock, a person in the neighbourhood discovered the flames issuing from the cellar window and immediately gave the alarm; but before the family could be apprised of their danger, the fire had got to an alarming height, the floors, staircase, etc being principally of deal. The master of the house however, rushed down stairs and having opened the street door, returned in order to rescue his family; but such was the fury of the flames, he was not able to effect it, being himself under the necessity of escaping out of the garret window, over the roofs of the adjoining houses. By the time a ladder could be procured, it was too late to render the unfortunate sufferers any assistance; and dreadful to relate, Mrs Marriott, the mistress of the house, together with five of her children, the eldest being about twelve years old, also two lodgers, a Journeyman hat-maker and his wife, perished in the flames, Mr Marriott, the landlord being the only person, out of nine, who escaped...'.

It subsequently emerged that a beam had penetrated the flue of the brewing copper and ignited, the flames spreading to the floor above; and that the hostelry had not been insured, the only salvageable item being the beer which had been untouched. Shortly afterwards, the inn was rebuilt and aptly renamed, the *Phoenix*.

The *Talbot* was one of the great inns of Northampton, which had originally been destroyed (like the *Hind*, the *George* and six hundred other buildings) during the Great Fire which had broken out at noon on the 20 Sept 1675, in the cottage of a poor woman in St Mary's Street. The fire was fanned by a strong west wind which blew the flames towards some of the adjoining thatched buildings, whereupon it spread towards the rear of the Horsemarket, on to Derngate, almost half a mile away from where the fire had started. It was subsequently rebuilt on its original site close to the junction with Sheep Street.

A notice was placed in the *Northampton Mercury* in 1723, by Thomas Miller, the landlord, offering a reward for the whereabouts or apprehension of one of his employees who had absconded with various items and more, with the following description and details:

'...a short thick Fellow, about 24 or 25 years old, of a round bluff Face, of a wan complexion, short thick brown Hair...ran away on Sunday morning from his Master Thomas Miller, at the Talbot Inn, and carried off some Money, and several other Things of Value, has also inveigled and carried away with him, John Tilley, a young Lad about 14 Years of Age, of a fresh Complexion, with lank light Hair...has a Cut newly-done, on the Forefinger of his Right hand: They took with them also a thick, short mungrel [sic] dark brown Dog, with a short Tail and Legs; and a little smooth Bitch, with Liver-Colour and white Spots...'

The inn passed through a number of hands, and like all hostelries being let, was advertised with as much appeal as possible, in the *Northampton Mercury*, one such occasion being in February 1749:

'To be Lett at Lady Day, Midsummer or St Michaels, or directly if required. A Good Accustomed Inn...known by the name of the Talbot, and all the House Goods, Brewing Vessels and a good Rick of Hay, to be sold to the Person that takes the Inn, at reasonable Prices, the present occupier being to leave off the business.'

The *Cooks Arms* stood on the south side of the square, at the north east corner of 'Bakers Hill', and had old vaulted cellars which extended thirty feet under the Market Hill. It ceased to be a hostelry in 1835 after which Waterloo House was built on the site (which was recorded as 'a space for three houses').

The *Peacock Inn* was rebuilt at least once, on the same site on the east side of the square 'upon the Market Hall'. This was another of the hostelries popular for political meetings, being the preferred choice of the Whigs in the eighteenth century, especially at the time of elections. It was also a venue for visitors offering specialist services, one being a 'Mr Grant, Her Majesty's Occulist Extraordinary' who advertised himself during one visit as having:

'performed several Operations relating to the Eyes with such success, that he has brought several People who were blind to sight in this Town and neighbouring villages...he is now at the Peacock where he proposes to continue for three weeks, or longer, if desir'd.'

The *Spread Eagle,* like the *Peacock,* seems to have been a favourite place in the town for visiting specialist tradesmen or professionals. The years 1720-1722 seem to have been particularly busy, among them a 'rupture master' demonstrating a new invention for both men and women, whilst offering a bond to anyone who doubts the efficacy of his 'cure'. A horticulturalist advertised in the *Northampton Mercury* in 1722:

'This is to give Notice to all Gentlemen and Others, of a large Quantity of Pine Stand Limes or Hedge Limes. All sorts of Wall Fruit Trees, of the best sort, that are grafted or budded. Also finest Apples, Cherries, Dwarf Apples for espallers [sic] of the Pest. Sorts of Winter Table Fruits, likewise all sorts of Garden Seeds. Note these will be sold at very moderate Prices...'

The *Golden Ball,* like the *White Lion* and *Hind,* played host to travelling theatres. At one time it was run by Joseph Satchell, who also traded as a milliner as well as offering 'paper hanging to match furniture'. However, by 1756, he had found, like many others, that 'keeping a Publick House was detrimental' to his other trade, announcing that year that he was going to concentrate solely on his millinery business. (Other proprietors in the town however would move on from one hostelry to another, such as John Holton of the *'Phenix'* who around 1825 took over the *Hare and Hounds* in Newland; and William Astley who before 1725 kept the 'tap' at the *Peacock Inn,* and then the *Bull and Goat* in Gold Street).

Gold Street:

The *Catherine Wheel* was another of the great coaching inns, not to be confused with the hostelry of the same name in Abington Street. In December, 1773 Northampton Stage Coaches advertised its passenger and goods tariff to London from the Catherine Wheel as follows: (for inside the coach) 'fourteen shillings per passenger and seven shillings for children sitting on the lap. Outside passengers, seven shillings. Parcels not belonging to passengers sixpence to one shilling, plus extra above twelve pounds in weight. Venison parcels could be carried at a penny per pound. Other coaches available 'to anywhere in England from the George and Red Lyon Inns'.

Also recorded in Gold Street were the *Blue Boar* and the *Dolphin*.

Other streets:

The *Star* stood on the corner of Dychurch Lane: and was described in 1679, four years after the Great fire as follows:

> 'The West part of the said Inn was formerly a messuage or tenement and bakehouse with backside and gardens called Saunders, his land and lately laid to the said Inn for inlarging [sic] the yard and building stables for the helpe and advantage of the said Inn. All which stables built upon the said Saunders his land and part of the said Tenement were burnt down and demolished by the late dreadful fire...'

For most of the seventeenth century and the early years of the eighteenth it was the centre of the town's leather trade, where tanners would take goods for sale. When it finally closed as an inn in 1723 (being occupied thereafter by a maltster and a farmer), it received the following historical notice in the *Northampton Mercury*:

> '(it) hath always been the accustomed place for Tanners to bring their Leather for Sale; and that Inn now being dispos'd of, these are to give Notice to all Tanners, That at a General Meeting of the Shoemakers and Curriers of the said Town, it is desired for them to bring their Leather, at Fairs and all other Times, to the Market-Hill, it being the usual Place where they bring it on St George's Fair, and on the Fair the 8th of September, being agreed on as the most proper and convenient Place for the Traders therein.'

The *Hind* stood in The Parade, 'near the Corn Exchange'. This was a large inn catering for all kinds of functions, being known before the Great Fire, as the Hynde. It acted as a playhouse where in January 1724, there were performances of a popular 'The Spanish Fryar or the Double Discovery', followed by Shakespeare's Hamlet the following month. In addition to being a place of grand balls, auction and trade, it hosted 'trials of skill' on at least two occasions, the first being in December 1721, after a challenge had been made by one Robert Blake, who designated himself 'Master of the Noble Science of Defence', who invited anyone to meet him and 'exercise the Quarter-staff, Sword and Buckler, Sword and Dagger and Back Sword'. The challenge was taken up by a local man, William Flanders of Potterspury, 'Master of the said Science' who stated in his response that he would 'meet this bold inviter at the Time and Place appointed, desiring clear Stage, sharp Swords... from him no Favours but to give all Gentlemen satisfaction'. Another such challenge took place between different men in September of the following year.

In 1747 it was recorded as 'a well-accustomed Coaching-Inn for the Market, Travelling and Town Business, with Back Passage and Gates opening into Sheep Street, with a piece of Land formerly used as a Bowling Green'.

The *George* (in George Row) was rebuilt after the Great Fire, by a member of the illustrious county family, John Dryden of Canons Ashby (1641-1707), MP for Huntingdon, and a relative of the eponymous nationally acclaimed playwright and poet laureate. In the *Gentleman's Magazine*, vol ii, 1791, there was a feature on its subsequent history, focussing on a white marble tablet at the base of the building with an inscription in Latin extolling the virtues of its benefactor, part of which in translation

adds: '(he) built this magnificent Inn which you see for an ornament and beauty of his native county, at great cost immediately after the fire, and in the year 1707 piously bequeathed it to found, by an example, to be desire a school for the poor'. [In other words, profits made by the inn were to be used for the foundation of a school]. This was subsequently carried out in the terms of his will. The inn was later sold by the trustees for £1500 to a 'tontine' company (one which operated an annuity scheme shared by subscribers, whose shares increased, with ultimate benefits for those concerned – a form of investment). The site is now occupied by Lloyds Bank.

The *Red Lion,* a coaching inn, stood in Sheep Street and was one of the main venues for political meetings and banquets. One landlord, Peter Peirce, who left to run the nearby smaller *Blue Boar* seems to have had regrets and proposed to reverse his decision, as this advertisement from a 1764 edition of the *Mercury* shows:

'As I some Time since proposed to quit the Red Lyon...and to that Purpose, had taken the Blue Boar on the Market Hill in the said Town, the Notion of which has been very detrimental; obliges me to take this publick Method to assure all Gentlemen, Others, etc that I have entirely quitted the Blue Boar to continue at the Red Lyon, where all such, who please to favour me with their custom, may depend on the best Accommodations and their Favours will be gratefully acknowledged...'

The *Angel* flourished as a large coaching inn, with a lucrative trade, being ideally situated at a strategically important part of the town in Bridge Street, close to the Nene, which is now part of the All Saints Conservation Area. It has long ceased trading as a hostelry, being currently occupied by a café and bar and other businesses. Like its contemporaries around the Market Square area, it also acted as a venue for important meetings such as that which was advertised in the *Mercury*, in February 1794 'for the prosecution of felons':

'Whereas it hath been proposed and agreed to re-establish a Society in the Town of Northampton, for the Prosecuteing [sic] of Horse and Sheep Stealers, and Felons and Thieves of every Denomination, in the Town and in the County of Northampton: The Proprietors and Occupiers of Houses, Lands, and Estates in the said Town and County, are therefore requested to meet at the Angel Inn, in the Town of Northampton on Saturday the 1st Day of March next at two o' Clock in the Afternoon, to consider of, and adopt Rules for the Regulating of the said Society, and to enter into a Subscription for supporting the same.'

Other hostelries recorded in the eighteenth century include the *Three Tuns*, in the Drapery; the *Harp* in Castle Street; the *Queens Dragoons* in Mercers Row; the *Crown* in Drury Lane; the *Plumbers Arms* in Sheep Street; and in Bridge Street, the *Eagle and Child* and the *Waggon and Horses*. Kings Head Lane is a reminder of the hostelry that once stood in the vicinity.

Little is known about The *Flying Horse* or its exact location. It may have however have been connected with the Flying Coach Company, rather than being a heraldic symbol, once adopted by the Knights Templar. The *Trooper* which is believed to have stood in the Market Square, had originally been the *White Hart* before 1750, and subsequently became the *Mail Coach*.

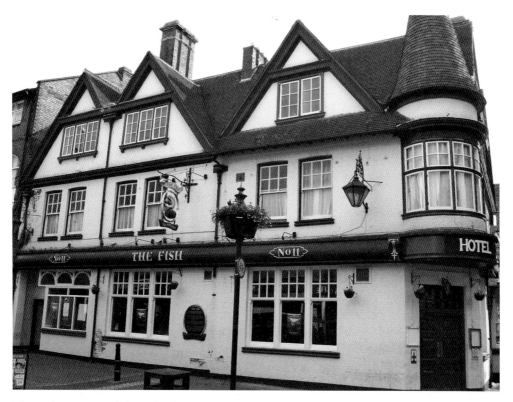

The *Fish Inn*, one of the only three surviving old hostelries in Northampton, all of which have since been rebuilt.

Needless to say, as the town developed and gained a substantial population, the number of pubs rose dramatically. By 1849 there were seventy one hostelries in the town, together with ninety one beer retailers. In 1849, at Bridge Street alone there were fourteen trading: *the Angel, Waggon and Horses, Warwick Arms, Half Moon, Lion and Lamb, Magpie, Pheasant, Bull and Butcher, Bell, Crown and Anchor, Eagle and Child, Fleece, Spread Eagle and Woolpack*, whilst Gold Street had the *Queen's Head, Crow and Horseshoe, Dolphin, Goat, Swan and Helmet, and the Rose and Crown*. By 1874, the number of hostelries has risen further to seventy four, with an astonishing two hundred and three beer retailers. Among these was the *Black Lion* in St Giles Street, and *Old Black Lion* next to the church of St Peter, on what is now called Black Lion Hill. Similarly there was the *Old White Hart* at Cotton End and a *White Hart* in the Drapery. In 1880 an incredible ninety hostelries were recorded within a square mile of the Northampton Boroughs alone.

The only survivors of the original hostelries today (all rebuilt) are the *Fish*, the *Bear*, the *Racehorse* and the *Bantam Cock* which, after undergoing name changes, has been modernised as a theme pub and is currently known as the *Bantam*. The *Old Black Lion* also still exists, in altered form, close to the railway station.

'PUBUTOPIA':
Names Old and New,
Origins and Meanings

There is a great deal of speculation and mythology about the origin of certain hostelry names: many are not as old as they seem – whilst the images themselves did originate in the medieval period, it was hundreds of years later that many of them came to be applied to hostelry names.

The earliest recorded signs anywhere are the *George* (1369), *Sun* (1374), *Tabard* (1384), *New Inn* (1397), followed by the *Chequer* (c.1400), *Bell* (1403), *Hind* (1420), *Swan* (1446), *Angel* (1458), *Star* (1462), *Saracen's Head* (1461), Hart (1463), *Crown* (1465), *Antelope* (1494), Bull (1494), *Talbot* (1494) and *Peacock* (1495). It is interesting to make a comparison with Northamptonshire, where the earliest *named* hostelries are in most cases recorded later: the *Tabard* at Towcester in 1446, the *Swan* at Oundle (1471), the *Angel* at Northampton* in 1504, *le Cocke* at Rothwell (1535), the '*Antyloppe*' at Brackley (1536), the *Checker* at Northampton in 1540, whilst at Oundle in 1565, six hostelries are recorded: *le Bull, le Lyon, Tabret, Crown,* '*Harts Head*', and again, the *Swan*. (*Two earlier un-named hostelries where the *Peacock* and *Bantam Cock* would later be sited were recorded in Northampton in 1456 and 1486 respectively).

Of the above names, five are worth looking at briefly. The *Tabard* is a reference to the surcoat worn by medieval heralds, depicting a manorial coat of arms. The earliest inn of that name in the county was in Oundle (as listed above) which subsequently changed its name to the *Talbot*, and still exists today. The *Tabret* was named after a small, brightly-painted and decorated drum of some antiquity. The *George* appears as a result of St George being adopted as the new patron saint of England (replacing St Edmund) during the reign of Edward III, after the introduction of the Order of the Garter in 1350. This is discussed further in the heraldic section below. Many years later this would become even more common after the first of four Hanoverian kings with that name came to the throne during the eighteenth and nineteenth centuries. The *New Inn* would have become very widespread when a new hostelry opened for business where another (or others) already existed. The most intriguing however is the *Chequer*. Note the name does not have a letter '*s*' at the end (the plural form only appeared surprisingly late – in the early nineteenth century – therefore is not so ancient as some sources have asserted). It seems to have derived in market towns such as Northampton and Peterborough, where a local exchequer was established to exact

tolls or duties on goods, or rents were paid. It was perhaps only natural for such a place (or another in the vicinity) to take on the name (minus the '*ex*') as a hostelry, carrying out both functions. The later form, *Chequers,* would be of a different origin – a chequered board such as that used in chess and other games – a striking visual image, that has its origins in ancient times, the Romans supposedly using it as a tavern sign. This meaning and another possibility are discussed in this chapter under 'Special Signs'.

Because the images were of a basic design and had such visual impact, being easily recognised and understood by the illiterate majority, it was only natural that they would eventually be used by tradespeople, above all innkeepers and alehouse victuallers. To attract custom, it was necessary to display them prominently. However, as competition increased, they became so numerous in towns like London and Norwich, obscuring the view and causing some obstruction, that a law was brought in by Edward III stating that all sign had to be at least seven feet above the ground. This did not help matters in 1393 when another law came out (in London) ordering all inns to have a sign. In the Elizabethan era, there was a fashion for stone or ceramic plaque/tablets affixed or slightly protruding from a wall, some having a niche, which gave a church-like appearance. After the Great Fire in 1666, a board hanging from a post, either fixed or swinging, became the favoured method of display for many hostelries. At the same time, the gallows sign, stretching across a road from one side to the other, became the favoured sign of inns. Some of these could be costly and over-elaborate the most famous or infamous being that of the *White Hart* at Scole in Norfolk, costing a thousand pounds, depicting carved wooden figures from mythology, Jonah and the whale, an astronomer seated on a globe, and a large hart. Some of these were so heavy, they could and did fall, causing injury or death, leading to new legislation in 1667 forbidding signs to be stretched across the road, but to be suspended from a post, balcony, or wall. Anyone ignoring the new law was to pay a forty shilling fine. This seems to have lapsed for as the coaching era dawned, the signs multiplied, albeit in a more secure, lighter form. Interestingly, in the second year of George III's reign (1761), hostelries were exempted from an Act which banned shops and tradesmen from using swinging signboards. Some hostelries came up with novelty ideas, like life-size statues, or 'live signs' like the sixteenth-century *Beehive* at Grantham (which still has a symbolic hive outside) and in the early twentieth century a topiary (box tree) 'green man' at Marholm, now under the unitary authority of Peterborough, became a symbol of the village (though the pub is officially the *Fitzwilliam Arms*), appearing also on the village sign and giving its name to an adjoining side road, Green Man Lane.

In some of the smaller villages, a number of hostelries were recorded as 'unnamed', as was the case in Glapthorn and Southwick in the 1793 Alehouse Recognizances, and Weekley in the 1796 listings. Perhaps because of the size and familiarity of a place, a name was not always considered necessary.

The most popular sign in the county was the *Red Lion* with thirty recorded names, followed by the *Royal Oak* with twenty three, *Plough* with eighteen and the *Horseshoe/ Three Horseshoes* with a combined total of eighteen; thereafter, the *Swan*, which with the *White Swan,* and *Black* Swan, constituted a combined total of sixteen; the *White Hart* and *White Horse* each with fifteen, the *Fox and Hounds* with fourteen, and the *George* and *Queen's Head* with thirteen.

A great number of signs seem to be of ancient origin, but this is not the case. Many appear for the first time in the nineteenth century like the *George and Dragon*, the *Fox*

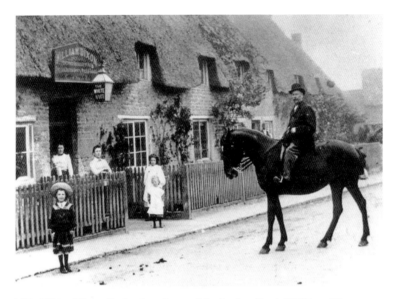

The *White Hart*, Corby in 1892, with the landlord, William Dixon, on horseback.

and Hounds and the *Plough*, whilst several others continued the heraldic tradition, by using ancient motifs for greater impact or prestige.

In other cases, there was a tendency to add a prefix to an existing hostelry: as early as the mid-seventeenth century, a colour was being added to names with heraldic origins, like the *Black Horse, Blue Bell*, and the *Golden Ball* (the roundel), though the *Blue Ball* (as at Potterspury) may be a corruption of the *Blue Bell*. 'Old' was already being added to names during the early eighteenth century, probably to give a touch of antiquity, quaintness and prestige, and in the 1800s there was a custom of extending the traditional 'three' into further 'multiples' such as 'six' or 'eight' – when used with bells such as the *Six Bells* (Sulgrave and Glinton) this is *usually* a reference to the number of bells in the tower before they were recast, newly hung, or with additions being installed during church restoration, a great deal of which happened during the Victorian 'Gothic Revival'. Other examples: the *Five Bells* (Hardingstone, and Middleton Cheney), the *Old Five Bells* at Kingsthorpe, and the *Eight Bells* at Corby and Desborough.

A number of hostelry names had their origins inside the larger inns or taverns themselves, during the Tudor and Stuart era, where individual chambers or rooms had their own specific appellations, such as the 'Peacock', 'Half Moon' and 'Wild Man'. Some of the great houses of the county also adopted a similar practice, such as Great Oakley Hall where rooms were named after specific colours: the Blue Room, Yellow Room and Green Room. This process continues today where conference or meeting rooms are named after renowned people, a locality or have a particular theme.

Sometimes two neighbouring hostelries would merge, by agreement – or perhaps reluctantly in some cases – between two competing victuallers. In other cases someone running a hostelry under a certain name, may have later moved into another one, and combined the two names. These changes would be reflected in names such as the *Swan and Dolphin* (Rushden), *George and Angel, Bull and Dolphin* (both in Peterborough),

Crown and Boot (Clipston), and *Plough and Bell* (Daventry), to name just a few. In other cases however, such combinations may have been purely discretionary on the part of the victualler, perhaps wanting something a little more unusual, such as the *Black Boy and Still* (Northampton), or *Salmon and Compasses* (Peterborough).

It is usually convenient to group hostelry signs into specific categories as has been the case in this book. Listed here are those that have appeared in Northamptonshire at one time or another, but mainly came into being before the twentieth century. It must be borne in mind however that some names can fall into more than one category and these appear as such in the relevant sections.

HERALDIC ORIGINS

These images were depicted either as badges, charges/devices, crests, or supporters on family and royal coat of arms. In most cases, they would have been chosen as a symbol of some kind of virtue or trait, such as power, strength, or adversity, as would have been needed in battle. Many originated from the time of the Crusades (1095-1270), or later conflicts, as a means of identification by knights on the battlefield. Several images were influenced by what they had seen during their travels and subsequently brought back to England, along with ideas for sculpture and architecture, much of which was influenced by Islam. Other images would have been taken from ancient mythology and medieval bestiaries. Thereafter, these became part of the coat of arms of each family and used by their descendants.

The *Lion, Red/White/Golden/Black Lion, Hart/Hart's Head/White Hart, Hind, Stag/ Stag's Head, Roebuck, Antelope, Reindeer, Boar's Head/Blue Boar, White/Black Horse, Flying Horse, Phoenix, Griffin, Green Dragon, Unicorn, George and Dragon, Fleur de Lys, Anchor, Blackamoor's Head/Turk's Head/Saracen's Head, Wild Man, Boy's Head, Sun/Rising Sun, Star, Half Moon, Globe, Bell, Swan, Swan and Helmet, Spread Eagle, Magpie, Falcon, Talbot, Three Crowns, Vine, Artichoke, Tabard.*

Certain charges would come to be identified with important people like John of Gaunt who had adopted the *Red Lion* as his armorial device, though its use as a hostelry sign would not appear until 1637, during the Stuart era, having first appeared on the royal coat of arms when James VI of Scotland became James I of England in 1603. This would subsequently become the most common hostelry sign in Northamptonshire and England. The *Fleur de Lys*, whilst not a common hostelry sign was, as the wording implies, of French derivation, first appearing on the French royal coat of arms in the twelfth century, and means 'flower of the lily'. Edward III (1327-1377) had laid claim to the throne of that country during his reign, and it remained on the English royal coat of arms until 1801, when the Act of Union, uniting the kingdoms of Great Britain and Ireland, came into being. It appeared under that name at Kettering, and at Oundle and Woodford Halse as the *Flower de Luce*.

Other charges connected with monarchs include the *White Hart* adopted by Richard II (1377-1399), and the *White Lion* by Edward IV (1442-1483). However, both only began to appear as hostelry names in later years, the former in 1492 (at Bristol) and the latter in 1512. The *Falcon* was associated with Richard III who was born at Fotheringhay in October 1452. Significantly, the surviving hostelry in the village still trades under that name today. At one time, the sign was also found around the county at

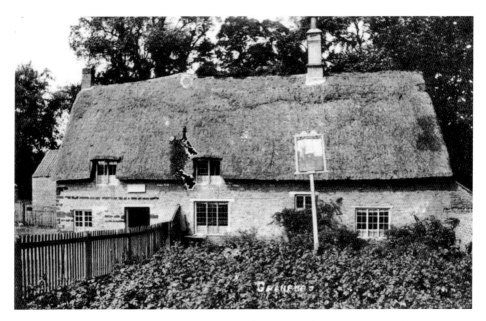

The former seventeenth-century *Stag* at Cranford St Andrew, 1870, which is now two dwellings.

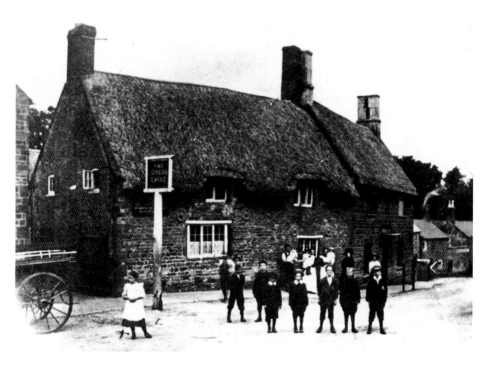

Now rebuilt, the *Spread Eagle* in Cottingham is seen here, *c.* 1912. It was one of five hostelries originally serving the village.

Cosgrove, Kettering, Old Stratford, Oundle, Passenham, Peterborough and Woodford; it still exists however, at Castle Ashby.

The *White Horse* is a relatively late sign, being the charge of the Hanoverian kings, beginning with George I (1714-1727). The image was also placed on a red background, and added to the royal coat of arms, some examples of which can still be found in various churches around the realm, including Northamptonshire, at Lowick, Aldwincle All Saints, Rothwell, Wadenhoe, Greens Norton, Lamport, Fotheringhay, Blisworth, Pattishall and Easton Neston. In some ways however it is a continuation of the German link with England, hundreds of years earlier with the arrival of the Angles and Saxons, who also used the same device. Whatever the case, it was extremely popular as a hostelry sign in Northamptonshire, as the fifteen known examples testify.

The *Bell* has already been discussed above, in connection with 'multiples' and apart from being a striking visual motif, would have the extra impact of having a religious connection, as can be seen by the number of hostelries under that name sited near churches. It has also been said that the former *Bell* at Helmdon later changed its name from the *King William* for that reason. A name with similar connections would be the *Five Ringers* at Rothwell (recorded in 1726), the *Ringers* at Brigstock (first recorded in the 1796 Alehouse Recognizances), and during the nineteenth century, the *Six Ringers* at Finedon and Raunds.

Perhaps the most 'exotic' of the heraldic devices originating from the Crusade era was the striking image of the European armies' Muslim opponent, hence its later appearance on hostelry signs, as the *Saracen's Head* (in the fifteenth century), the *Turk's Head*, the *Blackamoor's Head* (both eighteenth century), and the *Sultan* (at Northampton).

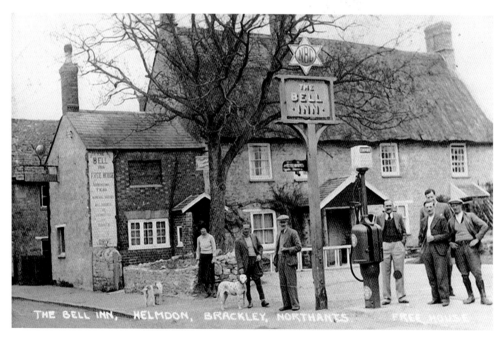

The *Bell*, Helmdon as it was in the 1930s, with thatched roof, and a petrol pump in the forecourt.

The *Talbot* is an interesting sign since no such breed of that name ever existed. It is a generic, heraldic term for any hunting dog. The dogs used in medieval hunting were harthounds (for red deer) and buckhounds (for fallow deer). These groupings were comprised of different breeds, each with a different purpose, and all of which were the ancestors of today's species: the lymehound was the forerunner of the modern bloodhound, and used for tracing a deer by scent; the gazehound, forerunner of the greyhound was used for its sight – as the name implies. (Note the origin of greyhound – as is known they are not necessarily grey in colour – another name for which was 'Greek hound' and would have been pronounced in medieval English like 'grake'. Somehow the 'k' disappeared as time wore on, but the old pronunciation was retained, hence the name in modern English). The third dog used was for bringing the deer down, a large heavy and aggressive animal related to the mastiff. Making up the pack was a fourth breed, the 'brache' and its smaller relative, the 'bercelet', both used for the chase, like modern foxhounds. The term 'talbot' is believed is to have been named after the white dog which appeared on the arms of the first Earl of Shrewsbury, John Talbot who was a major commander that saw action against the French in the Hundred Years War during the fifteenth century. Significantly the final years of that century saw the first recorded hostelry under that name. In Northamptonshire it appeared on ten hostelry signs: Daventry, Kettering, Kelmarsh, Northampton, Oundle, Peterborough, Stoke Albany, Towcester, Weldon, and Welford.

The hart, hind and antelope were used in some form among the earliest known hostelry signs, being of visual appeal and with the attribute and quality of swiftness. They were joined much later by other types or genders of deer: the reindeer (in the

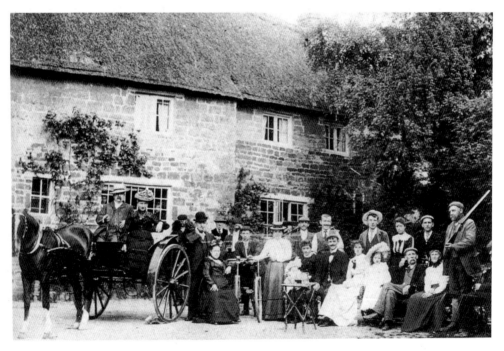

George Bayes, landlord of the *Red Lion*, Middleton, with a group of friends and relatives outside the pub, *c.* 1902.

seventeenth century) appearing at Potterspury and Yardley Gobion, the roebuck at Northampton, and the buck at Desborough and Ufford. Surprisingly perhaps, the stag only began to feature in the nineteenth century, either in eponymous form at Cranford St John, or as the *Stag's Head* at Chapel Brampton, Deanshanger, Doddington, Earls Barton, Great Billing, Maidwell and Northampton.

The dragon, like the griffin and unicorn and other mythological beasts, was also popular as a hostelry sign, usually in combination with St George. The *George and Dragon* however did not appear until the nineteenth century, when the image appeared on the reverse side of the gold sovereign in 1814. The Victorian penchant for anything medieval would have also later made the image fashionable. The *Green Dragon* did not appear until the early years of the eighteenth century, the county having four examples, at Higham Ferrers, Northampton, Peterborough and Brigstock, the exterior walls of the latter of interest, incorporating two stone images believed to have been brought from Fotheringhay by masons staying in the village three hundred years earlier.

NORTHAMPTONSHIRE MANORIAL ARMS

A large group of hostelries have taken their names from landed county families at one time or another, some undergoing a sequence of changes whenever a new lord of the manor has taken over, such as at Rushton where the *Cullen Arms*, became the *Hope Arms* and later, the *Thornhill Arms*, a name it still trades under today; whilst at Sudborough, the *Cleveland Arms* became the *Vane Arms*, which is its current name. There have also been a number of *Duke's Arms* (including four of that name within the manors of the Duke of Buccleuch, at Geddington, Grafton Underwood, Little Oakley and Warkton), and Northampton has had its own *Town Arms*. Others around the county include the following families:

Bartholomew, Buccleuch, Burghley, Carbery, Cardigan, Cartwright, Crewe, Elwes, Exeter, Eykyn, Fitzgerald, Fitzwilliam, Grafton, Harcourt, Hatton, Henley, Knightley, Langham, Montagu, Mulso, Pomfret, Ranelagh, Romer, Shukburgh, Sondes, Spencer, Tollemache, Ward, Westmorland.

The *Shukburgh Arms* is of particular interest, the name occurring in two different villages. The Reverend John Shukburgh, a cousin of George Capron, second son of rector of Stoke Doyle, bought the manor of that village in 1831, where a hostelry was later named after him. Ten years later the manor of Southwick came into his hands, where the existing *Langham Arms* was renamed.

Other hostelries were named after devices on the manorial coat of arms. In the eighteenth century, the male line of the manorial Stafford family had died out, leaving the two daughters of William Stafford as heirs of two villages: Ann marrying George Evans and living in Laxton, where the *Stafford Knot* was later set up, and Susannah marrying Henry O'Brien at Blatherwycke, where the *Sword in Hand was* subsequently established (the image taken from the husband's coat of arms, which can still be found on the old stable block of the now-demolished manor house). At Gayton and Duston, the *Squirrel Inn* and the *Squirrels* took their name from the coat of arms of the local manorial family, the Samwells, which depicts two of the animals back to back cracking nuts. The *Seahorse* at Deene was named after the crest on the Brudenell coat of arms (an image of which still survives in the form of a stone plaque on one of the estate houses close by).

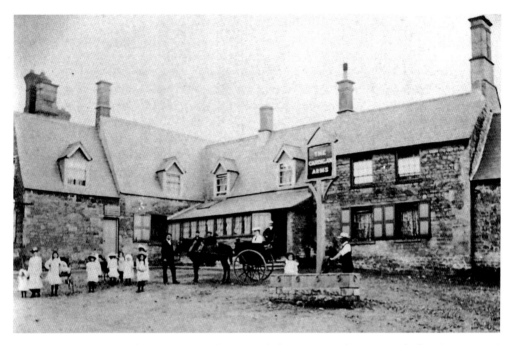

The *Cardigan Arms*, Corby, *c.* 1910 was first recorded in 1796, and was named after the manorial Brudenell family of Deene.

The Cockayne family of London came to Rushton after acquiring the Hall, formerly the property of Thomas Tresham, in 1619. Their coat of arms depicted three cockerels, which subsequently gave a new hostelry in the village its name the *Three Cocks*. When the road was diverted away from the hall by a new owner in 1829, the hostelry found itself lying within the grounds of the hall, and subsequently fell out of use, and became the home of the butler (now an outbuilding). The coat of arms can still be seen in the village church, and on the gable end of a farmhouse, having come from a nearby former bridge over the River Ise.

ROYAL, ARISTOCRATIC AND PATRIOTIC NAMES

Most of the names in this group are self-explanatory and commonly found everywhere. The *Crown* usually appeared eponymously, whilst in other cases it appeared in combination form with another object. Hence the *Crown and Cushion* at Daventry, would signify the two items carried at coronations or other special ceremonies, whilst the *Crown and Woolpack* (at Kettering) would probably have reflected the practice of officials in the House of Lords sitting on small cushions filled with wool at the opening of Parliament (wool once being the main source of wealth in the realm). The *Crown and Anchor* (Northampton) was a relatively late sign, with various naval origins, including a betting game played by sailors, and the arm badge won by a petty officer. In this case, the hostelry's proximity to the river and watercraft in Bridge Street may have

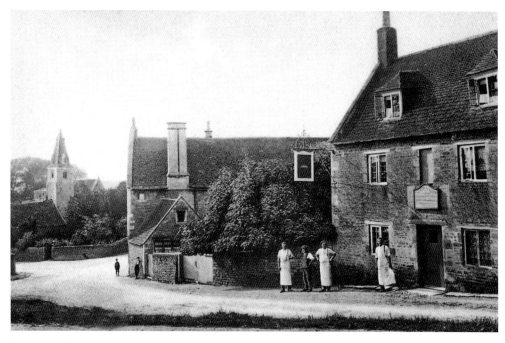

No longer in existence, the *Crown* at Duddington is pictured here *c.* 1896 with the landlord, Thomas Sanders and his staff.

been influential in determining the name, perhaps by a retired seaman. The *Crown and Thistle* at Piddington symbolised the union of England and Scotland in 1603.

The *Prince Regent* at Daventry was George IV who acted as king during the last ten years of his father's long reign, before becoming king himself in 1820. The *Duke of York*, and the *Prince of Wales* (Little Irchester, Helpston) need no comment, whilst the *Plume of Feathers* (Everdon, Northampton) refers to the crest of three ostrich feathers on the royal coat of arms, adopted by the Black Prince in the fourteenth century. The ubiquitous and popular *George* sign has been discussed above.

The *Old Duke of Clarence* at Northampton was a reference to William IV, a popular king who came to the throne at an old age and reigned from 1830 until 1837, when his niece, Princess Victoria, succeeded him. There was also a *William the Fourth* in the town, and at neighbouring Kingsthorpe there is still a *King William IV*. At Helmdon however, the former *King William* is likely to have been a reference to William III. The *Queen Adelaide* at Warmington and Kingsthorpe was named in honour of William's wife.

The *King's Head* dates from the Tudor era, and indicated loyalty to the Crown, but the *King's Arms* did not appear until the Restoration in 1660, for reasons discussed below. Although some hostelries had depicted Elizabeth I's image on their signs, many had been rejected by her as unflattering, and were ordered to be destroyed, and substituted with a set design of which she had approved. Whatever the case, the *Queen's Head* was comparatively rare until the reign of Queen Anne in the eighteenth century, shortly before which the *Queen's Arms* had come into being during the short reign of William and Mary (1689-1702). Only three hostelries in the county, at Orlingbury, Rushton and

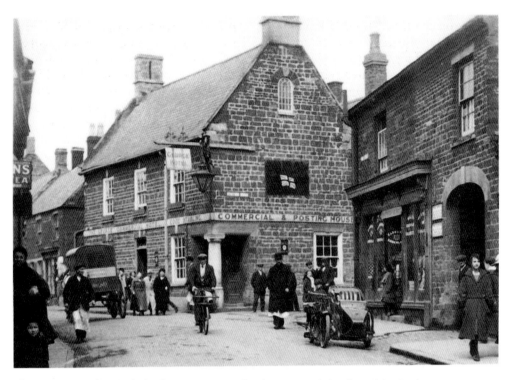

The *George*, Desborough, in the 1930s, one of only two surviving hostelries in the town.

Northampton, had this latter sign, whilst the *Queen's Head* appeared at fourteen places, one of which, at Apethorpe, later changed to the *King's Head*.

The long reign of Victoria saw the rise of the British Empire and the country becoming the richest and leading industrial nation in the world. The queen was honoured in signs such as the *Queen Victoria* at Gayton, and the *Victoria* at Wellingborough and Oundle, the latter town also having the *British Queen*. At Kettering after a brief visit by the queen and her husband in 1844, the landlord of the White Hart changed the name of his inn to the *Royal*, a name also found at Northampton. The *Princess* at Easton on the Hill may well have been a reference to her before her accession to the throne. There was also a *Princess Royal* in Northampton. Pride in the status of the realm would have been further reflected in names like the *Britannia* at Peterborough, *British Arms* at Irthingborough, *British Banner* at Northampton, and the *Albion Inn* at Finedon and Towcester. A further sense of patriotism may have been the reason for the sign of the *Alfred's Head* at Aynho, a look back to the time of King Alfred, the ninth century Saxon ruler, who founded a navy, defeated the Danes, and carried out educational, judicial and military reforms. He is the only English ruler ever to be known as 'the Great'.

Imagine the joy and widespread celebrations that took place around the realm when the monarchy was restored in 1660, with the return of Charles II. After years of austerity under the Puritan-dominated Commonwealth when theatres were closed, singing was only allowed in church, maypoles were banned, and an attempt was made at prohibiting Christmas celebrations, a welcome wind of change seemed to have

blown over the land. 'The Merry Monarch' did indeed love luxury and frivolity, and the status quo was re-established, but at a price to the general population who had to bear the cost of his lavish lifestyle at court, with the Hearth Tax! Even so, a number of new hostelry signs appeared reflecting the new era. The *Rose and Crown* derived from the royal coat of arms, and symbolised loyalty to the king and country. At least eleven hostelries of that name are recorded, four of which still exist. The *Royal Stuart* appeared at Wellingborough, and the *King's Arms* at Desborough, Hargrave, Irthlingborough, Orlingbury, Thrapston, Weldon, and Wellingborough.

But it was the *Royal Oak* which really struck a chord with publicans, commemorating the time when Charles II had hidden amongst the greenery of the 'Boscobel Oak' after the Battle of Worcester, the final battle of the Civil War, in September 1651, after which he lived in exile until his return, nine years later. Despite having parts of Northampton Castle demolished in 1662, he became something of a hero after donating a thousand tons of timber from Salcey Forest to help rebuild the town after the Great Fire in 1675. A commemorative statue was erected in his honour outside the church of All Saints, and the town was particularly fervent in the way it celebrated Oak Apple Day, a national event established by act of parliament which took place annually on 29 May, from 1660 until 1859. In Northampton, the statue would be covered with boughs of oak, and the children of the town's charity schools would walk in procession to the statue and church wearing an oak sprig, or a gilt oak apple pinned to their clothes. In some of the local villages, houses would be decorated with oak, and any child not wearing a sprig would be beaten with nettles by its peers. A testament to its popularity as a hostelry sign was the twenty three recorded examples around the county, making it the second most common sign. The former *Royal Oak* at Geddington however had a different origin, being named after a massive oak tree which stood outside until the 1880s when, like so many other trees in the area, it succumbed to a storm. The building is now the village shop and post office.

Also associated with the king hiding in the oak tree, and appearing during the Restoration was the *Green Man,* for reasons which are apparent. This is one of the more intriguing hostelry names, with a much more ancient pedigree, and is discussed in greater detail in another section of this chapter.

The county hostelries also honoured two prime ministers during the nineteenth century. The *Melbourne Arms* at Duston and the *Melbourne Hotel and Gardens* in Northampton were named after Lord Melbourne (William Lamb) who lived between 1779 and 1848, and was a close confidant of Queen Victoria in the early years of her reign. He was MP for Peterborough at one stage of his career, and sometimes stayed with friends in Northampton. Also in Northampton, the *Lord Palmerston* was named after Henry Temple (1784-1865) who, like Melbourne, was a Whig MP and prime minister on two occasions. He was popular in England, as a result of his assertion of British interests abroad, using a tough 'sabre-rattling' stance against any potential threat to the realm, and coped successfully with the pressures caused by the Crimean War and Indian Mutiny.

OCCUPATIONAL AND TRADE NAMES

It was only natural that a certain specialist occupation or trade in a village or town would be reflected in the name of one of its hostelries. A number would add 'Arms' to their name though all have since become unfashionable and have disappeared, with

three exceptions in the county, the *Bricklayers Arms*, at Creaton (which has the record for the longest serving landlord, John Blunt, who ran the pub from 1902 until 1962), the *Crispin Arms* (named after the patron saint of shoemakers) at Wollaston, and the *Slaters Arms* (a reintroduction) at Collyweston. Note that with these and in other cases, the apostrophe is seldom used, leaving an indeterminate singular or plural appellation. The following 'Arms' pubs have also existed at one time or another around the county: *Turners, Foresters, Tradesmens, Carpenters, Thatchers, Bakers, Butchers, 'Taylors', Maltsters, Panniers, Cooks, Panniers, Plumbers, Masons*, and *Graziers Arms*.

An alternative would be a pictorial representation from the coat of arms of the various trades. These central features depicted on a heraldic shield are known as 'charges'. Charters were granted to many trade guilds during the medieval period and beyond, and each one designed its own specific coat of arms as a sign of recognition. On hostelry signs, these appear in multiples of three, and are likely to represent the primary occupation of the victualler himself, who was running the establishment as a secondary occupation, or side-line. Thus the county has seen the following: the *Three Horseshoes* (Worshipful Company of Farriers, 1693), *Three Goats* or *Three Goats Heads* (Worshipful Company of Cordwainers, 1439), the *Three Tuns* (more likely to be the Worshipful Company of Brewers, though it was also the arms of the Vintners, both being granted charters in 1437), and the *Three Compasses*, for carpenters. The *Three Crowns* (Kettering) were depicted on the coat of arms of the Worshipful Company of Drapers (1364). The *Three Cups* was a sixteenth century device on the arms of Worshipful Company of Salters (1558) which at only appeared in the county during the latter years of the nineteenth century in Northampton.

The *Three Horseshoes*, Nassington, *c.* 1914. It was run at the time by Elias Knight, a blacksmith who had moved from nearby Yarwell.

The number 'three' was popular in the general imagination, being considered both lucky and powerful, and was therefore a desirable addition, perhaps reflecting hoped-for prosperity, as well as giving 'an official' look like a coat of arms. Thus there were the *Three Lasts* (at Oundle) for a cobbler or shoemaker, and *Three Mill Bills* (at Nassington), both of which are described below. The *Three Conies* (Thorpe Mandeville) was used by a dealer in game and poultry, the name referring to the original name for a rabbit, the latter word used only for the young animal, which is now called a 'kit'.

More common on a hostelry sign were depictions and names of a victualler's main occupation, thus a butcher would run the *Shoulder of Mutton*, or *Bull and Butcher*, although *Leg of Mutton* (Northampton) often referred to the practice of celebrating the completion of an apprenticeship in a certain trade, with a meal of this at a special banquet in a hostelry. A brewer or maltster displayed the *Shovel and Firkin, Malt Shovel, Maltsers Arms, Three Tuns*, or *Two Brewers*. A miller might use the *Millstone*, or even the *Windmill* (though this might be just a reflection of a local landmark, as at Paulerspury). The *Three Mill Bills* was named after the chisel-like tools used by craftsmen for dressing or shaping the coarse surface of millstones. A wheelwright portrayed the *Wheel and Compass;* a carpenter the *Rule and Compass or the Compasses* (though the latter was also used as mason's symbol). The *Bill & Hatchet* (Southwick) was named after the tools used by a hedge trimmer or woodcutter.

A farrier or blacksmith would run the *Horseshoe*. This was a very popular sign in the county with thirteen recorded examples, whilst the *Three Horseshoes* appeared in ten places. The horseshoe would also have had an extra advantage in those superstitious times of being a good luck symbol to help avoid any mishap or accident at work, and perhaps to encourage a flourishing trade.

A shoemaker (cordwainer) or cobbler had a preference for the *Boot* (a common name in the county from the eighteenth century, and even more so with the development of the industry in the 1800s), or alternatively, the *Boot & Shoe, Shoe & Clog, Crispin*, or *Needle & Awl*. At Oundle, there was the *Three Lasts*, named after the form/model for shaping or repairing footwear, and there was another possible connection in the town, with the *Hand and Slipper*. Shoemakers were also once known as 'snobs' (derived from a word 'snab' of uncertain meaning), and one added his occupation to the strangely-named *Snob and Ghost* at Middleton Cheney.

At Weldon, rope making was a speciality and one such hostelry was the *Jolly Roper*, the path adjoining the building still known locally as Rope Walk. Sometimes there was a combination of two occupations in the locality as seen in the name *Axe and Compass* (Ringstead, Ashley) or the *Axe and Cleaver* (Helpston, Wellingborough). Names like the *Waggon and Horses* and *Wheatsheaf* can have more than one derivation reflecting different occupations, the former being that of a carrier or a farmer, the latter of a baker or brewer (the symbol/device featuring on the coats of arms of both).

The *Woolpack* has an obvious connection with sheep farming and the wool trade, being a reference to the large packs of bales of wool used for transportation and retail in Europe when English wool was in high demand for its quality after the Black Death, and well into the Tudor era. An alternative name was the *Woolpocket* which once existed in Oundle. The *Sugarloaf* (at Bradden) was frequently used as the trademark of a grocer, and most likely, in this case, the main occupation of the victualler. At Abthorpe, the *Stocking Frame* is a reference to a mechanical knitting machine invented in the late

sixteenth century but developed during the Industrial Revolution as an inexpensive method of spinning cotton for stockings.

HISTORICAL, LEGENDARY AND LITERARY FIGURES

The *Thomas a Becket* (Northampton) commemorates the Archbishop of Canterbury who, in 1163/64 had angered his friend, Henry II, by not agreeing to a new set of regulations, including one stipulating that any church official breaking the law of the land, should be dealt with by civil, not ecclesiastical, authorities. He was consequently summoned to Northampton Castle to appear before a council to answer charges brought against him. After his appearance, he fled the town disguised as a monk, stopping (according to tradition) at a well, which was subsequently named after him, and can still be seen today housed in a Victorian structure, on the Bedford Road.

The *William Shakespeare* seems a suitable name for a Northamptonshire hostelry, since his granddaughter and last descendant, Elizabeth Barnard, came to live in Abington during her second marriage and died there in 1670, being buried next to her husband in the village church. Their house is now a museum, and the adjoining grounds are a public park.

A contemporary of Shakespeare and fellow playwright and poet, Ben Jonson (1572-1637), also had a hostelry named after him at Oundle, *Ben Jonson's Head*. He also wrote the poem 'Song to Celia' which was set to music in the nineteenth century as 'Drink to thee only with thine eyes', surely a factor underlying the choice of name by the landlord. Similarly, the *Paul Pry* (at Werrington) was named after a farce written in 1825 by John Poole, which was performed throughout the century, about an idle busybody later turned hero. It was also noted for the inclusion of the popular contemporary song, 'Cherry Ripe' based on the seventeenth-century poem by Robert Herrick.

The *Samuel Pepys* at Slipton is a modern sign (replacing the *Red Cow*), named after the famous diarist who recorded much of London life between 1660 and 1669, including many names of hostelries in the city at the time. The *Whyte-Melville* at Boughton was named in honour of the writer, George Whyte-Melville (1821-1878) who came to live in the village after marrying a local girl from Kelmarsh. He wrote several novels recording the Victorian sports and social scene, in particular fox hunting in the Pytchley Hunt area.

The Victorian era, with its flourishing Empire, expanding population and the growth of towns and industrialisation needed some kind of balance to cope with the rapidly changing way of life and loss of many traditions. It found it in the form of nostalgia for the past via art, architecture, history and literature.

Swept up in the wave of this nostalgia was the resurrection of legendary figures like King Arthur and Robin Hood. The latter needs no introduction of course. Whether he was real, imaginary or a combination of the two, or in which area he was active, is irrelevant. The image struck a chord. He is said to have been in Brigstock and Corby and there is a record (albeit late) of a Robyn Hode, a common name at the time, being held at nearby Rockingham Castle for 'trespass against the vert and venison' in 1354. It was inevitable therefore that such a colourful character would be chosen for a hostelry name, hence the *Robin Hood* at Duston, Kettering and Raunds, and *Robin Hood and Little John* at Dallington.

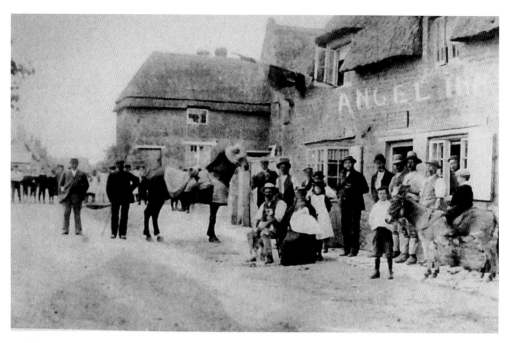

Celebrating the coronation of Edward VII in August 1902, are a crowd of villagers outside the *Angel* in Yarwell.

RELIGIOUS CONNECTIONS

Signs in this group were not very common in Northamptonshire, perhaps because of the strong nonconformist connections. Of the early signs, leaving aside the *Bell*, discussed below, the most common was the *Angel* (at Brigstock, Bugbrooke, Geddington, Desborough, Northampton, Oundle, Peterborough, Warmington and Wellingborough). The *Mitre* existed at Northampton, as did the *Catherine Wheel*, an image to one of the most popular saints during the pre-Reformation era found painted on the walls of several county churches, before the iconoclasts caused their obliteration in the reign of Edward VI, and later during the seventeenth century Commonwealth years. In 1541, after centuries of being in the Diocese of Lincoln, Northamptonshire became part of the new Diocese of Peterborough, whose symbol was the keys of St Peter. Fittingly this subsequently appeared on hostelry signs, as the *Cross Keys* (Brackley, Kettering, Kingscliffe Northampton and Oundle), whilst at Irthlingborough the sign became the *St Peter's Arms*, after the parish church dedication to the same saint. Interestingly, there has never been a hostelry of either name at Peterborough itself.

The only other religious connection in the county is the partly-thatched *Old Friar* at Twywell, named misleadingly after a monastery that according to tradition was sited nearby where an earthworks now exists. Inevitably this gave rise to another tradition: that it has one of the many ubiquitous secret underground passages supposed to exist around the realm, in this particular case linking the site with the church.

MILITARY CONNECTIONS AND HEROES

At Collingtree there is the uniquely named *Wooden Walls of England*. It origins lie in ancient Greece, from a comment made by the commander of the Athenian forces against the Persians, referring to his ships as a defence against the realm. This phrase was resurrected and changed in the sixteenth century and applied to the warships of the English fleet, subsequently becoming a favourite expression in years to come especially during the eighteenth century when the country was frequently at war.

In 1794, George III asked all counties to raise troops for the defence of the realm against potential invasion by the French who had taken control of a large swathe of Europe in the wars following the Revolution. It was also necessary to dampen any revolutionary fervour that might spread to and sweep across England. The Northamptonshire Yeomanry was founded that year to act in that role, the cavalry of which had to provide its own horses, with uniforms and saddler paid for by county subscriptions. There were many recruits, and the new military unit subsequently adopted the white horse of Hanover for its crest. A hostelry known as the *Northamptonshire Yeoman* opened in Brigstock shortly after the formation, and flourished for a short period until it was put up for auction at the nearby *Angel* in 1804. It may well have been run by the village fellmonger (an occupation associated with the village well into the twentieth century), who would collect and prepare hides and fleece from slaughterhouses and butchers, for the leather and woollen industries, evidence for which can be seen in the auction details:

'A very desirable copyhold estate in Brigstock, consisting of a well accustomed public house called the Northamptonshire Yeoman with a piece of ground adjoining containing one rood. Convenient tanyard, granaries, tan vats, lime pits, working shops, drying sheds, store rooms for leather, also a cottage adjoining the pub in the occupation of Solomon May. The premises well supplied with hard and soft water, well situated for bark and well adapted for carrying on trade of fellmonger or tanner.'

On the road between Finedon and Thrapston stands a large circular building, on the wall of which is a white sign commemorating the victory of the British and Prussian forces over Napoleon at the Battle of Waterloo in 1815. It was erected there by General Arbuthnott, a friend of the Duke of Wellington, who occasionally stayed with him at nearby Woodford. During one such visit he is said to have mentioned that the fields in the vicinity reminded him of the landscape around Waterloo. The round building was consequently constructed on the spot where he had stood as a three-storey view-point overlooking the site, with a railed off platform at the top and a circular window, or oculus in the front wall. In the mid-1800s it became a hostelry known variously as the *Waterloo Victory Inn*, but soon gained an unsavoury reputation, fostered by its isolated situation, as the haunt of poachers and undesirables, so that it eventually lost its licence, subsequently becoming a social club and then a farmhouse. Today it is a private residence. A silent film about the battle was made at the site in 1913. The building and surrounding land are unique in being at the meeting point of four parish boundaries: Burton Latimer, Woodford, Great Addington and Finedon.

There were hostelries called the *Duke of Wellington* at Kettering, Weedon Bec, Northampton, Peterborough and Wellingborough, whilst another contemporary hero, the great naval commander, Horatio Nelson was honoured at Brixworth, Daventry and Weedon Bec at the *Admiral Nelson*, whilst at Towcester it was the *Nelson's Arms*. At Brigstock, Bozeat, Kettering, and Stanion the sign was the *Lord Nelson*. The latter

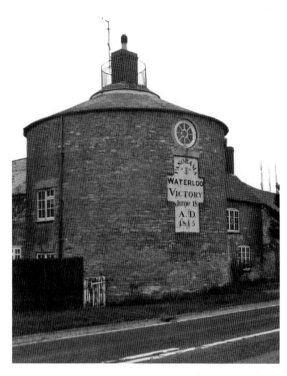

The *Waterloo Victory Inn.*

village is situated near Weldon, which has a double Nelson connection, in each case with stained glass windows being donated to the church, firstly by John Clarke, an assistant ship's surgeon in Nelson's fleet, who had retired to the village and secondly by Finch-Hatton (a friend of Hamilton, husband of Nelson's mistress, Emma) who was rector of the village. The window he gave to the church was originally a gift of Hamilton's.

Other heroes honoured in hostelry names include the Marquis of Granby (1721-1770), one-time commander in chief of the British Army, which was allied with Prussia during the Seven Years War, and who led a victorious cavalry charge in 1760 against the Austrian, French and Russian forces at Warburg in Germany. During the charge he is said to have lost his hat and wig, leaving his bald head showing, which was consequently painted on some hostelry signs. He was also a benefactor towards some of his men when they retired, helping them get fixed up as victuallers and innkeepers. His name graced signs at Wollaston, Daventry, Stamford St Martin and Wansford. Two of his contemporaries were honoured in a similar way: at Oundle the *Admiral Keppel* was named after a British naval officer (1725-1786) who won several victories against the French, whilst being critical of the state of the Navy at the time; and at Northampton, *Admiral Rodney* (1719-1792), who had also figured in many successes at sea against the French, during the American War of Independence, in particular the Battle of the Saintes, which took place between Dominica and Guadeloupe in the Caribbean and lasted for four days in 1782. The *Duke of Cumberland* (Passenham), was the second son of George II who defeated Bonnie Prince Charlie at the Battle of Culloden in 1746, and was honoured by the composer Handel in an oratorio which included the well-known, 'See the Conquering Hero Comes'.

119

The *Battle of Inkerman* (Earls Barton) commemorated the famous battle of the Crimean War in 1854 when the Allied forces of Britain, France and Turkey fought against the Russians in thick fog, and despite being heavily outnumbered, won a famous victory. The resilience and bravery of the troops was also honoured in the name of a street in Oundle, Inkerman Place, which has since been built over and renamed, Inkerman Way.

The traditional association between hostelries and the military as recruitment centres and as places for the billeting of troops had come to the fore in the eighteenth and nineteenth centuries with the various wars with France, Spain, Austria, the American colonies, Russia and latterly the Boer War followed by the First World War. A number of hostelries had emerged acknowledging the association and giving a heightened sense of patriotism. Thus in Northampton there appeared the *Recruiting Sergeant, Queen's Dragoons,* and the *Trooper,* whilst at Bozeat there was the *Royal Engineer,* and (still in existence) there is the *Volunteer* at Wellingborough and the *Bold Dragoon* at Weston Favell.

The former *Lion and Lamb* which existed in Bridge Street at Northampton in the nineteenth century, with its depiction of two animals of opposite disposition, may have symbolised peace after a period of war.

AGRICULTURE

As can be expected in what was traditionally a predominantly agricultural county for centuries (Northamptonshire being one of the last counties to be industrialised), the number of names connected with farming would be high. The Wheatsheaf is self-explanatory, with twelve hostelries so-named, but only three of which exist today (Northampton, Titchmarsh, Weedon) and the *Sheaf* still survives at West Haddon. Of the eighteen known as the *Plough,* five still exist (at Caldecott, Northampton, Shutlanger, Towcester and Upper Boddington). After ploughing, the fields needed preparation for seeding, by breaking up the clods with a metal-teethed harrow dragged over the surface. One such hostelry known plainly as the *Harrow* existed in the county, at Braunston, but there have may well have been others at one time, unrecorded. The *Barley Mow* was a very popular name in the county, being found at Ailsworth, Evenley, Everdon, Hellidon, Kislingbury, Paulerspury and Watford. The final process in harvesting was threshing the crops by hand, using a flail, to separate the husks of grain from the chaff. When this traditional method was replaced by the stream traction engine in the nineteenth century, a new hostelry name came into being: hence the *Engine* at Collyweston and the *Steam Engine* at Woodford.

Animal husbandry was also another important feature of farming, and not surprisingly, cattle featured prominently in the hostelry names of the county. There were ten named the *Bull, and* three known as the *Bull's Head* (at Kingscliffe, Northampton and Rothwell). The nineteenth century saw experimentation in the breeding of livestock, resulting in prize bulls being taken around the country for display at shows, causing a great deal of sensation in their day. Three were particularly well-known, originating in Hereford, Durham and Devon, the latter two giving their names to the *Devon Ox* at Kilsby, and the *Durham Ox* at Northampton. Cows however never appear as a hostelry name without some form of marking, hence the *Spotted Cow* at Wappenham and Whilton, the

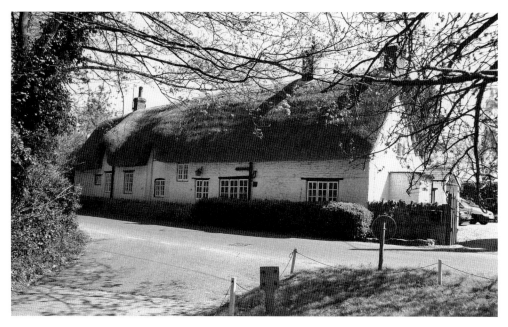

The former *Plough Inn* at Alderton was closed in 1958. Serving a small population, it was frequently aroused from its normal routine, with crowds of visitors on coach trips in the county.

Brown Cow (Ashley) and the popular *Red Cow* at Burton Latimer, Clipston, Finedon, Harrington, Haselbech, Higham Ferrers, Slipston and Stamford St Martin. The dull greyish-brown colour known as 'dun' was also very popular, hence the *Dun Cow* at Astcote, Daventry, Glapthorn, Middleton Cheney, Moreton Pinkney, Wellingborough, and West Haddon – though the name in some instances may have been determined by the legendary dun cow, discussed below. Sheep farming was undoubtedly the most important form of husbandry in the county, and although not quite so visually appealing as an image, was reflected in names like the *Woolpack*, *Graziers Arms* (Ashley, West Haddon), the *Ram* (Northampton), the *Lamb* (Little Harrowden, Oundle), and the *Fleece* (Grafton Underwood and Northampton). The goat was rarely depicted, occurring only twice as a sign, at Maidwell as the *Goat*, and in Northampton as the *Bull and Goat*. Pig farming also had its place and appeared in the name *Sow and Pigs* at Wellingborough (close to the hog market) and at Higham Ferrers, Irthlingborough and Little Oakley – though in one or two of the latter cases, it may be derived from a one-time popular farmers' card game known as 'My Sow's Pigged'. The game subsequently degenerated into a children's game using the rhyme: 'Higgory, diggory, digg'd, My sow's pigg'd'.

SPORTING NAMES

Until the seventeenth century when it gradually petered out, Forest Law had held a grip on hunting certain beasts, namely red deer, fallow deer, boar, and (for a time) roe deer. These were termed 'beasts of the hunt' and were strictly the prerogative of successive

121

English monarchs and their guests ever since William I had sent out commissioners to determine the best areas in his new kingdom for hunting, which were consequently placed under a set of laws with a hierarchy of officials to oversee everything. Northamptonshire was divided into three hunting areas, Rockingham Forest (which initially stretched from Stamford to Northampton), with Salcey and Whittlewood to the south. Until Henry III came on the throne, this meant that landowners of any status were confined to hunting only 'beasts of the chase', namely hares, foxes, game birds and other small creatures. From 1228 the king allowed landowners to create a deerpark, or purlieu (private) woods, subject to certain conditions and at a price. The first of these in the county was at Wakerley, part of the later boundaries of which are still visible today. From 1299, the areas of royal forest slowly diminished in size until the time of Charles I (with a temporary restoration of the old boundaries between 1637 and 1641). Landowners now had a free hand to extend their hunting opportunities.

Foxhunting gradually established itself by the end of that century, mainly on a private basis at first. Gradually it became more organised with packs, one of the earliest records of which appeared in the diaries of Sir Justinian Isham of Lamport Hall. In an entry for April 1712, writing in the second person, he mentions his participation in one such hunt:

'Mr Isham dined at the Ale House in Siwell with several of the fox-hunters who during the morning had hunted a big fox.'

However a pack had been established in the county at Althorp as early as 1635, and later combined with Pytchley where a club was formed in 1750, the two hunting packs riding together until 1874, when the Woodland Pytchley Hunt established its own kennels at Brigstock, and where in later years, Bill Chudley, who had acted as kennelman from 1912 to 1932, became landlord of the nearby Green Dragon. In the north of the county, the Cottesmore Hunt had been active in the Welland valley area from 1666, and in the south, the Grafton Hunt which had been hunting hare and deer until the mid-1700s, became a major foxhunting club.

As befits what became a prime hunting county, a number of hostelries sprang up or changed their name to reflect aspects of the sport, hence the ubiquitous *Fox*, *Fox & Hounds*, and *Hare and Hounds*. *Three Foxes* (Brackley), *the Stag and Pheasant at Kettering*), *Dog & Partridge* (Titchmarsh), *Pointer* (also at Titchmarsh), and the *Dog & Gun at Braunston*. Brixworth, as a centre of the Pytchley Hunt, is noteworthy in formerly having three hostelries with a hunting connection: the *Fox & Pheasant*, *Fox & Hounds* and *Hare & Hounds*. There was also the curiously-named *Fox & Grapes* at Nortoft (now part of Greens Norton), and according to local tradition, this was also a short-lived name for the *Fox* at Thorpe Waterville. At Gretton, the *Fox* had a trade rhyme, with an invitation to sample the wares:

'I am a crafty fox you see,
But still there is no harm in me,
It's my master's wish to place me here,
To let you know he sells good beer'.

The *Snooty Fox* (Lowick) however is a modern name, appearing around England in the last years of the twentieth century, allegedly deriving from an incident in which a

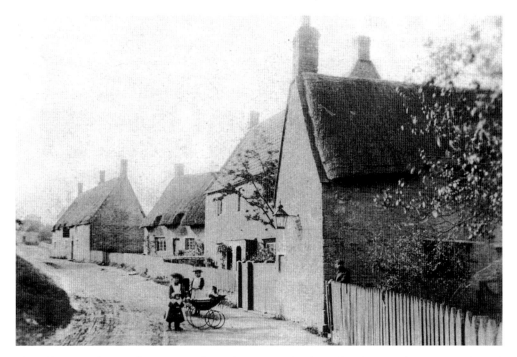

The old *Fox and Hounds* in Brigstock can be seen on the far right of the Bridge Street. It burned down in 1938. The village is closely connected with the Woodland Pytchley Hunt.

nonchalant fox crossed the road in front of some bystanders as if they were not there!

Horse riding and racing also have their acknowledgement in the names *Horse & Jockey, Horse and Groom,* and the *Racehorse,* whilst amongst other sporting activities, the *Greyhound,* and the *Chequered Flag* are self-explanatory.

TRANSPORTATION

Gone are the days when the horse (and its various attachments) was the only means of transportation, whether for people or goods, which was reflected in the many names that could once be found around the county such as the *Coach and Horses, Old Posting House, Mail Coach, Waggon and Horses, Old London Waggon, Packhorse, Panniers,* and even the *Wheel.* It is possible that the *Nag's Head,* a very common name in the county, was connected with those hostelries which hired out horses locally, but which equally provided a striking visual image.

Travelling by stagecoach could be an unpleasant experience. In July 1782, a young German clergyman, Charles Moritz, visiting England decided to begin his journeys around the country on foot, and then take the stagecoach later, which he did – travelling from Leicester, via the villages to Northampton. At Market Harborough, it began to rain incessantly, all the way to his destination, a wet, tiring experience he afterwards regretted, and something he would be loathe to undergo again. It could also be dangerous, and even costly. To help reduce problems a traveller might experience,

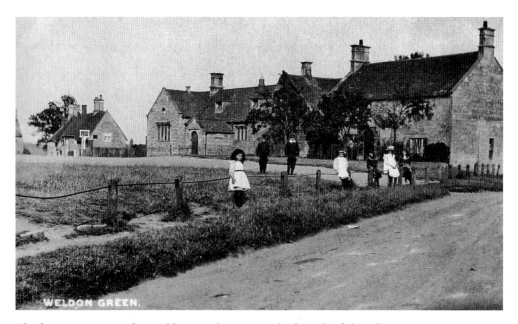

The former *Nag's Head* at Weldon, can be seen on the far side of the village green, *c.* 1910.

The Traveller's Oracle was compiled by W. Kitchiner and published in 1827, with estimates of various expenses that might be incurred whether going on foot, travelling on horseback, by post-chaise, or private carriage); seven songs were included to sing on the journey, and information for horse and carriage keepers. The author also advised the following cautionary measures;

'Take a powerful weapon – an iron stick with a hook, terminating at the other end in a spike...a night lamp placed in a little lantern...a tinder box... Never go without an umbrella, the stick of which may contain a telescope or sword... If circumstances compel you to ride on the outside, put on two shirts and two pairs of stockings...[at the inn] if you carry firearms, it may be well to let the landlord see that you are armed. Secure the door to your room at night using a corkscrew fastening. This is screwed in between the door and the doorpost and unites them so firmly that great power is required to force a door so fastened. Especially in winter, have the bed clothes in your presence put before the fire. As Fielding [the novelist] says "at a good inn you pay extravagantly for good cheer, at bad inns you pay for nothing at all"...'

The coming of the railway to the county with the opening in September 1838 of the LNWR line from London to Birmingham, via Blisworth, Roade, Weedon and Welton, started a new era which saw much of the county criss-crossed by a rail network by the end of the century. This opened up not just greater (and faster) travel opportunites for county people but brought an increase in the number of visitors from outside. Inevitably, with commercial gain in the offing, a number of hostelries sprang up or changed their names, thus the following were recorded: the *Railway (Hotel, Inn)*, the *Midland (Hotel)*, *Locomotive* and *Steam Engine*.

Until the eighteenth century, the river Nene had only been navigable from the Wash to Peterborough. After earlier plans had not come to fruition, work finally got underway to reach Northampton. This was done over a thirty-one year period, getting as far as Oundle in 1730, followed by Thrapston in 1737, and finally reaching Northampton in August 1761, to scenes of general rejoicing by the townspeople. Significantly, hostelry signs appeared at settlements along the river such as the *Boat* at Peterborough, Nassington, Northampton and Oundle, the latter town also having the *Wharf*.

With the gradual development of the Grand Union Canal linking London with Birmingham during the nineteenth century, it was inevitable that certain villages in the county would profit from the associated trade, among them Braunston (which had the added advantage of being at the junction of the Oxford Canal), Cosgrove, Blisworth, Long Buckby, Welford, Kilsby and Crick. A number of hostelries sprang up to cater for the thirsts of the canal users, reflected in some of the names, such as the *Navigation Inn* and *Boat Inn* at Stoke Bruerne, the *Navigation Inn* at Blisworth and Cosgrove, the *Wharf* and *Grand Union Inn* at Crick, and the *Wharf* at Aynho.

As England became a great maritime power during the seventeenth century, a number of sea-related names came into being, notably the *Ship*, *Anchor*, and *Crown and Anchor*. Allied to these were the *Dolphin* and *Mermaid*, both of which first appear as hostelry names shortly after 1650. In the previous century, the 1539 arms of the Worshipful Company of Fishmongers depicted (as they do today) three dolphins, with a mermaid

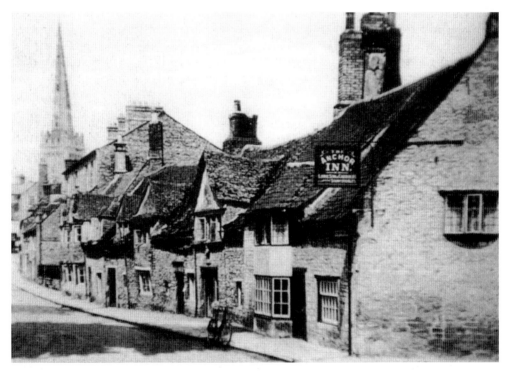

The former *Anchor* in St Osyth's Lane, Oundle, was affectionately known as 'the Duck's Nest'. It was rebuilt in 1637, serving as a hostelry until its closure in 1956.

and merman on either side as supporters. At one time in Oundle there were five of these water-related hostelry names: *the Ship, Mermaid, Anchor, Dolphin,* and *Maidenhead* (the latter discussed elsewhere), with two other signs in later years. The *Ship* also occurred at Wellingborough and Peterborough. The dolphin was also believed by sailors to be a sign of good luck if spotted whilst at sea and may have been viewed as an auspicious sign for potential success in business when chosen as a hostelry sign. Sea-related or not, all five images would have had great visual impact for attracting custom.

DRINK RELATED NAMES

As to be expected, some hostelries would be more direct in advertising their establishment, with a number of names relating to drink. Reference has already been made about 'Mother Redcap' for an alewife. Representing drinking vessels in the county were: the Blackpots at Oundle, the *Quart Pot* at Daventry, Denton, Northampton and Wellingborough, the *Leather Bottle* at Daventry, Glapthorn and Wellingborough, and the *Rose and Punchbowl* at Northampton, the latter combination of names uniting symbols of the realm and contentment. Of great interest is the *Hen and Chickens* which throughout the centuries has had different meanings, but when used as a hostelry sign is likely to be old slang for large and small pewter drinking vessels, 'hens' and 'chickens' respectively. Maltsters and brewers were alluded to in the *Malster, Malt Shovel, Shovel & Firkin, Maltsters Arms* and *Two Brewers*, the latter name possibly an indirect reference to a partnership. The *Old Jolly Smokers* of course, needs no comment, and the *Three Tuns* has been discussed above. Also in this category we might include a little relaxation and domesticity represented by the *Retreat* (Easton on the Hill), *Cabin of Comfort* (Desborough), the *Cottage* (Little Irchester) and the *Cottage Inn* (Titchmarsh), places where there might be a little bit of merriment and wayward singing, as was the case at Clipston in the 1800s:

'Old Gamble bawls, his daughter squawks, Old Bodkin beats the time;
They make a noise and fright the boys, and spoil the doctor's rhyme.
And Cooper Joe, he sings so low, we hate to hear him crow,oh, oh!
Yet Baker Natt he sings so flat, and flatter still sings Matt.'

SPECIAL SIGNS

The *Green Man* hostelry sign appeared during the reign of Charles II, as discussed above. The image however is much more ancient. A now-defunct word, *greenmans,* was used from the medieval period until the first quarter of the seventeenth century, as a catch-all term for the open countryside. In heraldry its forerunner frequently appeared as a supporter on family coats of arms in England and Europe, as the 'wild man' (which also became a hostelry name, but with no examples in Northamptonshire) and was usually portrayed wielding a club, small tree, branch or banner, wearing a garland around his forehead or loins, and sometimes accompanied by a wild woman. He acted as a guardian of the family bloodline, helping to ensure continued fertility and guarantee male succession.

Outside the *Fitzgerald Arms* in Marholm, is this unique 'pub sign', which gives its alternative name to the pub, and to an adjacent street. It also features on the present village sign.

During the Tudor and Stuart periods, 'green man' was applied to a 'wildman' figure leading processions and pageants, either dressed as such, or covered with greenery, and carrying a leafy staff. In 1638, a popular drama, 'The Seven Champions of Christendom' by Robert Kirke, has one of the characters asking: *'Any Green Men in your shows?'* It had also been one of a group of names used for different rooms in certain inns. Samuel Pepys recorded the name in his diary, and in the following century it was included among a list of hostelry signs in a two-volume book by the ballad collector, John Bagley in 1716 in which he states: *They are called woodman or Wildman, thou at thes day we in ye signe call them Green Man couered with grene bowes.* It soon became a popular sign, with London having thirty-one recorded at one time during that same century, with only a few less in 1864, when twenty four are listed. Northamptonshire had a maximum five at different times, at Oundle, Rothwell, Hannington, Duston and Brackley Hatch, the latter being the sole survivor today. The maximum anywhere at the present time is eleven, in neighbouring Buckinghamshire.

The *Chequer* has been discussed above as one of the earliest signs, but the plural form, *Chequers*, did not appear until much later, in the final years of the eighteenth century, one of the earliest in the county being that at Great Oakley, where it was first recorded in the Alehouse Recognizances in 1796. There are two possible origins of the name in this form, one taken from board games like draughts or chess which would have been played in some hostelries; alternatively, it may have been taken from 'checkers', the

fruit of the uncommon wild service tree, which is particularly fussy where it grows, the majority surviving today in the north of the county. The fruit is very distinctive, like a large hawthorn berry, and when ripe has a taste which has been likened to a mixture of apricot and raisin, with a hint of tamarind. At one time they were very popular with children – a natural healthier equivalent of manufactured sweets. The *Chequers* as a sign was recorded elsewhere in the county at Bozeat, Bulwick, Higham Ferrers, Holcot, Lilbourne, Lower Benefield, Maidwell, Old, Spratton, Upton and Wappenham.

There is one single example in the county of the *World's End*: at Ecton – a name usually associated with a hostelry located at the far end of a village, or one in isolation from it – which is the case in this instance. The *World Turned Upside Down* is another uncommon name and is more complicated to unravel, the one example in the county being at Raunds. Various explanations have been given for the origin of the phrase, from its appearance twice in the Bible, to the effects of too much drink! What is most likely is its use in the seventeenth century, and may originally have reflected the troubled times of the Civil War and its aftermath when the status quo and balance of society was literally 'turned upside' down by events, especially after the king had been beheaded, heralding an unprecedented period of uncertainty and confusion. In 1643, a broadside of that title had been published opposing Puritan attempts to suppress Christmas, who wanted to make it a purely a religious occasion. As a hostelry sign however it does not appear until the nineteenth century, the phrase certainly being attractive for a name, as well as giving lots of scope for artistic licence. The pub still flourishes today.

Raunds also has the distinction of having once boasted another rare nineteenth century sign in the county: the *Live and Let Live,* with proverbial origins, in the sense of 'you live your way, I'll live mine' – reflecting a kind of 'everyone to their own taste' attitude. An alternative explanation is that it implies someone being resigned to a situation that he or she is not happy about – perhaps something happening in the locality affecting one's lifestyle or business – times do not change!

Slightly more common was the *Bird in Hand* (Croughton, Thrapston, and Upper Stowe). Again this is a late sign, first appearing in the nineteenth century, but based on the old proverb, 'a bird in the hand is worth two in the bush', in other words, it is best to be content with what you have, rather than what you could have. As a sign it could be given a touch of heraldry, such as a falcon on a gloved hand.

The *Case is Altered* is yet another name with proverbial roots, a hostelry of that name appearing briefly at Sywell around 1805 (recorded in the Alehouse Recognizances for the Brackley Division). The name appeared as the title of a play by Ben Jonson, written in 1599, and published later in 1609, the phrase itself having become proverbial after its use in the legal system during the early Tudor period, when a lawyer made the remark after new evidence was presented during a trial that was in progress. Its reason for being chosen as a hostelry name however is nebulous, and would probably have originated in a publican's circumstances at the time, such as kind of local dispute in which he was involved, the name containing a hint of irony or sarcasm.

A touch of humour seems to underlie the name *Labour in Vain* (Northampton). One can imagine a nineteenth century publican attempting to attract enough custom to make ends meet, and vying for trade with the numerous other hostelries in the town – a situation that many publicans find themselves in today! It may also refer to any impossible task, such as trying to make a marriage work! The very nature of the sign would probably have done the trick for a while, but it later changed to the *Black Boy*, a

variation of which, the *Black Boy and Still* (also at Northampton), was an early example of combining two unrelated names, the latter a reference to the apparatus used for distilling alcohol, the image of which was sometimes used for indicating that alcoholic drinks were sold on the premises.

The *Eagle and Child* sign (Northampton) was based on a legend involving the Stanley family (Earls of Derby). In the fourteenth century Thomas Latham of Stoneley had an illegitimate son which he hid from his wife in the nest of an eagle. Suggesting to her that they go for a walk around their estate, they came upon the infant who seemed unharmed and unperturbed in its strange resting place. She needed little persuasion from her husband in adopting the child as their own, who was then designated to be his heir. As time progressed the marriage failed to produce another boy. However, on his deathbed he confessed to his wife that the infant they had found had been his illegitimate son, therefore their daughter inherited the estate instead, the boy being generously provided for elsewhere. According to one version of the story, when the daughter married, her husband took on a new surname based on that of the estate, changing it from Stoneley to Stanley. Thereafter the Stanley family depicted the 'eagle and child' on its coat of arms. This story of a 'discovered child' was once a common theme in European folklore having its roots in Greek mythology and the Biblical story of Moses in the bulrushes.

The *Chequered Skipper* at Ashton (formerly the *Three Horseshoes*) is another sign unique to the county. The pub was renamed by Dr Miriam Rothschild, an eminent naturalist, in honour of her father, Charles, who had managed to capture one of this rare species of butterfly. He was an early conservationist and founded the first organisation devoted to the environmental cause in 1903. She continued her father's work and produced a great deal of literature on aspects of nature, in particular insects and butterflies. The pub is well patronised today in its idyllic setting facing the large green where the annual International Conker Championships take place each autumn.

The strangely-named *Ten o'Clock* at Little Harrowden was at one time thought to have acted as a collecting point for the post, hence the time of collection in the name. This cannot be verified, so the most likely explanation is that this was the time at which the pub closed in the evening under the local licensing regulations in force at the time – something obvious to its customers, but emphasised in the name, whilst making it unique among signs in the country.

The *Hautboy & Fiddle* (Warmington) is a rare hostelry name describing two instruments that were formerly played in village bands at dances, church, waits, celebrations, and not uncommonly in hostelries. A brief glimpse into a typical festive occasion with music, dancing and drinking appeared in the Bacchus' Bountie of 1593 by the wittily-named, Philip Foulface of Ale-foord': '*While thus they tippled, the fiddler he fiddled, and the pots danced for joy the old hop-about commonly called the Sellanger's Round*'. A rare survivor of one of the instruments (a bassoon) can be found at the church in Easton on the Hill. Another instrument featured in a hostelry name, albeit much later, during the Victorian era, was the *Drum and Monkey* (Wellingborough), a reference to gypsies or travelling buskers from southern Europe, who would often include a monkey playing a drum in their programme. Similarly, a 'monkey stick' often featured in pub music, which was a pole with beer bottle tops attached at intervals, and which when tapped on the floor would give a combined drum and tambourine sound, something like tap dancing. It was also a humorous nickname for the *Morning Star* at Earls Barton in the 1930s.

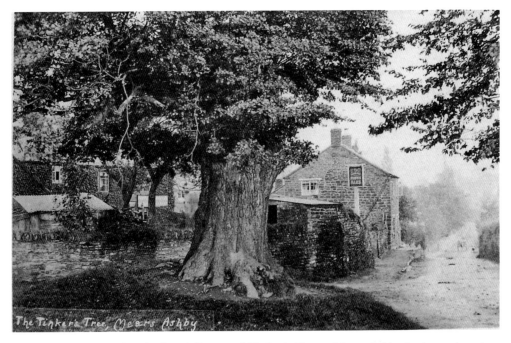

Long gone as a hostelry, the fancifully-named *Tinker's Tree* at Mears Ashby is shown here just before the First World War.

The former *Tinker's Tree* at Mears Ashby received its name from nearby three-hundred year old elm tree that stood nearby on the green, described as having 'wreathing and fantastic roots'. A legend behind the tree's name has come down through time, relating how a travelling tinker would work all day mending pots and pans, one night leaving a thin stick of elm which he normally carried with him, stuck in the ground. It subsequently grew into a fine tree accessible by steps, and was especially popular for climbing by the village children.

In July 1417, Sir John Oldcastle visited Byfield in the county. He was leader of the Lollards, a heretical religious sect which was a precursor of Protestantism, attacking the traditional role of the church, and claiming that the Bible was the only authority, not a hierarchy of officials and church ritual. They called the Pope the Antichrist, and were also extremely modern in their ideas of free love, pacifism, and their belief that women should be ordained. They had been influenced by the rector of Lutterworth, John Wycliffe (c. 1330-1384), who had started the movement and had powerful allies who shared his ideas whilst giving him protection at the same time. He was the first person to translate the Bible into English and his work was continued in this county by his followers at Braybrooke, where they issued sermons in English. The *Cross Tree* at Byfield is a symbolic representation of Oldcastle's meeting with a group of fellow local Lollards.

The *Drumming Well* at Oundle was named after one of the most unique sources of water in the county. Situated at the rear of the *Talbot* it was believed to have supernatural powers. It had a tendency to produce a drumming sound 'like a march'

from the depths whenever a catastrophe was about to befall the realm. One observer in the seventeenth century noted that:

'it beat for a fortnight at the latter end of the month and the beginning of this month. It was heard in the same manner before the King's death and the death of Cromwell, the King's coming in, and the Fire of London'.

In later years a simple explanation for the strange sound was given by a leading geologist who determined that the noise was created by air being expelled from rock crevices into the well via a water seal that periodically produced bubbles. Even so, old habits die hard, and as recently as August 1997, some local people were said to have heard the sound once more (even though the well has long been filled in) shortly before the tragic death of Pricess Diana.

The *Haycock (Wansford)* derives its name from a lengthy poem by Richard Braithwaite, called The Tales of Drunken Barnaby, published in 1716 (see the chapter on Literary References). During his inebriated travels between London and Westmorland via Northamptonshire, he falls asleep on a haystack near plague-stricken Wansford, and gets carried along the Nene during a flood, taking him for a considerable distance, whereupon he wakes up in the presence of some bystanders who ask him where he has come from. In his befuddled state, he tells them 'Wansford in England'. The name of the old coaching inn commemorates the fictitious event. It was here that the seventeen-year-old Princess Victoria made a visit in 1836, the year before she became queen.

The former *Round House* at Sudborough began life as a farmhouse in 1660, subsequently becoming a toll house, then a hostelry in the mid nineteenth century, associated with the brewery of the Tewe family which was next door (now Brooke House). It is now a private residence, one of its former occupants being the renowned county naturalist and author, Lamport-born Denys Watkins Pitchford (1905-1990) who wrote under the pen-name, 'BB'.

The *Guy of Warwick* at Northampton was believed to have been situated on Market Hill, according to a survey of old Northampton made in 1890. He was one of England's great legendary heroes like Robin Hood, and Randolph, Earl of Chester, and belongs, like St George, to a group of 'monster' slayers. He is the protagonist in the Dun Cow legend, supposedly having slain a gigantic cow ravaging and destroying the land around Dunchurch during the Middle Ages. Legends of a similar giant cow and some of its ribs have been found all over England, including Stanion in this county, where the rib can be found in the church (actually a whalebone) and is inscribed with seventeenth-century graffiti. Some of the seven hostelries known in the county as the *Dun Cow* (the others being at Astcote, Flore, Glapthorn, Moreton Pinkney, West Haddon and Wellingborough), may have been influenced by the local version of the legend which describes how a giant cow provided milk for the whole village except for a witch whose company was shunned by everyone. In a fit of malice, she took a sieve one night to the field and milked the cow dry, so that the animal keeled over and died. It was subsequently buried by the sorrowful villagers in a nearby field, but one of its bones was taken to the church of St Peter as a memorial, where it can still be seen today. Unfortunately it looks suspiciously like a whale bone! A rhyme formerly accompanied hostelries of that name:

'Walk in gentlemen, and you will find, the dun cow's milk will please your mind'.

There are also a certain number of names that are not so straightforward: those having more than one possible derivation; and those of uncertain provenance and which have consequently given rise to a number of fanciful if not dubious interpretations!

The *Maidenhead* or *Maiden's Head* as a hostelry name first appears in 1527 (in Lincoln). It can refer to a landing place by a river, or a device featured on the arms of the Mercers Company, who had been granted a charter in 1394 (the mercers specialising in luxury fabrics such as silk). Both origins would have been apt for the hostelry of that name in Oundle, which is situated on a wide stretch of the Nene and had historic trade connections, especially with London. It can equally lay claim to the figureheads of ships, which were of ancient origin, but gradually came to the fore during the Tudor period, which saw the growth of English sea power, and when the hostelry name appears. During the same era, the figure was also often used on the headstock/pegbox of a plucked wire string musical instrument such as the 'orpharion'.

Two names, rare in Northamptonshire, the former *Cat and Fiddle* (Gretton) and *the Elephant and Castle* (Warkworth) may well be a jocular names, the former based on the eighteenth-century nursery rhyme 'Hey Diddle Diddle', the opening words being the name of an Elizabethan dance (recorded 1569, although it has been suggested that the cat and fiddle are Elizabeth herself and the Earl of Leicester. Whatever the case, it was a striking name and image and was certainly the precursor of the modern trend of combining two unrelated words to form the name of a hostelry. The *Elephant and Castle* as image has ancient origins in medieval manuscripts and carvings, and may be a throw-back reference to Hannibal crossing the Alps. It also appeared as the crest on the arms of the Cutlers Company in 1622, the elephant being associated with the ivory used for knife handles.

For a short period in the last decade of the eighteenth century, the *Buffalo's Head* flourished at Apethorpe. This is certainly an unusual sign for such a tiny village, and would appear to have no connection with the 'Royal Antediluvian Order of Buffaloes', a friendly society, which was founded under that name a few years later, in 1822. What is likely is a hunting connection, with Apethorpe Hall dominating the area. This had been a favourite place for James I to stay during several hunting trips there he made during his reign, and the sport certainly continued throughout the following century. Depicting a buffalo would have simply been a variation of the more common bull, and a continuation of the traditional practice of using a foreign or more exotic creature as a hostelry sign.

Daniel Lambert of Leicester (1770-1809) caused a sensation in his time, a giant of a man, with a waistline of 112 inches and weighing at almost fifty-three stone when he died at the early age of forty. Keeper of the jail at Leicester for four years, he was pensioned off at the early age of twenty-five, and began to tour the country, to display his ample frame to inquisitive spectators at a shilling a head. His unhealthy constitution finally gave in, and he died whilst staying at the *Waggon and Horses*, in Stamford St Martin's, where a wall had to be dismantled in order to remove the body. He was buried in the graveyard of the nearby church of St Martin in a coffin. The *Stamford Mercury* reported:

'He had apartments at Mr Berridge's, the Waggon and Horses on the ground floor, for he had long been incapable of walking upstairs...His coffin, in which there had been great difficulty in placing him, is six feet four inches long, four feet four inches wide. The immense substance of his legs makes it necessarily almost a square case...'

The large plot can still be seen today with an information notice, however, the *Waggon and Horses* situated opposite the church, is no more although another hostelry on the other side of the river is named after him.

VISUAL IMPACT

The use of heraldry did not stop in the medieval era, and has continued through the ages, up to the present day, with new images being depicted according to custom, discovery, some images deriving from the earlier motifs such as the *Golden Ball* (from the heraldic roundel, or *rondel d'or*), which first appeared shortly after 1650. Others might be named after a local feature, landmark, or the site of such a place, such as the *Fountain* at Wellingborough with its thirty five recorded springs, five of which are featured on the town coat of arms. At Paulerspury there was the *Old Windmill Inn,* at Duddington and Staverton the *Windmill,* whilst at Kingscliffe the *Windmill Inn* was adjacent to the tower mill which was situated perilously close to the main village street until its demolition in 1925.

Another popular image was a gate, examples being the *Garden Gate* at Weedon Bec, and the *Gate* at Finedon and Cotterstock, a sign that usually a rhyme attached, the latter village adding two extra lines:

'This gate hangs well and hinders none,
Refresh and pay and travel on.
But if perchance a storm appear,
Furl up your sail and anchor here'.

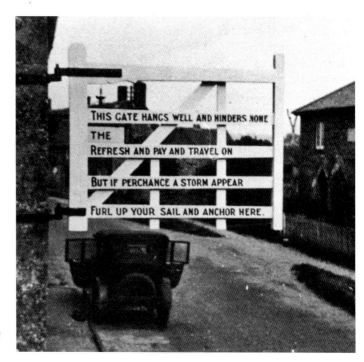

Another unusual hostelry sign, this is the former *Gate* at Cotterstock in the 1930s.

Images from the natural world also made attractive sign: *Beehive, Leopard, Kingfisher, Blackbird, Peacock, Swan and Nest* and the *Magpie*, the latter being especially popular in the county, hopefully not an allusion to the habits of the proprietor! Plants and trees included the *Primrose, Lilacs, Rose, Bay Tree, Cherry Tree, Pines*; and celestial objects such as *Star of the West* (Wellingborough), *Morning Star* (Earls Barton), and the *Seven Stars* (Barnack). However, the *Sun, Moon and Seven Stars* (Blisworth) has a much different origin (see chapter on 'Features'). The *Half Moon* and the *Star* were of course of ancient heraldic origin.

MODERN TRENDS

Today's hostelries in the county have retained a fair number of the older names, in some cases prefixing 'Old' to an existing name or adding the word 'Hotel' or 'Inn', whilst others have conjured up images of the past, with names like the *Brave Old Oak, Mail Coach, Ock n' Dough* (named after the traditional county dish of meat and potatoes with a pastry topping), *Watercress Harry* (a reference to a local vagrant who once peddled that plant and other commodities), *Earl of Dalkieth, Thomas a Becket, Workhouse, Wig and Pen, Leather Craftsman and Foundryman Arms*. The modern trend however is to invent new names like the *Snooty Fox, Jekyll and Hyde, Road to Morocco* (from the Bing Crosby and Bob Hope film series of the 1940s), *Cutting Room, Pike & Eel*. One hostelry has retained its original name, whilst adopting a new one, using both in tandem, at Great Brington where the *Fox and Hounds* has become the *Althorp Coaching Inn*. At Moulton, the *Lumbertubs* takes its name from Lumbertubs Lane, supposedly once used by shopkeepers as a rubbish tip for empty cartons and other containers. Name combinations continue to be popular, some with animal and place combinations: the *Hare at Loddington, Cock Inn at Roade, Hart of Duston*, and the *Goose on Two Streets*; whilst others follow the earlier tradition of using unrelated names such as the *Frog and Fiddler*, or *Monk and Minstrel*.

The *Moon on the Square* (Northampton) is one of a series of early J. S. Wetherspoon chain pub names, based on 'Moon on the Water', a fictitious hostelry that appeared in a London newspaper in 1946. It was invented by the novelist George Orwell, who described it as 'the perfect pub', and listed ten features that it should have, including glasses with handles, a garden, Victorian architecture, a telephone, snacks and lunches, and barmaids who know their customers' names.

Another set of modern names came into being with the creation of the new town of Corby (1950) which had sprung up after the building of one of the largest iron and steel making complexes in the world in 1933/4. During the 1950s and 1960s a string of new hostelries were built for the expanding population around the various new estates. Some of the names were connected with the industry such as the *Open Hearth*, the *Corby Candle*, and the *Pluto*, an acronym for 'Pipe Line Under The Ocean', a reference to the Second World War codename for the production of tubing at Corby for conveying fuel across the Channel to the allies in Europe. Another name chosen was the *Domino*, which despite its obvious one-time connection with pub life, is a rare hostelry name in England. More recently, the *Samuel Lloyd* has opened, in honour of the man who helped transform Corby from a sleepy village into a thriving industrial town, initially with ironstone quarrying in the 1880s, and smelting in 1910, which in turn led to the development of

the later steelworks. On the western periphery of the town, on the Beanfield estate, the *Knights Lodge* was created after the conversion of a former farmhouse, part of which had been built by Sir Christopher Hatton in 1610 for one of his keepers to oversee the nearby woods and land in his possession. Inevitably, like many older buildings, it was claimed to have a ghost (of a monk from Pipewell Abbey which stood close by) whose presence frightened staff for several years – but which has since vanished!

NAME CHANGES

The list below is not exhaustive, and the current scene is very volatile – like closures, names undergo change in accordance with fashion, or the whims of the brewery or landlord. Interestingly, a few hostelries have initially lost their old name for a while to a new one, but have regained it later, sometimes with a slight modification. Several of those listed below no longer exist, but are shown purely because of the name changes they underwent during their lifetime.

During the English Civil War a number of hostelries with a potentially 'offensive' name, depending on which side you were on (or rather the lord of the manor, or locality) such as the *Crown*, or the *King's Head* (which had existed since the reign of Henry VIII) changed their names albeit temporarily, to something less contentious. Though no such cases are recorded in Northamptonshire, this does not meant to say it did not happen – 'absence of evidence is not evidence of absence' – even more so with the amount of action the county saw, culminating with the Battle of Naseby in 1645.

Occasionally there are clerical errors to be found in certain records, particularly alehouse recognizances and trade directories. A frequent occurrence is recording 'Lord's Arms' or 'Duke's Arms' such as for *Hatton Arms* (Gretton), or *Cardigan Arms* (Corby) in the 1820 alehouse recognizances. Similar 'shorthand' occurs in the same listings, giving *Fryers* for the Old Friar at Twywell. Less pardonable however is 'Actor's Arms' for *Exeter Arms* at Middleton. The same type of inaccuracy occurs in the earlier recognizances for the same area in 1796, where 'Flying Eagle' is recorded for the *Spread Eagle* at Cottingham, and at Great Oakley, the latter also 'suffering' on other occasions, with the indeterminate 'Phenix', 'Cockayne Arms' and 'New Inn'! (To confuse matters, it had been set up in 1753 as a coaching inn, known as the *Eagle and Tower*). Another hostelry in the same village underwent a similar change, this time in 1849, where the *Chequers* was listed in the Whellan Trade Directory as the *Anchor*! What may have happened here is that the agent visiting the area may have mistaken the anchor depicted on the manorial coat of arms – that of the Capell Brooke family – as the name of the pub, just used guesswork, or had one drink too many! There was no such recurrence in the 1874 directory however, for the hostelry had closed four years earlier.

The same directory recorded the *Sun, Moon and Stars* at Blisworth as the 'Sun and Moon' in 1849, and the 'Moon and Seven Stars' in 1874. More bizarre is 'Three Cronies' for the *Three Conies* at Thorpe Malsor in 1849; and in the same directory, the 'Three Tons' for the *Three Tuns* at Kings Sutton, perhaps to avoid confusion with the *Three Tuns* at Astwell, one mile away in the east of the parish, which was run by Richard Banks, maltster. Just as strange is a single reference to the *Red Man* at Oundle, mentioned in a notice in a June 1737 edition of the *Stamford Mercury*, with another hostelry, the *Leather Bottle*, as a collection point for wagons taking venison to London.

There appear to be no other records of this name occurring elsewhere in the country. It may well be that the advertiser or printer meant the *Green Man, Red Lion* or *Red Horse* which also existed in the town at the time.

In Kettering, the Victorian proprietors of the Cross Keys Coffee Tavern would probably have been shocked to see their premises many years later become a succession of public houses, and surrounded by an intense cluster of other drinking establishments in the Dalkeith Place area.

Inevitably, certain pubs would be better known locally by nicknames, sometimes as a shortened form of the original, or affectionately with some kind of association, or description. Others might retain the old name of one that had been replaced by a new one that was not as popular. Hence there was the 'Nags' at Corby for the *Nag's Head*, the 'Duck's Nest' for the *Anchor* at Oundle, the 'Jockey' for the *Horse and Groom* at Burton Latimer, the 'Flue' at *Fleur de Lys*, Kettering (frequented by local furnacemen), or the Oakley Hay for the Spread Eagle at Great Oakley. In Northampton, the *White Elephant* started out as the *Kingsley Park Hotel*, but when the race course closed in 1904, there was a dearth of trade; locals subsequently called it a 'white elephant', the name stuck and it was eventually changed by the brewery.

Ashley: *George and Dragon – George.*
Ashton: *Three Horseshoes – Chequered Skipper.*
Aynho: *Red Lion – Cartwright Arms; Alfred's Head – Great Western Arms.*
Blakesley: *Red Lion – Bartholomew Arms.*
Blisworth: *Plough – Royal Oak; Chequers – Half Moon – Sun, Moon and Stars.*
Brackley: *Plough – Harrows – Plough.*
Braybrooke: *Black Swan – Swan.*
Burton Latimer: *Coach and Horses – Waggon and Horses – Latimer's Family Bar; Horse.
 and Jockey – Horse and Groom – Olde Victoria.*
Chapel Brampton: *Stag's Head – Spencer Arms.*
Charwelton: *Fox – Fox and Hounds.*
Clay Coton: *Fox and Hounds – Fox.*
Collingtree: *Ship – Wooden Walls of England.*
Collyweston: *Slaters Arms – Cavalier – Collyweston Slater.*
Corby: *Nag's Head – The Nags; Old White Horse – Village Inn; Six Bells – White Hart.*
Deene: *White Hart – Sea Horse.*
Desborough: *King's Arms – Oak Tree; Eight Bells – White Hart.*
Duston: *Green Man – Thomas a Becket; White Lion – Squirrels; Foundry Arms –
 Foundryman's Arms.*
Eastcote: *Rose and Crown – Eastcote Arms.*
Finedon: *Shoe & Clog (1739) – Mulso Arms; Albion – Tradesman's Arms; Gate – Tudor
 Gate Hotel.*
Gayton: *Squirrel – Squirrel and Crown – Crown and Squirrel – Eykyn Arms.*
Great Oakley: *Eagle and Tower – Spread Eagle.*
Geddington: *Swan – Black Swan – Star.*
Gretton: *Hynde – White Hart.*
Hannington: *Old Red House – Oasis – Old Red House.*
Helmdon: *King William – Bell.*
Irchester: *Queen's Head – Carpenter's Arms; Red Lion – 19th Hole.*

Irthlingborough: *St Peter's Arms – Cross Keys – Railway Inn.*

Islip: *Red Lion – Monk and Minstrel.*

Kettering: *White Hart – Royal – Royal Periquito – Royal; Lord Nelson – New White Horse; Cock – George; Royal Oak – The Crispin; King's Arms – Cross Keys; Angel Inn – Steps; Golden Lion – The Gaiety – Watercress Harry – Manny's – (reverting to) Watercress Harry; New Inn – Market Tavern – Old Market Inn; Crown and Woolpack- Woolpack –* (currently) *Henry's; Stag and Pheasant – Shire Horse; Queen – Hogshead.*

Kingsthorpe: *Old Five Bells – Frog and Fiddler.*

Kislingbury: *Rose and Crown – Red Lyon – Old Red Lion.*

Little Bowden: *Greyhound – The Oat Hill.*

Lowick: *White Horse – Snooty Fox.*

Maidwell: *Goat – Stag's Head.*

Marston Trussell: *Swan – Sun.*

Mears Ashby: *Boot – Griffin's Head.*

Moreton Pinkney: *Red Lion – England's Rose.*

Newnham: *Bakers Arms – Romers Arms.*

Northampton: *White Hart – Old White Hart – Mail Coach – Trooper; Flying Horse – Lord Palmerston; Queens Dragoons – Old Duke of Clarence – Leg of Mutton; Crown – Roebuck (or) White Hart – Shipman's; Royal Oak – Windmill – Queen's Arms; Blue Boar – Shoemakers Arms; Shoulder of Mutton – Phoenix; Saddlers Arms – Falcon Inn; Earl of Northampton Arms – Northampton Arms; Bantam Cock – Danny Boy's – Monkey's Head – Bantam; Kingsley Park Hotel – White Elephant, Labour in Vain – Black Boy; Forget Not – Sportsman's Arms; Plasterers Arms – Black Lion – Wig and Pen.*

Old: *Chequer – Old Chequers.*

Orlingbury: *King's Arms – Queen's Arms.*

Oundle: *Beehive – Vine; Black Pots – Horse and Jockey – Half Moon; King's Head – Angel; Crown – Horseshoe – Half Moon – Three Tuns; Red Horse – George; Maidenhead – Nag's Head; Three Lasts – Crown; Falcon – Rose and Crown; Le Bull – Hind – Waggon and Horses; Old London Waggon – King's Arms; Unicorn – Masons Arms – Old Hind; Railway Hotel – Riverside; Hart's Head – White Hart.*

Passenham: *Duke of Cumberland – Duke's Head.*

Pattishall: *George and Dragon – Peggotty's Restaurant – Four Pillars Restaurant.*

Peterborough: *Fighting Cocks – Spread Eagle; Oak Branch – Painters; Chequers – Nag's Head; Steam Engine – Besant; Wheelwrights Arms – Sportsman.*

Raunds: *Six Ringers – Red Lion; Maidenhead – Robin Hood and Little John – Robin Hood.*

Ravensthorpe: *Woolpack – Old Woolpack.*

Rothwell: *Old Woolpack – Chequers; Crown and Boot – New Inn; Sun – Rowell Charter; Bell Inn – Bluebell – The Pub – Bell; Greyhound Inn – Sexton – Old Greyhound.*

Rushden: *Swan and Dolphin – Swan – Coach and Horses; New Inn – Railway Inn.*

Rushton: *Cullen Arms – Hope Arms – Thornhill Arms.*

Sibbertoft: *Black Swan (by 1874 the Old Swan).*

Slipton: *Red Cow – Samuel Pepys.*

Stamford St Martin's Without: *Falcon and Woolpack (1660) – Swan and Woolpack – Swan and Woolpocket – Bull and Swan.*

Staverton: *New Inn – Countryman.*

Sudborough: *Cleveland Arms – Vane Arms.*

Sulgrave: *Three Compasses – Compass.*
Towcester: *Pomfret Arms – Saracen's Head; George – New White Horse.*
Wakerley: *Red Lion – Exeter Arms.*
Weedon Bec: *New Inn/Hotel – Heart of England.*
Weldon: *White Horse – Nag's Head; Talbot – King's Arms.*
Welford: *Hind – Swan.*
Wellingborough: *Sun – Drum and Monkey; Duke of Wellington – Duke of York; Sow and Pigs – Cambridge Hotel – Leather Bottle; Angel – Red Well; King of Prussia – Globe – Rafferty's; Railway Inn – Crispin.*
Weston by Welland: *Carpenters Arms – Wheel and Compass.*
Wollaston: *Nag's Head – Wollaston Inn.*
Woodnewton: *Swan – White Swan.*

THE 'LOST' HOSTELRIES OF THE VILLAGES

The list shows most of the former hostelries and beershops that existed in the county mainly before 1900, some having changed their name as a new owner took charge, and in some cases, changing location but retaining the same name. Whilst the greater majority in the list have been accounted for, one or two may well have 'got through the net' and still exist, but under a new name.

Some of these still survive today as private homes, occasionally displaying a name plate denoting their former existence eg the *Hautboy and Fiddle* at Warmington, and the *Old Queen's Head* at Dodford. Perhaps the most abundant of former hostelry names occurs at Brixworth where no less than five houses acknowledge their past use, namely the Hare and Hounds, Fox and Hounds, Fox and Pheasant, Old Vine, and the Crown.

A few have vestiges of their former use such as a hanging post or arm which once held the sign, whilst some have retained stone tablets in the external walls of the building, as in the case of the *New White Horse* in Kettering (now Burton's) which depicts a rampant horse, the *Wig and Pen* in Northampton with a black lion from its days as the *Black Lion*, whilst in the courtyard of the *Talbot* in Oundle, is the resited image of 'three tuns' from the demolished John Smith Brewery and its *Half Moon* pub in North Street.

Several others have been demolished. Some have closed and reopened elsewhere, only to close once again permanently, such as the *Peacock*, and *Bantam Cock*, both in Wellingborough. Many villages are now 'dry' as trade has become more attractive in towns with a choice of specialised or cut-price establishments, though even some towns are seeing an alarming decline in the number of hostelries. The situation remains volatile.

Some 'pubs' had a very short life, in some cases being set up purely to supply beer to hosts of temporary workers such as railway navvies, or craftsmen working at isolated places away from the nearest settlement. One of the most interesting existed during the Second World War, and was patronised by US forces from nearby Deenethorpe airfield. It was constructed by them on the edge of Weldon, by the Stamford Road, and had a proper sign: *The Lady in the Bath* – pubs obviously being a novelty for the Americans being away from their homeland! Many of the airbases also had their own bar, such as the *Roosevelt Bar at Kingscliffe, where beer was advertised as free!*

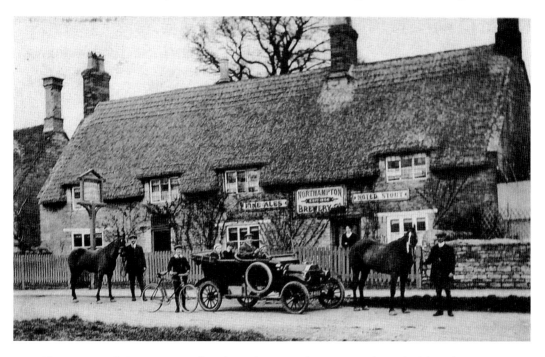

The *Rose and Crown* situated midway between the two parishes of Aldwincle St Peter and Aldwincle All Saints, *c.* 1910 and now in 2010 as a dwelling.

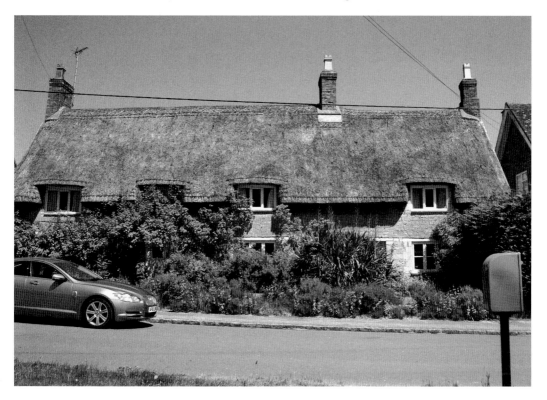

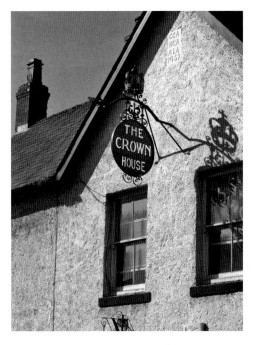

A vestige of its past use as a hostelry is this sign at Crown House in Rothwell.

Local historians and researchers have managed to trace the location of many of those listed below, whilst the sites of others have been lost in the mists of time. A list of those hostelries (existing or vanished) which underwent a change of name at some time are listed in a separate section.

Abthorp: *Stocking Frame.*
Adstone: *Wheatsheaf, White Swan.*
Alderton: *Old Crown, Plough.*
Aldwincle: *Castle Tavern, Red Lion, Rose and Crown.*
Apethorpe: *Buffalo's Head, Queen's Head, Westmorland Arms.*
Arthingworth: *Kelmarsh Arms.*
Ashley: *Axe and Compass, Black Horse, Brown Horse, Carpenters Arms, Graziers Arms.*
Astcote: *Dun Cow, Queen's Head, Rose Inn.*
Astrop: *Crown, Red Lion, Three Tuns.*
Aynho: *Bell, Red Lion, Wharf, White Hart.*
Badby: *Maltster.*
Barby: *Black Horse, Horse & Jockey, Old Crown.*
Barnwell: *Swan.*
Barton Seagrave: *Three Tuns.*
Blakesley: *Greyhound, Red Lion, Royal Oak.*
Blatherwycke: *Horse and Jockey, Sword in Hand.*
Blisworth: *Sun, Moon and Stars; Grafton Arms, Navigation Inn, Woodhouse.*
Boddington: *Star.*
Boughton: *Griffin, Lion.*
Bozeat: *Chequers, Cross Keys, Lord Nelson, Royal Engineer (Shoulder of Mutton).*

Bradden: *Sugar Loaf.*

Brampton Ash: *Fox.*

Braunston: *Anchor, Castle, Champion, Cross Guns, Dog and Gun, George and Dragon, Harrow, Ship, White Swan.*

Braybrooke: *Sun, White Horse.*

Brigstock: *Angel, Black Horse, Fox and Hounds, Golden Lion, Grocers Arms, Montagu Arms, Masons Arms, Lord Nelson, Nag's Head, New Inn, Northamptonshire Yeoman, Ringers, White Hart.*

Brixworth: *Admiral Nelson, Crown, Fox and Hounds, Fox and Pheasant, Hare and Hounds, Peacock, Vine.*

Broughton: *Buccleuch Arms, Green Dragon, Griffin, Three Tuns, White Horse.*

Bugbrooke: *Angel, Crown, George, Swan, Wagon and Horses.*

Bulwick: *Bell, Carbery Arms, Chequers, Swan.*

Byfield: *Bell, New Inn, Rose and Crown.*

Chapel Brampton: *Old Posting House.*

Clipston: *Boot and Crown, Red Cow, Rose and Crown, Sun Inn.*

Clopton: *Red Lion.*

Cogenhoe: *Sportsman's Arms.*

Cold Higham: *Crown.*

Collingtree: *Royal Oak.*

Collyweston: *Blue Bell, Corner Inn, Engine, Talbot, White Swan.*

Corby: *Black Horse, Eight Bells, Nag's Head, Robin Hood.*

Cosgrove: *Falcon, Plough.*

Cotterstock: *Gate.*

Cottingham: *Crown, King's Head, Racehorse, Three Horseshoes, White Hart.*

Cranford St Andrew: *Woolpack.*

Cranford St John: *Stag.*

Cransley: *Red Lion, White Horse.*

Creaton: *Horseshoe.*

Crick: *Flying Horse, George, Grand Union Inn, Shoulder of Mutton, Wharf.*

Croughton: *Bird in the Hand, Bluchers Arms, Chequers, White Hart, White Horse.*

Culworth: *Horseshoe.*

Dallington: *Robin Hood and Little John.*

Deanshanger: *Duke's Head, Mount, Old Brook's Head, Stag's Head, Woodman.*

Deene: *Seahorse.*

Deenethorpe: *Nag's Head (Cardigan Arms).*

Denford: *Rose and Crown.*

Denton: *Quart Pot.*

Dingley: *Horse and Jockey.*

Dodford:, *New Inn, Swan.*

Draughton: *New Inn.*

Duddington: *Crown, Windmill.*

Duston: *Florence, Forge Hammer, Green Man, Harborough Arms, Hare and Hounds, Old Wooden Spout, Quarry Arms, Rifle Butt, Robin Hood, Tram Car.*

Eastcote: *Boot.*

East Farndon: *Bell Inn, Three Horseshoes.*

East Haddon: *Plough.*

Easton on the Hill: *Carpenters Arms, Crown Inn, Princess, White Horse, Princess, Retreat, Slaters Arms.*

Ecton: *Globe.*

Evenley: *Barley Mow.*

Everdon: *Barley Mow, Crown and Anchor, Plough, Plume of Feathers, Red Lion.*

Eydon: *Blackamoor's Head, Plough.*

Farthinghoe: *Royal Oak.*

Faxton: *Fox.*

Flore: *Chequer, Dun Cow, Fox and Hounds, New Inn.*

Fosters Booth: *Carriers Inn, George and Dragon.*

Fotheringhay: *New Inn, Old Inn, White Hart.*

Gayton: *Anchor, Queen Victoria, Red Lion.*

Geddington: *Angel, Duke's Arms, Royal George, Royal Oak.*

Glapthorn: *Crown, Dun Cow, Leather Bottle, Royal Oak.*

Grafton Regis: *Blackamoor's Head, Bull, King's Arms, Rose and Crown.*

Grafton Underwood: *Duke's Arms, Fleece.*

Great Addington: *Leopard.*

Great Billing: *Stag's Head.*

Great Harrowden: *Dolphin, Royal Oak.*

Great Oakley: *Chequers.*

Greens Norton: *George and Dragon, Old Gate, Red Lion, Rose.*

Gretton: *Bull, Cat and Fiddle, Crown, Fox, White Hart.*

Guilsborough (including Nortoft): *Fox and Grapes, Red Lion, Sun Inn*

Hannington: *Green Man, Old Mill Stone.*

Hardingstone: *Five Bells.*

Hardwick: *Royal Oak.*

Hargrave: *King's Arms, Waggon and Horses.*

Harlestone: *Hare and Hounds.*

Harpole: *Bull and Butcher, Red Lion.*

Harrington: *Old White Bear, Red Cow.*

Harringworth: *Crown.*

Haselbech: *Red Cow.*

Hellidon: *Barley Mow.*

Helmdon: *Chequers, Cock and Magpie, Cross, Cross Keys.*

Hemington: *Bill and Hatchet.*

Holcot: *Old Chequers, Chequers.*

Hollowell: *Coach and Horses.*

Horton: *Gunning's Arms.*

Irchester: *Crown and Anchor, Queen's Head, Red Lion.*

Isham: *The Pines.*

Islip: *Bell.*

Kelmarsh: *Fox and Hounds, Golden Lion, Talbot.*

Kilsby: *Devon Ox.*

Kings Sutton: *Bell, Red Lion.*

Kingscliffe: *Bull's Head, Crown, Eagle Tap, Golden Ball, Maltsters Arms, Red Lion, Shovel and Firkin, Sun, Turners Arms, Wheatsheaf, Wheel, Windmill Inn.*

Kingsthorpe: *Cock, Five Bells, Horseshoe, Rose & Crown, White Horse.*

Kislingbury: *Barley Mow, Bull, Chequer Inn, Old Fighting Cocks, Wheatsheaf.*
Lamport: *Fox.*
Laxton: *Carpenters Arms, Stafford Knot, Swan.*
Lilbourne: *Bell, Bull, Chequers.*
Little Brington: *Britannia Inn.*
Little Harrowden: *Red Lion.*
Little Irchester: *Cottage, Prince of Wales.*
Little Oakley: *Sow and Pigs.*
Long Buckby: *George Inn, Greyhound, Horseshoe, Red Lion, Three Horseshoes.*
Lower Benefield: *Chequers, Hind.*
Lowick: *George.*
Maidford: *George.*
Maidwell: *Chequers, Goat, Horseshoe.*
Marston St Lawrence: *Red Lion.*
Mears Ashby: *Boot, Red Lion, Tinker's Tree.*
Middleton: *Exeter Arms, Woolpack.*
Middleton Cheney: *Five Bells, Greyhound, Royal Oak, Snob and Ghost.*
Moreton Pinkney: *Crown, Dun Cow, Red Lion.*
Moulton: *Boot, Chequer, Dolphin, Old Bluebell, Old Shoulder of Mutton.*
Naseby: *Bell.*
Nassington: *Boat, Carpenters Arms, Crown, Plough, Three Horseshoes, Three Mill Bills.*
Nether Heyford: *Anchor, Bricklayers Arms, Globe.*
Newbottle: *Bell, Rose & Crown.*
Newnham: *New Inn.*
Newton Bromswold: *Swan Inn.*
Norton: *Spread Eagle.*
Old: *Old Chequers*
Old Stratford: *Black Horse, Falcon, Saracen's Head, White Lion.*
Overstone: *Red Lion.*
Passenham: *Black Horse, Duke's Head, Falcon, Fox and Hounds, Swan.*
Pattishall: *Malt Shovel.*
Paulerspury: *Barley Mow, Bricklayers Arms, Old Windmill Inn, Plough, Red Lion, White Hart.*
Piddington: *Crown & Thistle, New Inn, Old Crown.*
Pilton: *Blue Bell (Bell).*
Pitsford: *Fox and Hounds.*
Polebrook: *Boot and Shoe, Duke's Head, Duke of Wellington.*
Potterspury: *Anchor, Blue Ball, Red Lion, Reindeer.*
Preston Capes: *Swan.*
Pytchley: *Fox and Hounds.*
Ringstead: *Swan.*
Roade: *Fox & Hounds, George, New Inn, Swan, White Hart.*
Rockingham: *Three Horseshoes.*
Rushton: *Queen's Arms, Three Cocks.*
Scaldwell: *Red Lion.*
Shutlanger: *Horseshoe.*
Sibbertoft: *Black Swan.*

Silverstone: *Compasses, Royal Oak, White Lion.*
Slipton: *Plough.*
Southwick: *Bill and Hatchet.*
Spratton: *Chequers.*
Stanion: *Mason's Arms.*
Staverton: *Crown, Windmill.*
Stoke Albany: *George, Talbot, White Hart.*
Stoke Doyle: *Langham Arms, Swan.*
Sudborough: *Rose and Crown, Round House.*
Sulgrave: *Compass, Magpie, Six Bells.*
Sutton Bassett: *Queen's Head.*
Syresham (including Crowfield): *Bell, Bull, Case Is Altered, Fox.*
Sywell: *Fox and Hounds.*
Tansor: *Black Horse, White Horse.*
Thornby: *George Inn.*
Thorpe Malsor: *Rose and Crown.*
Thorpe Mandeville: *Magpie.*
Thurning: *Rule and Compass, Wagon and Horse, Wheatsheaf, White Horse.*
Titchmarsh: *Vine, Carpenters Arms, Cottage Inn, Pointer, Rose and Crown, Swan, Three Horseshoes.*
Twywell: *Masons Arms, Queen's Head.*
Upper Heyford: *Barley Mow.*
Upper Stowe: *Bird in Hand.*
Upton: *Chequers.*
Wakerley: *Exeter Arms, Three Horseshoes.*
Walgrave: *Langton Arms.*
Wappenham: *Bull, Chequers, Horseshoe, Spotted Cow.*
Warkton: *Duke's Arms.*
Warkworth (Grimsbury): *Elephant & Castle.*
Warmington: *Angel, Hautboy and Fiddle, Queen Adelaide*
Watford: *Barley Mow, Henley Arms, Plough.*
Weedon Bec: *Admiral Nelson, Black Horse, Bull Inn, Duke of Wellington, Fox and Hounds, Garden Gate, Horseshoe Inn, Old Crown, Queen's Head, Red Lion, Royal Oak, Sun (Boot and Slipper), Swan, White Hart.*
Weekley: *Montagu Arms.*
Weldon: *Fox and Hounds, Jolly Roper, King's Arms, Nag's Head, White Hart.*
Welford: *Cross Keys, Peacock, Sun, Swan, Talbot, Wheatsheaf.*
Welton: *Red Lion, White Swan.*
West Haddon: *Bell, Cock, Dun Cow, Grazier's Arms, Red Lion, Spread Eagle, White Swan.*
Weston by Welland: *Crown, Shoulder of Mutton.*
Weston Favell: *Horseshoe Inn.*
Whilton: *Plough, Spotted Cow.*
Whitfield: *Sun.*
Whittlebury: *Horse & Groom, Stags Head.*
Wilbarston: *Harcourt Arms, Hare and Hounds, King's Head, Queen's Head, Red Lion, Rose and Crown, Royal Oak, Swan, Wheel.*
Wollaston: *Bell, Fox and Hounds, Marquis of Granby, Nag's Head.*

Woodend: *Magpie.*
Woodford: *Bakers Arms, Coach and Horses, Falcon, Masons Arms, Queen's Head, Steam Engine, White Horse.*
Woodford Halse: *Flower de Luce, Hare and Hounds.*
Woodnewton: *Hare and Hounds, Horse and Jockey.*
Wootton: *Fox and Hounds, Old Crown, Rose and Crown, Red Lion.*
Yardley Gobion: *Packhorse, Reindeer.*
Yarwell: *Fox Inn, Masons Arms.*
Yelvertoft: *Old Panniers, Boat.*

The following places were formerly part of Northamptonshire. Little Bowden was absorbed into Market Harborough between 1891 and 1895. Stamford Baron/St Martin's Without was that area of the town which lies south of the river Welland and which was part of the county until 1889. Peterborough, and the surrounding villages forming part of the Soke, geographically remained part of Northamptonshire until 1965 when it merged with Northamptonshire, and has since become the Unitary Authority of Peterborough.

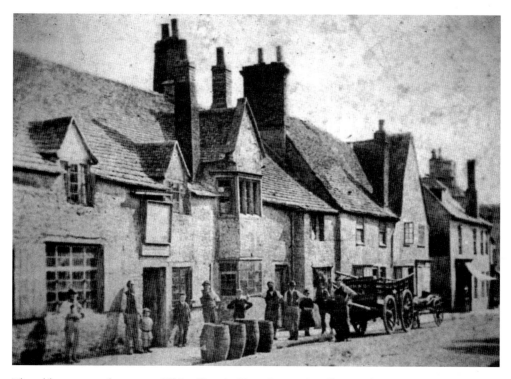

The old seventeenth-century *White Hart* in New Street, Oundle seen here in 1873, seven years before its demolition and its replacement with the cloisters of Oundle School.

Ailsworth: *Barley Mow, Wheatsheaf.*
Bainton: *Blue Boar.*
Barnack: *Carpenters Arms, New Inn, Red Lion, Seven Stars.*
Borough Fen: *Three Horseshoes.*
Castor: *George and Dragon.*
Eye: *Greyhound, Red Lion, Spade & Shovel.*
Glinton: *Six Bells, Crown.*
Helpston: *Axe and Cleaver, Carpenters Arms, Fitzwilliam Arms, Prince of Wales, Queen's
 Head, Railway Hotel, Royal Oak.*
Little Bowden: *Greyhound.*
Maxey: *White Horse.*
Newborough: *Bull, Crown.*
Paston/Werrington: *Blue Bell, Paul Pry, Royal Oak, Wheatsheaf.*
Peakirk: *Bull, Boat, Railway Inn.*
Stamford Baron/St Martin Without: *Beehive, Coach and Horses, Exeter Arms, Fitzwilliam
 Arms, Fox and Hounds, Marquis of Granby, Red Cow, Sun, Telegraph, Waggon and
 Horses, White Lion.*
Sutton: *Cross Keys Inn.*
Ufford: *Buck.*
Wansford: *Black Swan, Marquis of Granby, New Mermaid, Old Mermaid.*

THE LOST HOSTELRIES OF THE TOWNS

At Oundle, several hostelries vanished within a short time, as early as the 1860s. A
'free grammar school' had been founded in 1556 by William Laxton, a prosperous
merchant and lord mayor of London. This had been rebuilt between 1857 and 1862,
which subsequently evolved into two separate institutions five years later, one of
which became The Grocers' Company School, now Oundle School. In order to expand
and glorify the 'new' school, it was essential to acquire a large amount of land and
several buildings, which included a number of hostelries and a brewery site. A series
of purchases began with the acquisition of the *Dolphin* in North Street in April 1867,
which subsequently became the Old Dryden Boarding House. This was followed by the
purchase of the *Three Tuns*, adjoining the churchyard on the corner of North Street, in
June 1873, which was demolished, the site with adjacent buildings being replaced with
the grandiose School Room and a new Laxton Boarding House. The next hostelry to be
affected was the *Plough* at the far end of West Street, near Mill Lane, in October 1874,
for inclusion in Laxton House. As expansion continued, a large portion of New Street
was targeted, beginning with the substantial seventeenth-century *White Hart* on the
east side of the street, with ninety pounds compensation being given to the leaseholders.
Demolition began in November 1880 (with the school boys allowed to join in for half
an hour at the commencement of the work) and was completed in April the following
year. The opening of the Cloisters took place on the site in 1883. On the opposite
side of the road the Thomas Barnes Brewery and yard (itself on the site of the former
Mermaid) was purchased between 1883 and 1884, for demolition and the building of
the School House (which opened in 1887). The latter was extended in 1909, following
the acquisition of the *Red Lion* three years earlier. Finally, the *Turks Head* and adjoining

buildings between the School House and the *Talbot* were purchased in July 1909 to provide an open space enabling the School House to have more light and air. A range of barns at the rear of this area was converted for use as the Talbot Studies building which opened five years later.

The following list shows only those town hostelries that existed before the twentieth century, and have since disappeared. Some of these reappeared after their demise, at a different site, only to vanish once again later. Many of those listed underwent name changes over the years, sometimes several times, and are marked with an asterisk. Some of these still exist under the 'new' name. The alternative names can be found in a separate section in this book, which is useful for cross checking.

Brackley: *Antelope, Cross Keys, George, Horse and Jockey, Kings' Head, Royal Oak, Three Foxes, Wheatsheaf, White Lion, Woolpack.*

Burton Latimer: *Bell, Red Cow, Rose and Crown, Thatchers Arms, Waterloo Victory Inn.*

Daventry: *Admiral Nelson, Bear Inn, Black Horse, Boot, Brown Bear, Crown, Crown and Cushion, Eagle, Fox and Hounds, Greyhound, Leathern Bottle, Marquis of Granby, Odd Fellows' Arms, Peacock, Plough, Plough and Bell, Prince Regent, Quart Pot, Royal Oak, Sun, Swan, Waggon and Horses, White Horse, World's End.*

Desborough: *Angel, Black Horse, Buck, Cabin of Comfort, Swan, New Inn, Talbot.*

Earls Barton: *Battle of Inkerman, Beacon, Fox and Hounds, Horseshoe, Morning Star (aka Drum and Monkey), Old Swan.*

Finedon: *Albion, Gate, Masons Arms, Plough, Prince of Wales, Red Cow, Royal Oak, Shoe and Clog.*

Higham Ferrers: *Anchor, Bell, Chequers, Red Cow, Saracen's Head, Sow and Pigs, White Hart, White Horse.*

Irthlingborough: *King's Arms, Railway Inn*, Sow and Pigs, White Horse.*

Kettering: *Angel, Blackamoor's Head, Cock, Cross Keys*, Crown Inn, Crown And Woolpack*, Duke's Arms, Duke of Wellington, Fleur de Lys, Golden Lion, Half Moon, Hare and Hounds, Nag's Head Inn, New White Horse*, Old White Horse, Queen Inn, Racehorse, Robin Hood, Royal Oak*, Saracen's Head Inn, Spring Gardens, Sun Inn, Talbot, Three Crowns, Vine.*

Northampton: *Admiral Rodney, Angel, Black Boy, Black Boy and Still, Blue Boar* , Boot and Slipper, British Banner, Bull, Bull and Butcher, Bull and Goat, Bull's Head, Burghley Arms, Catherine Wheel, Chequer, Coach and Horses, Cock, Cooks Arms, Crispin Arms, Cross Keys, Crow and Horse, Crown*, Crown and Anchor, Dolphin, Dun Cow, Durham Ox, Eagle Tavern, Eagle and Child, Fleece, Flying Horse, George, Golden Ball, Green Dragon, Guy of Warwick, Half Moon, Hare and Hounds, Hen and Chickens, Hind, King's Arms, King's Head, Knightley Arms, Labour in Vain, Little Bell, Mitre, Melbourne Tavern, Mother Redcap's, Northampton Arms, Old Black Lion, Old Jolly Smokers, Old White Hart, Peacock, Pheasant, Plumbers Arms, Plume of Feathers, Princess Royal, Quart Pot, Queen's Dragoons, Queen's Head, Ram, Recruiting Sergeant, Red Lion, Rose and Punchbowl, Royal, Royal Oak*, Saracen's Head, Shakespeare, Shoulder of Mutton*, Spread Eagle, Star, Stag's Head, Sultan, Talbot, Three Cups, Three Tuns, Toll House Inn, Town Arms, Travelling Scotchman, Two Brewers, Vine, Waggon and Horses, Warwick Arms, White Hart*, White Horse, White Lion, William the Fourth, Woolpack.*

Oundle: *Admiral Keppel, Anchor, Angel*, Bell, Ben Jonson's Head, Black Horse, British Queen, Bull, Carpenters Arms, Cross Keys, Crown*, Dolphin, Drumming Well, Falcon*,*

Flower de Luce, Green Man, Half Moon, Hand and Slipper, Lamb, Masons Arms, Mermaid, Nag's Head*, Old Hind*, Mason's Arms), Old London Waggon*, Plough, Red Horse*, Red Lion, Riverside*, Swan, Three Horseshoes, Turk's Head, Victoria, Vine*, Waggon and Horses*, Wharf, White Hart*, White Lion, Wool Pocket.*

Peterborough: *Angel, Bell & Oak, Boat, Black Dog and Trumpet, Black Swan, Blackamoor's Head, Britannia, Bull and Dolphin, Carpenters Arms, Cherry Tree, Crown, Duke of Wellington, Falcon, Ferry Boat, Fighting Cocks, Fleece, George and Angel, George and Dragon, Horse and Jockey, King's Head, Locomotive (x2), Ostrich, Pony's Head, Rose and Crown, Salmon & Compasses, Saracen's Head, Ship, Spittal Bridge, Spread Eagle, Steam Engine, Talbot, Three Tuns, Waggon and Horses, Wheel, White Horse (x2).*

Raunds: *Bakers Arms, Cock Inn, Foresters Arms, George and Dragon, Golden Fleece, Live and Let Live, Robin Hood*, Six Ringers*, Tailors Arms, Wheatsheaf.*

Rothwell: *Bull's Head, Chequers, Cock, Crown Inn, Five Ringers, George, Green Man, Horse and Groom, New Inn*, Old Woolpack*, Plough.*

Rushden: *New Inn*, Swan and Dolphin*, Waggon and Horses*.*

Stamford Baron/St Martin Without: *Beehive, Bull and Swan*, Coach and Horses, Exeter Arms, Fitzwilliam Arms, Fox and Hounds, Marquis of Granby, Red Cow, Sun, Telegraph/Telegraph and Painter, White Lion.*

Thrapston: *Beehive, Bird in the Hand, George, King's Arms, King's Head, Plumbers Arms, Railway, Red Lion, Swan, Wheatsheaf, White Hart Inn.*

Towcester: *Albion Inn, Bell, Crown, Horse and Jockey, Mermaid, Nelson's Arms, New White Horse, Pomfret Arms, Royal Oak, Running Mare, Star, Sun, Swan, Talbot, Wheatsheaf, White Hart, White Horse, Yeoman.*

Wellingborough: *Angel*, Axe and Cleaver, Beeswing, Bell, Calendar, Crispin's Arms, Cross Keys, Crown, Dew Drop, Drum and Monkey, Dun Cow, Exchange, Fountain, George, Half Moon, Horse and Jockey, Leather Bottle, Masons Arms, New Inn, Old King's Arms, Oxford Tavern, Primrose, Railway, Red Lion, Rose and Crown, Royal, Royal Stuart, Rule and Compass, Shining Hour, Ship, Star of the West, Sun, Swan and Nest, Three Tuns, Victoria, White Hart, White Horse, White Swan.*

RISE OF THE BREWERIES

Traditionally there was usually a maltster, either in the village or locally, to cater for the needs of both the alehouse and the individual. Many of the buildings, or 'maltings', can still be seen in villages around the county, some of exceptional size.

However, a substantial blow was dealt with the introduction of a tax on malt in 1780. This had a profound effect on the great number of alehouse keepers, as they struggled to make ends meet as a result of the rising costs. This was not helped by a series of bad harvests. Unable to brew economically, many licensees began to rely on the bigger commercial brewers for stock, more so after 1869, for loans and leases to make ends meet. Inevitably, this dependence led to a complete take-over of the hostelry by the brewery, transforming it into what would later become known as a 'tied house'. By 1900, an estimated 95% of licensed premises were tied in some way or another.

These commercial brewers had their roots in the Tudor period after the 1485 Act allowed a new type of brewery to come into being, which could produce larger, more consistent batches which resulted in a better quality product. These gradually evolved into the large breweries of the eighteenth century, which were helped in a number of different ways: by the creation of the turnpike roads with their better surfaces; the Industrial Revolution, with the introduction of steam power; scientific advances such as the invention of the hydrometer and thermometer; and a better understanding of the brewing process.

One of the most unique breweries in the county was established relatively late, at Syresham in the 1890s, by the Kirby family who had expanded their grocery business into a large retail outlet, selling all kinds of goods, and had now set up a two-floor brewery building, known as King's Brewery, adjacent to their store. Motorcycles would be sent out to collect orders from retail outlets and individuals in local villages within a wide area, and deliveries were made initially by handcart or dray and later by vans.

The largest breweries like Phipps in Northampton had clusters of their own tied houses, close to the brewery and were also able to deliver within a thirty mile radius by horse-drawn dray. At its height, the Praed Campbell Brewery in Wellingborough had as many as 150 tied houses – such was the power of these industrial giants in the county, as they bought up rival breweries, enabling them to place other public houses and off licences under their wing at the same time.

In the nineteenth century there were several small brewers established around the county, providing beer locally, some flourishing for just a short time. One of these went on to build up an 'empire' in Northampton. Starting with a brewery in Towcester in 1801, Pickering Phipps set up new premises at Bridge Street in Northampton in 1817 that soon began to pay off handsomely. His main rivals the Phillips Brothers established the Phoenix Brewery (1856) also in Bridge Street, which went from strength, becoming the Northampton Brewery Company (NBC) in 1874, and subsequently acquired the Lion Brewery in 1890. Phipps also began to take over other breweries in the town: the Albion in 1899, and later, the Castle in 1933. Both Phipps and the NBC amalgamated in 1957 and were subsequently acquired by Watney Mann in 1960.

In Wellingborough, John Woolston had been running a brewery in Sheep Street since at least the early 1820s which was purchased by Arthur Praed Campbell in 1878, the building subsequently being rebuilt and trading as Campbell Praed and Company. In the same street, William Dulley had established a brewery in 1840 and also became very successful, even becoming a benefactor to the town in 1892, by providing the community with a swimming pool using warm water from the brewery – perhaps an early form of recycling – which flourished until 1914. A corner of the original deep end has been excavated and restored by the Wellingborough Museum where it is now on display. His brewery was also acquired by Campbell Praed in 1920, the latter flourishing for many years, until becoming part of Phipps in 1954.

At Kettering, Elworthy's Crown Brewery became the dominant supplier in the area by the end of the nineteenth century, whilst at Oundle, four breweries: the Oundle Union, Anchor, Barnes's, and Smith's, had the monopoly of the area, the latter having been established in 1775 and flourishing remarkably for almost two hundred years, finally closing in 1972, after a takeover by John Smith of Yorkshire.

Inevitably, drinkers would discuss the merits of the beer available in the county, and one particular jocular rhyme was commonplace for many years, despite being completely mixed up and contentious!

'Campbell's beer is very good, Dulleys's ain't amiss, Bedford beer is damnable,
And Praed's is worse than ...' (this?)

With the big national breweries taking over those in the county, the rise of keg beer and lager and the demise of cask-conditioned ale, there was inevitably going to be a reaction, and with the rising demand for real ale, a number of local micro-breweries came into being. Whilst nine in the county have closed since 1993, nine others are currently flourishing: at Barnwell, Brackley, Great Oakley, Guilsborough, Kettering, Kislingbury, Northampton, Rothwell and Silverstone.

The subject of breweries requires a book in its own right, and fortunately such a publication does exist, in the form of *Brewed in Northamptonshire, A Directory of Northamptonshire Brewers, including the Soke of Peterborough, 1450 to 1998* by Mike Brown and Brian Wilmott (Brewery History Society, 1998). This is a thorough in-depth view of the subject and is highly-recommended.

One of today's micro-breweries in the county, at Great Oakley.

THE COLOURFUL
ATMOSPHERE AND
LANGUAGE OF THE PAST

Imagine you were living during the sixteenth and seventeenth centuries, and were visiting a hostelry in the towns like Northampton, Peterborough or Oundle. You might have wondered if you were in a foreign country – such was the wide range of unfamiliar vocabulary and expressions used by the patrons and host, much of it little used outside the walls. Hostelries were like microcosms of the world – a place to meet all types of people, to socialise, to drink, to eat, to sleep, to get robbed, assaulted or murdered, a brothel, a gambling den, an information centre, a venue for entertainment, a money changing bureau, a place for underhand dealings such as hatching a conspiracy or plot, money-laundering, and receiving, exchanging or selling stolen or smuggled goods. The main reason for frequenting a hostelry of course was to drink or tipple, and a lot of that certainly went on, as it does today. 'Toping' – drinking excessive amounts, originally meant to seal a wager or bet with a drink. These words have survived, unlike the following.

If an argument at a 'boozing ken' (alehouse) got upheated you would hear either the host or one of the brawlers shout: 'stow you!' (shut up) or if it got completely out of hand, 'bring a waste!' (get out). If after a few drinks you needed to visit the toilet you would go to 'pluck a rose', or 'ming' (urinate). You might be drinking a 'gage of booze' (a quart of ale), usually 'noppy ale' (which probably derives from 'hops'. A variation, 'nappy' survived in Northamptonshire dialect as a word for beer until the nineteenth-century). An alternative word for tipple was 'lap' and if you got drunk, you were 'cup-shot'. You would pay for your drinks with 'bits' or 'bites' (coins) or white money (silver coins).

If you were gambling you would be the potential victim (a 'simpler' or 'cousin') of a 'cony-catcher' – a con-man who would be adept at 'cogging' (cheating at cards or dice). You would also have to be on your guard against pickpockets ('nips' or 'foists'). Other shifty characters you might be mixing with were 'flicks' (thieves) and 'padders' (highway robbers). 'Sacking' (prostitution) would be part and parcel of the establishment and there would be plenty of 'stales' 'callets', 'trugs' or 'traffics' who would like to 'occupy' (have sex with) you.

NORTHAMPTONSHIRE CONVERSATION

The following everyday expressions and words were commonly used around Northamptonshire until the middle years of the nineteenth century, when social and demographic changes began to transform everyday life and customs, leading to their disappearance from the language. You would certainly have been familiar with these and they would enter the conversation at some point whilst discussing local matters over a drink or two.

You might be discussing certain individuals in the village who would have stood out in some way in their behaviour or appearance. If discussing women, 'Amy Florence' was a general term for any shabbily-dressed female, whilst a 'cank' would be a gossip or scold. A 'pigeon' would be a young girl, whilst a flirting or chatty one, would be a 'fiz-gig'.

Anyone who was skinny would be a 'scribe', whilst a slovenly person would be a 'trolley-mog'. A clever person would be described as a 'shiner', whilst an idle or dishonest person would be frowned upon as a 'shackler'. Someone who was always sour-tempered would be compared to a crab apple, and known as a 'crab stick'. A person who usually spoke his or her mind would be called either John or Joan Blunt. Any wild, noisy youth, especially male, would be scornfully termed a 'jingle brains', whilst a spoilt child would be a 'cade'. One description has however still survived, albeit in a modified form, with a slightly different meaning and pronunciation: 'molly-cot' (from which is derived 'mollycoddle') for a husband tied to his wife's apron strings.

Whilst discussing work matters, perhaps with a 'brother chip' (fellow worker) you might refer to the 'bummer' (foreman), or your working clothes (disabil – a word curiously derived from the French verb for undressing!). If you were an agricultural worker, you would probably talk about a 'bleed' (a good yield of crops), or at worst, a 'blind' (a poor yield). In the fields you would take bait (lunch) along with you (usually a piece of 'fat bacon' or cheese and a hunk of bread, with a costrel of beer or a bottle of cold tea). In the winter, you might even be wearing 'cockers' – gaiters or legs of old stockings to keep out the snow, and there would be a roaring fire in the hostelry with plenty of 'chats' (sticks) and 'chumps' (thick logs) to keep it going.

Your conversation would include the latest 'budget' (news and gossip), or maybe a good bargain you had picked up ('a lumping penn'orth'). Talking about your financial position, you would mention 'kelter', 'butter pound' or 'blunt' (money). 'Tizzy' was the county word for a sixpence. If for some reason you disagreed about a certain topic or had a different point of view about something, you might have a 'breeze' (argument). You might even be complaining about a neighbour's dog continually 'waffling' (barking). You would both be enjoying 'bever' (refreshment), and a pipe (cigarette smoking did not come into fashion until after the Crimean War, which ended in 1856. Cigarette ends come to be known in the county as 'doddles'). You would probably be drinking from a 'tot' (half pint mug), and the landlord would get you a refill of beer from one of the barrels standing on a 'thrall'. If you were in a lower class establishment, it would be known as a 'pot house'.

ACTS AND HISTORICAL LANDMARKS

616	Ethelred attempts to restrict the consumption of ale.
728	Ina of Wessex brings in a law to check the number of ale booths.
1215	King John inserts a clause in the Magna Carta, for standard measures for ale and wine.
1375	Ale house signs to be at least seven feet above the ground.
1420	Hops introduced into England by Flemish immigrants.
1437, 1445	The Vintners Company, and Brewers Company formally recognised by charter.
1482	Pewter introduced into England by the Dutch.
1494	Whisky first recorded by name in Scotland, though its origins go back to the Iron Age.
1495/6	Concern at the overwhelming number of alehouses, leads to a check being carried out on all pliers of the trade.
1514	Worshipful Company of Innholders formed (originally known as the Hostellers).
1552	First Licensing Act. No-one to keep an alehouse without the authority of two justices who took sureties for the observance of the regulations, and punished any offenders. The price of ale fixed at one penny a quart.
1553	Act regulating and restricting the number of taverns.
1577	A census made on the number of hostelries in England.
1604	Restraint made on excessive drinking. Innkeepers not allowed to serve 'outsiders', unless invited by a boarder. Offenders to pay ten shillings to be given to the poor.
1606	The 1604 Act having driven tipplers into unlicensed houses led to two further enactments: constables to imprison any offender not paying the above fine within six days; and no offender to keep an alehouse for three years thereafter.
1623	Every village or town official to act as an informer against any tipsy man, whether local or a stranger.
1625	Penalties applied to all keepers of public houses who allow tippling.
1627	Anyone keeping an alehouse without a licence to forfeit two shillings, or be whipped. For a second conviction, one month in a House of Correction.
1638	Worshipful Company of Distillers formed.
1643	First ever tax imposed on all ale, strong beer, cider and perry.
1650	Rum first recorded (in Barbados).

1667	Hostelry signs not permitted to stretch across the road, but hung from a post, wall of a building or balcony.
1688	Gin introduced from the Netherlands.
1698	Ale Measures Act stipulating beer should be sold in pint or quart measures.
1703	Lower, competitive import duty for Portuguese wine products, like port, introduced.
1722	'Entire butt' created (using dark malts and roasted barley) – the forerunner of porter and stout.
1729	A check made on 'the growing evil' of gin production.
1736	Gin Act imposes a tax of twenty shillings on every gallon of gin. Every retailer to pay a licence fee of fifty pounds.
1743	Repeal of the Gin Act, reduces retail licence from fifty pounds to one pound. The twenty shilling tax abolished.
1751	Hostelries to be registered with the wording 'at the sign of...'
1762	Further regulation and restriction of hostelry signs.
1773	Turnpikes Act.
1780	Malt Tax.
1823	Excise Act gives a fair deal to whisky distillers for the first time ever.
1828	Alehouse Act.
1830	Beer Act.
1834	Introduction of 'off licences'. Mild ale invented by Whitbread in response to public request for a less alcoholic beer.
1850	Repeal of the Glass Tax. Beginning of mass produced bottles and drinking vessels. Pale ale and IPA appear shortly afterwards.
1860	Licences granted to wine and refreshment houses.
1869	Wine and Beerhouse Act. Magistrates given the power to control all types of on- and off-licensed premises. Annual sessions and licence restrictions, which led to retailers being tied to large brewers who provided the loans.
1872	Licensing Act restricts opening times to two hours at lunchtime and four to five hours in the evening. All day opening no longer permitted.
1890	Public Health Act. Magistrates to refuse a licence if brewers did not improve their premises, especially with regard to sanitary conditions.
1916	Emergency legislation to protect wartime munitions workers from intoxication: Liquor Control Act restricts number of opening hours.
1921	Despite the end of hostilities, the old wartime measures maintained. Hours cut on Sunday to five, with a compulsory three hour gap in the afternoon between sessions.
1923	Lady Astor's Bill restricts the consumption of alcohol to over eighteens.
1961	Licensing Hours Act gives the option for earlier opening, and staying open longer.
1967	Advent of the drink and drive campaign: the Breathalyser introduced (in October).
1970	Formation of the National Association of Licensed House Managers.
1971	CAMRA (Campaign for Real Ale) born. First meeting in November the following year.
1972	The Brewery History Society founded to promote research into aspects of the brewing industry.
1980	The Small Independent Brewers Association (SIBA) formed to represent the interests of a growing number of micro-brewers. Renamed 'The Society of Independent Brewers' in 1995.

1988 Licensing Act, allows standard Sunday opening (12 to 2, 7 to 10.30) to be extended by an hour.

1989 Following widespread complaints by small breweries, publicans and real ale afficionados about the control of hostelries by the big brewers, the Monopolies Commission rule that any brewery must be limited to no more than 2,000 public houses. Tied houses to allow the tenant to have a regularly-changed guest beer.

1990 The Inn Sign Society formed.

1991 Following the 1989 report, if any brewery did have over 2000 public houses, that half the stock to exclude the brewer's own brands.

1995 Licensing Act allows pubs to plug the remaining four-hour gap during Sunday afternoons.

2003 The Beer Academy founded by a small group of beer enthusiasts, funded by interested parties, which resulted in the setting up of beer-related courses and the production of training materials.

2005 In line with new freedom in opening times, all hostelries and off-licences to reapply for a licence to sell alcohol for 24 hours a day, even if only keeping their usual opening hours. More real ales being brewed (over 2000 different ones) than at any time since 1971. Eighty new breweries established since the previous summer (twice as many since 2003).

2007 From July, smoking banned in all public places.

BIBLIOGRAPHY, RECORDS
AND REFERENCES

Baker, George: *The History and Antiquities of the County of Northampton (1822/4)*

Barford, Samuel: *Passages in the Life of a Radical* (Fisher Unwin, 1843)

Barrett, D. W.: *Life and Work among the Navvies* (Wells, Gardner, Dapton, 1880)

Bonney, H. K.: *Historic Notes in Reference to Fotheringhay* (Bell, 1821)

Braybrooke, R. (ed): *The Diary of Samuel Pepys* (London, 1906)

Brown, M. & Wilmott, B: *Brewed in Northamptonshire* (Brewery History Society, 1998)

Bull, Frederick William: *History of Kettering* (NPPC, Kettering, 1891)

Burke, Thomas: *The English Inn* (Jenkins, 1947)

Clark, P.: *The English Alehouse, a Social History 1200-1830* (London, 1983)

Cobbett, William: *Rural Rides* (The Political Register, 1830)

Cole, John: *The History and Antiquities of Wellingborough* (C. M. Darby, 1837)

Cox, Barrie: *English Inn and Tavern Names* (University of Nottingham, 1994)

Davis, D. C.: *English Bottles and Decanters* (Letts, 1972)

Defoe, Daniel: *A Tour through the Whole Island of Great Britain* (Strahan 1724, Everyman, 1962)

DeWilde, George: *Rambles Roundabout* (Dicey, 1872)

Dibdin, Charles: *Observations on a Tour in England* (Goulding, London, 1801)

Duffey, R. (ed): *The Story of Wadenhoe* (Wadenhoe History Group, 1998)

Dunkling, L. & Wright, G.: *A Dictionary of Pub Names* (RKP 1987)

Everett, Alan: *Perspectives in English Urban History* (Macmillan, 1973)

Fry, P. S.: *Two Thousand Years of British Life* (Collins, 1977).

Gibson, J. & Hunter, J.: *Victuallers' Licences* (Federation of Family History Societies, 1997)

Gibson, Jeremy: *Quarter Sessions Records for Family Historians* (5th edition, 2007)

Girouard, M.: *Victorian Pubs* (London, 1894)

Golby, Fred: The History of Old Duston (self-published, 1992)

Goodwin, J. Martyn: *The Book of Easton on the Hill* (Spiegl Press, 1989)

Gough, H.: *A Glossary of Terms used in Heraldry* (Oxford, 1894)

Gover, A. et al: *Place Names of Northamptonshire (CUP, 1933)*

Hackwood, F. W.: *Inns, Ales and Drinking Customs of Old England* (Fisher Unwin, 1910)

Harlock, Joseph: *Recollections of Finedon in the 1830s (Smith & Frostwick, 1930)*

Hartley, V. (ed): *Northamptonshire Militia Lists* (NRS xxv, 1973)

Haydon, Peter: *The English Pub: A History* (Robert Hale, 1974)

Hill, Peter: *Folklore of Northamptonshire* (Tempus 2005, The History Press, 2009)

Hill, Peter: *Secret Northamptonshire* (Amberley, 2009)

Hill, Peter: *Rockingham Forest Revisited* (Orman, 1998)

Hill, Peter: *A History of Great Oakley in Northamptonshire* (Orman, 1991).

Hill, P., Sismey, R. & Taylor. D (ed): *Corby At War* (Orman, 1995)

Hindley, Charles & West, William: *Tavern Anecdotes & Sayings* (Chatto, 1881, Batsford, 1974)

HMSO: *An Inventory of Architectural Monuments in North Northamptonshire* (1984)

Hogg, G.: *English Country Inns* (Batsford, 1974)

Horn, Pamela: *Life and Labour in Rural England, 1760-1850* (Macmillan, 1987)

Horn, Pamela: *Labouring Life in the Victorian Countryside* (Gill and Macmillan, 1976)

Ireson, Tony: *Old Kettering – A View from the 1930s* (Robert Hale, 1999)

Irving J., Rowe, R., & Thomas, A.: Oundle Pub and Brewery Trail (Oundle Museum, 1997)

James, Francis: *Syresham, A Bygone Age* (self pub. 2000)

Kettering Civic Society: *Lost and Hidden Kettering* (1974)

Kitchiner, W.: *The Traveller's Oracle* (Colburn, London, 1827)

Larwood, J. & Hotten, J. C.: *A History of Signboards* (Chatto & Windus, 1898)

Latham, R. & Matthews, W.: *The Diary of Samuel Pepys* (London, 1983)

Law, W. Smalley: *Oundle's Story* (Sheldon Press, 1922)

Lawrence, V. & Hill, P.: *The Royal Kettering Troop of the Northamptonshire Yeomanry* (1974)

Linnell, John Edward: *The Old Oak* (Constable, 1932)

Longden, Henry Isham: *The Diaries of Sir Justinian Isham, 1704-1736* (RHST, 3rd series, i, 1907)

Markham, C. A. (ed): *Northamptonshire Notes and Queries, volume 4* (1892)

Markham, Christopher: *The Old Inn, Fotheringhay* (1906)

Monson-Fitzjohn, G. F.: *Quaint Signs of Old Inns* (Herbert Jenkins, 1926)

Monson-Fitzjohn, G. F.: *Drinking Vessels of Bygone Days* (Herbert Jenkins, 1927)

Moore, J. R.: *The History of Desborough* (1901)

Northampton Arts Development: *In Living Memory – Life in the Boroughs* (1984)

Northampton Federation of Women's Institutes: *Northamptonshire Within Living Memory* (1992)

Northampton Federation of Women's Institutes: *The Northamptonshire Village Book* (1989)

Northampton and County Independent: *Cheers! A Special Brew of Tales* (1978)

Osborn, A. & Parker, D. (ed): *Oundle in the Eighteenth Century* (Spiegl Press 1994)

Page, W. (ed): The Victoria History of the County of Northampton, volume 3 (1930)

Palmer, Joyce and Maurice: *A History of Wellingborough* (Steeple Press, 1972)

Palmer, Joyce and Maurice: *Earls Barton, History of a Northamptonshire Parish* (Greensleeves, 2006)

Partridge, L.: *Portrait of Kettering in the Age of Reform 1800-1850* (Civic Society, 1981)

Pettit, Philip: *Syresham, A Forest Village* (self-published, 1996)

Pitt, William: *General view of the agriculture of the county of Northamptonshire* (Sherwood, 1813)

Rayne, Monica: *Geddington As It Was* (Stryder, 1991)

Rotary Club: *Old Oundle* (1985)

Rotary Club: *Old Rushden* (1979)

Rothery, G. C.: *The ABC of Heraldry* (London, 1915)

Salgado, G.: *The Elizabethan Underworld* (Rowman & Littlefield, 1977)

Schlesinger, Max: *Saunterings in and about London* (Cooke, 1853)

Stow, John: *Survey of London* (London, 1598)

Taylor, John: *The Carriers Cosmography* (London, 1637)

Taylor, John: *All The Workes of John Taylor, the Water Poet* (London, 1630)

Taylor, John (ed): *Northamptonshire Notes and Queries, volume 3* (1890)

Tibble, J. & A.: *John Clare, His Life and Poetry* (Heinemann, 1976)

Warren, Bill (ed): *Thrapston, A Glimpse into the Past* (Rotary Club, 1987)

West, W.: *Tavern Anecdotes and Reminiscences* (Cole, 1825)

Woodward, J.: *Ecclesiastical Heraldry* (London, 1894)
Wright, G.: *A Dictionary of Pub Names* (London, 1987)
Wrightson, Keith: *English Society, 1580-1680* (Routledge, 1981)

TRADE DIRECTORIES AND RECORDS

Pigot's Commercial Directory of Northamptonshire (1823, 1830, 1841, 1847).
Post Office Directory of Northamptonshire (1847)
Whellan's History, Gazetteer and Directory of Northamptonshire (1849)
Whellan's History, Topography and Directory of Northamptonshire (1874)
Wright's Northampton Directory (1884)
Kelly's Directory of Northamptonshire (1861, 1890, 1894)
Kelly's Directory of Bedfordshire, Hunts and Northamptonshire (1898)
Grand Metropolitan Estate Records (now part of the Diageo organisation)
Universal British Directory (1791)
Bennett's Business Directory (1888)

LIBRARY COLLECTIONS

The Frederick William Bull Collection (Kettering Library)
The Gotch Family Collection (Kettering Library)

NEWSPAPERS, MAGAZINES, JOURNALS, AND ORRESPONDENCE

The Gentleman's Magazine (1731-1907)
Northamptonshire Past and Present, volume I (1953), volume II no. 4 (1957)
Northamptonshire Notes and Queries, vols. 1-6 (1884-1895)
Taking Stock of the Pubs in Gretton (Gretton History Society, 1996)
Aspects of Helmdon, no.2 (Helmdon History Group, 1998)
Northampton County Magazine (ed. A. Adcock), vol 3 (1930)
Extracts from the following newspapers: *Northampton Mercury, Northampton Independent, Stamford Mercury, Peterborough Advertiser, Kettering Guardian and Leader, Kettering Leader*
Letters to C. D. Linnell (1937) inc. memoirs of William J. Frost (Paulerspury), Mrs B. Friday (Syresham)

RECORDS HELD AT NORTHAMPTON RECORD OFFICE

(a) Inns & Alehouses (1562-1828) records at NRO, including:

Northamptonshire Alehouse Recognizances 1737-1828 especially: Brackley Division (1805, 1813); Kettering Division (1796, 1820-1); Oundle Division (1790-1828); Wellingborough Division (1822-1828)
Northamptonshire Quarter Sessions records: 1630, 1657-1972 (presentments and orders relating to licensing).
Northampton Borough Quarter Sessions Rolls: 1745-1902.
Northampton Borough records (assembly books including alehouses 1553 to 17th century).
Liberty of Peterborough Quarter Session Rolls: 1699-1710, 1872-1917.
Finch Hatton papers (early licensing records/individual recognizances 1615 (FH 1077-1116);

regulations for licensing 1630 (FH18); Recognizances file 1630 (FH 2962; for Corby Hundred, 1690-1706 (FH 293).

(b) Inns, Public Houses, and Beershops

Quarter Sessions: liquor licensing committee minutes 1905-1961, with correspondence 1872-1907. Minutes in the Compensation Authority ledger, 1904-1928; and Northampton Borough financial statements, 1905-1920.

Petty Sessions records (includes records of unlicensed and disorderly premises): Division Returns for: Brackley 1878-1948; Daventry 1891-1973; Towcester 1879-1887 (with licence transfers 1885-1886); Higham Ferrers 1903-1924; Kettering 1830-1834 (with registers 1872-1953); Wellingborough 1891-1970; Oundle (registers) 1928-1967; Northampton Borough (police registers, 1888-1967); Thrapston 1902 (registers 1917-1973); Peterborough 1872-1883.

Northampton Police Archives: chief constable licensing reports (NBP), four volumes 1901-1965.

(c) other records

The Clifton Daybooks (m/s) 1763-1784 (minus 1774, 1775, 1780, 1783).
Northamptonshire Militia Lists 1762-1798.
Parish Constables' Disbursements.
County Hundred Court Rolls.
The Phipps Brewery Collection (photographic records of pubs and off licences).
Tithe, manorial, enclosure and Ordnance Survey maps (for identification of sites).

RECORDS AT THE NATIONAL ARCHIVES

Mompasson Licences (1620) for Blisworth, Collyweston, Croughton, Kelmarsh, Kingscliffe, Middleton Cheney, Stamford Baron, Towcester, Wappenham, Weedon Bec, Wellingborough.
Coventry Licences (1626-1639) include Grafton Regis, Higham Ferrers, Kilsby, Northampton, Oundle, Peterborough, Weedon Bec and Weldon.
Letters Patent (1554-1571): Northampton, Stamford Baron, Wellingborough.
Vintners records/fines (1569-1572): Daventry, Northampton, Towcester.
Victuallers Lenten Recognizances (1572-1634).
Raleigh Wine Licences (1585-1586).
Wine Licences (Pipe Office) 1670-1756.